The Picture History of

PHOTOGRAPHY

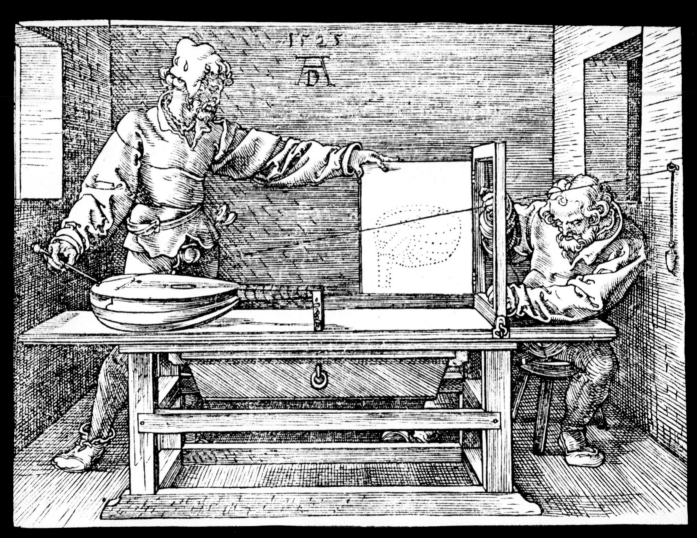

Albrecht Dürer (1471–1528). Engraving of 1525, showing
the German artist's sighting device for drawing and teaching perspective.
The Art Institute of Chicago

PETER POLLACK

The Picture History of
PHOTOGRAPHY

From the Earliest Beginnings

to the Present Day

Harry N. Abrams, Inc., Publishers · New York

Library of Congress Cataloging in Publication Data

Pollack, Peter.
 The picture history of photography.

 Includes index.
 1. Photography—History. I. Title.
TR15.P55 1977 779 76-51916
ISBN 0-8109-2056-5
ISBN 0-8109-1462-X

Concise edition 1977

Library of Congress Catalog Card Number: 76-51916

Contents

Author's Preface

It is with photography as an art and with photographers as artists—with the vision of the man behind the camera—that this book is largely concerned.

Photography was invented by nineteenth-century artists for their own purposes. These men were seeking a lasting, literal record of their visual surroundings, and they found it. The new combination of illumination, lens, shutter, and flat surface coated with chemicals sensitive to light produced, within a short interval of time, images more lasting, more convincing in their reality, and more richly detailed than painters could produce manually in weeks and months of effort. This alone was enough to throw consternation into the ranks of fellow artists; and, after their first reaction of pleasure in a new kind of image, art critics rallied with the haughty charge that photography was not and could not be an art. The actual world in which we live had too strong a grip on photography, they said, and pictures so dependent upon mechanical means could not be called acts of man's creative imagination.

Despite the critics, photographers knew that they had found a new art form, a new mode of expression. As artists, they had extraordinary visual sensitivity, and they thought and expressed themselves naturally through visual images. As artists, they used the new tools as other artists before and after them have used brush and pencil—to interpret the world, to present a vision of nature and its structure as well as the things and the people in it.

The most important use of photography was in communication. Here the value of photography was seen in its quality of immediacy, of literal description and convincing presentation of reality. This quality was retained to a large extent even after pictures had been translated into forms that made them available as printing plates for the illustration of books. Almost anything that could be photographed could be printed; and books on travel, medicine, science, and art were published with a wealth and authenticity of visual information never before possible. By now, photography has become as important as the word—perhaps more important as all linguistic barriers fell before this "picture talk."

We use photographs as memories, memories of ourselves when we were younger, of places where we have lived or visited, of friends and relatives who are no longer with us. With the advent of the roll-film Kodak, manageable even by a young child, photography became a folk art—the most democratic art in history. The millions practice it, as well as the few who make of it a medium of high art and a tool of science and industry.

1

The Beginnings of Photography

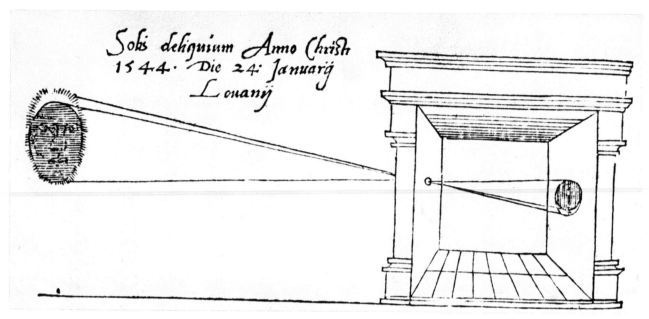

The first published illustration of a camera obscura, which is registering the solar eclipse of January 24, 1544.
The drawing is by the sixteenth-century Dutch scientist Rainer Gemma-Frisius.
Gernsheim Collection, University of Texas, Austin

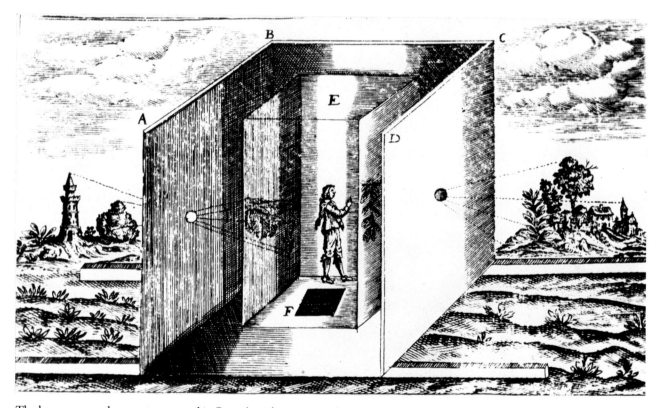

The large camera obscura, constructed in Rome by Athanasius Kircher in 1646, is shown with the top and front cut away.
It was a small portable room that could easily be carried by an artist to the scene that he wished to depict; he would climb inside
through a trap door. In this engraving he is tracing, from behind, an image cast on transparent paper that hangs opposite one of the lenses.
George Eastman House, Rochester, New York

The Long Road to Photography

IT IS A POPULAR BELIEF that photography was invented by one man. When the process was made public in 1839, his name was attached to it. But the "one man," Daguerre, did not actually take the first photograph. Another man did, Joseph Nicéphore Niepce, seventeen years before Daguerre made his momentous announcement in 1839. Four years before Daguerre's announcement, Fox Talbot took a photograph on a one-inch-square paper negative placed in a camera. In the very year of the announcement, Hippolyte Bayard exhibited direct-positive prints in Paris and Sir John Herschel read to the Royal Society his paper on a method he had discovered of fixing photographs with hyposulphite of soda, the same hypo still used in every darkroom.

The first person to prove that light and not heat blackened silver salts was Johann Heinrich Schulze (1687–1744), a physician and professor at the University of Halle in Germany. In 1725, while attempting to make a phosphorescent substance, he happened to mix chalk with some nitric acid that contained some dissolved silver. He observed that wherever direct sunlight fell upon it the white mixture turned black, whereas no changes took place in the material protected from the sun's rays. He then experimented with words and shapes cut from paper and placed around a bottle of the prepared solution—thus obtaining photographic impressions on the silvered chalk. Professor Schulze published his findings in 1727, but it never entered his mind to try to make permanent the image he secured in this way. He shook the solution in the bottle and the image was lost forever. This experiment, however, started a series of observations, discoveries, and inventions in chemistry that, when combined with a "camera obscura" a little more than a century later, culminated in the invention of photography.

The chemical prehistory of photography goes back to the mists of antiquity. Men have always known that exposure to the sun's rays tans human skin, draws the sparkle from opals and amethysts, and ruins the flavor of beer. Photography's optical prehistory goes back about a thousand years. The original camera obscura may be called "a room with a sunlit view." The tenth-century Arab mathematician and scientist Alhazen of Basra, who wrote on fundamental principles of optics and demonstrated the behavior of light, recorded the natural phenomenon of the inverted image. He had observed this on the white walls of darkened rooms or

Johann Heinrich Schulze (1687–1744), the German physician who obtained the first images in 1727
by the action of light on a mixture of white chalk and silver.
George Eastman House, Rochester, New York

11

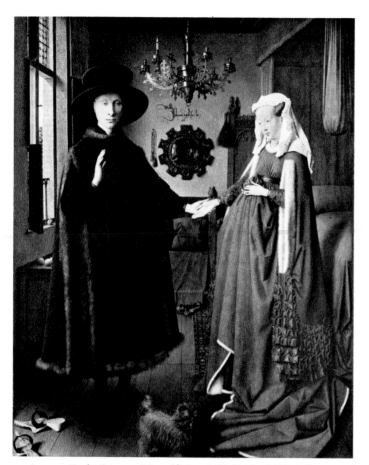

Jan van Eyck. *Giovanni Arnolfini and His Bride*. 1434. Oil on panel. The National Gallery, London. Detail at right

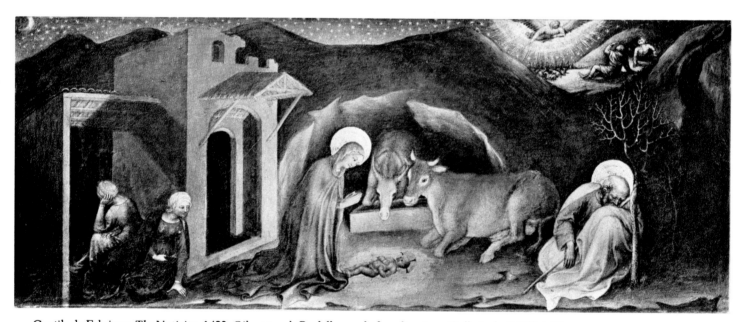

Gentile da Fabriano. *The Nativity*. 1423. Oil on panel. Predella panel of an altarpiece. Galleria degli Uffizi, Florence

tents set in the sunny landscapes of the Persian Gulf area, the image passing through a small round hole in wall, tent flap, or drapery. The camera obscura was first used by Alhazen to observe eclipses of the sun, which he knew were harmful to the naked eye.

The inverted image of the camera obscura is easily explained, for light passes in straight lines through the small hole cut in the center. The lines of light reflected from the bottom of a sunlit landscape will enter the hole and continue upward in a straight line to the top of the wall of the darkened room. In the same way, the lines of light reflected from the top of the landscape will travel downward to the bottom of the wall, and all lines in between the top and bottom will similarly pass

12

through the center, producing an upside-down image.

By the opening years of the fifteenth century, artists were turning to the description of light. On page 12 we see reproduced the first painting in which light was handled as a visual element apart from form and color: a tiny night scene of the Nativity executed by the Italian artist Gentile da Fabriano in 1423. The way things look, Gentile tells us here, depends on the way light hits them. He could not realize it, of course, but he took a big step toward today's photographic vision. The Flemish artist Jan van Eyck, in a little more than a decade, went far beyond Gentile in the study of light, as we may see in his painting *Giovanni Arnolfini and His Bride*. Here is not only a marvelously delicate play of light on forms, but a marvelously precise study of how light and color are modulated by distance. We call this phenomenon "atmospheric perspective."

The lively sixteenth-century interest in optics broke the ground for a new scientific era in the century that followed. In 1604 Johannes Kepler determined the physical and mathematical laws governing reflection by mirrors. In 1609 Galileo invented the compound telescope. In 1611 Kepler worked out the theory of lenses, which now became reliable scientific instruments. Interest in optical phenomena rose to a fever pitch and swept all over Europe. Artists as well as scientists were strongly affected by this development.

If the artists had taught the scientists how to observe, the scientists were now returning the favor. Sixteenth-century painting, especially in Venice and North Italy, had reflected the general interest in optical phenomena. In the seventeenth century this interest became almost obsessive. Architects, stage designers, and sculptors were its captives, falling in love with illusion. Painters drove their vision as far as it would go. Certain Dutchmen—Carel Fabritius, Jan Vermeer, Samuel van Hoogstraten—and the Spaniard Velázquez even went beyond the perceptual limits of the unaided eye to paint phenomena that could be seen only in conjunction with the mirror or lens. Almost certainly, they used the camera obscura. Vermeer's *Girl with a Red Hat*, for example, gives us cameralike vision in showing the "circles of confusion" that occur around points of intense illumination when not every ray in a beam of light is brought into the sharpest focus.

The practical usefulness of the camera obscura to artists of the seventeenth, eighteenth, and early nineteenth centuries greatly increased as the size of the instrument diminished. Camera obscura became available for field use when sedan chairs and tents were modified for the purpose in the seventeenth century. In 1620 Kepler, the great astronomer and optical physicist, set up a black tent in a field, inserted a lens in a hole cut in one flap, and traced the image that fell on paper attached to the flap opposite the lens. Gradually, the camera obscura became smaller and more easily portable. It was soon to measure about two feet in

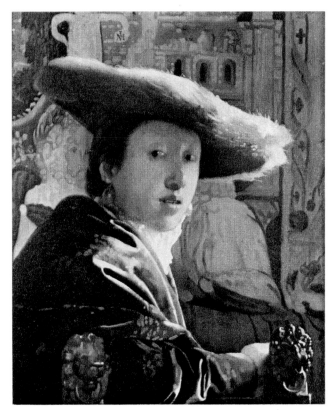

Jan Vermeer. *The Girl with a Red Hat*.
c. 1660. Oil on panel.
National Gallery of Art, Washington, D.C.

Chair, finial, drapery, and background tapestry—analogous to elements in Vermeer's *The Girl with a Red Hat* (top). Art historian Charles Seymour, Jr., set up the objects, studied them with a camera obscura, and Henry Beville photographed them with a modern camera adjusted to simulate the image in the camera obscura. The optical effects in the photograph and the painting are similar

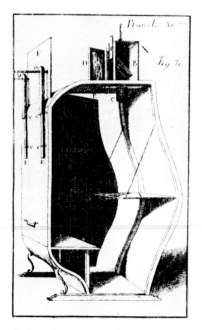

Sedan-chair camera obscura. 1711.
Gernsheim Collection, University of
Texas, Austin

An early nineteenth-century portable camera obscura.
George Eastman House, Rochester, New York

length and less than a foot in height, with a lens fitted on one end and a ground glass on the other.

A reflex type of camera obscura was designed by Johann Zahn in 1685. His box had the advantage of a mirror placed inside at a 45-degree angle to the lens, so that the image was reflected upward to the top of the box. Here he placed a sheet of frosted glass, which could be covered with tracing paper so that the image was easily traced. Zahn also invented an even smaller reflex-box camera obscura fitted with a lens. It resembled the cameras used by Niepce a hundred and fifty years later.

The important growth of the middle class in the eighteenth century created a demand for portraits at reasonable prices. Previously, portraits had been a luxury of the wealthy. The first response to this demand was the development of the "silhouette," which required only that a person trace outlines or shadows cast on a paper and then mount the cut-out likeness.

The "physionotrace," invented by Gilles-Louis Chrétien in 1786, worked on the same principle as the silhouette but had the added advantage that a small engraving on copper resulted from the tracing. This plate could be used to pull an edition of prints.

The eighteenth-century need for the camera came close to being realized in 1800 by Tom Wedgwood (fourth son of the famous potter Josiah Wedgwood), who secured an image but was unable to make it permanent. In 1796 he experimented with sensitized silver salts to produce images of botanical specimens. He copied the woody fiber of leaves or the wings of insects, which he placed on paper or leather moistened with silver nitrate and exposed to the sun. Had he used ammonia as a fixing agent, a discovery of Carl W.

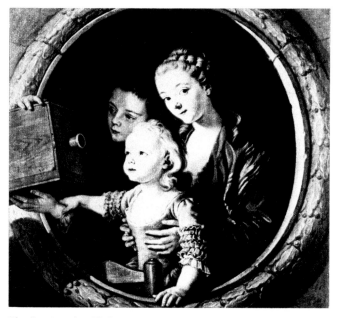

Charles-Amédée-Philippe van Loo. *The Magic Lantern*. 1764.
Oil on canvas. The painting shows the artist's family with
a camera obscura. National Gallery of Art, Washington, D.C.

Scheele in Sweden twenty years earlier, or had he washed the image in a heavy solution of common salt, he could have stopped any further action of light on the sensitive silver salts. Instead, he washed the negative with soap, or he varnished the picture when dry. Though he examined the image by only the weakest of candlelight, it was of no avail, for the image gradually grew black.

How close Tom Wedgwood was to becoming the father of photography! In addition to contact printing he attempted to secure images on prepared paper

Peep Show. c. 1790. French mezzotint.
The sign above the door reads "camera obscura."
Collection Peter Pollack

"Hand-cut" American silhouettes of Charles Wage, aged two,
and his mother. 1824. (In the early nineteenth century,
the American painter Rembrandt Peale made similar
silhouettes that he called "profileographs.")
The Art Institute of Chicago

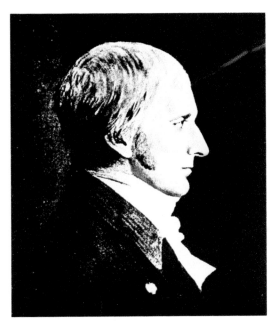

Tom Wedgwood, who first conceived the idea of practical
photography in 1800, but was unable to fix the image.
George Eastman House, Rochester, New York

placed in a camera obscura. As he met with no success,
he abandoned further experiments and recorded those
he made up to 1802. In that year his friend Sir Humphry Davy wrote a paper explaining Tom's experiments
and sent it to the Royal Society. The paper was entitled
"On an Account of a Method of Copying Paintings on
Glass and of Making Profiles by the Agency of Light
upon Nitrate of Silver—Invented by T. Wedgwood
Esq." It reads, in part, "the images formed by means of
a camera obscura have been found too faint to produce,
in any moderate time, an effect upon the nitrate of
silver."

The man who first successfully obtained an image
from the sun was Nicéphore Niepce of France, who, in
1827, attempted to present a paper to the Royal Society
in London while he was in England visiting his brother
Claude, like himself a dedicated inventor. Since he
kept his process a secret, refusing to describe it in his
paper, his proposal was rejected by the Royal Society.
Accompanying his paper, however, were several
photographs either on glass or metal. In 1853 Robert
Hunt, one of photography's first historians, reported
several of these plates to be in the collection of the
Royal (British) Museum. Mr. Hunt writes, "They
prove M. Niepce to have been acquainted with a
method of forming pictures, by which the lights, semi-tints, and shadows, were represented as in nature; and
he had also succeeded in rendering his heliographs,

when once formed, impervious to the further effects of
the solar rays. Some of these specimens appear in a state
of advanced etchings."

It should not surprise us that these prints resembled
etchings, since Niepce actually invented photogravure;
and the examples Mr. Hunt saw might well have been
"heliogravures" and not photographs taken in the camera obscura.

Niepce: The World's First Photographer

IT IS GRATIFYING TO FIND Joseph Nicéphore Niepce, eclipsed for more than a hundred years by his one-time partner, Louis-J.-M. Daguerre, now once again being honored as the world's first photographer. Niepce not only produced a picture in a camera obscura; he invented an iris diaphragm to correct defects he observed in the full lens (an invention forgotten for more than fifty years; it had to be reinvented). Above all, Niepce was the first to make the image permanent.

He called these images caught in the camera obscura *"points de vue"* to distinguish them from his *"copies de gravure."* In the latter, he made a sandwich consisting of an engraving (made transparent with oil) placed

Artist unknown. *Portrait of Joseph Nicéphore Niepce as a Young Man.* c. 1785. Courtesy Janine Niepce, Paris

between a sensitized plate and a sheet of clear glass; the glass kept the engraving flat while he exposed the array to the sun.

The images produced by both processes were referred to as "heliographs." The plates on which they were made were coated with bitumen of Judaea, a substance soluble in ethereal oils, such as oil of turpentine, oil of lavender, petroleum, and ether.

Niepce in 1813 had already been interested for several years in improving the process of lithography, which Alois Senefelder had invented in 1796. For Senefelder's heavy Bavarian limestone Niepce substituted a sheet of tin, upon which he had his young son draw designs with a greasy crayon. When the boy was called to the army in 1814, Niepce, unable to draw, found himself handicapped. He then began a series of experiments with various silver salts, intending to eliminate the need for an artist's talent by making light itself draw for him. He achieved the most satisfactory results with a varnish made of bitumen of Judaea dissolved in Dippel's animal oil. This solution he coated on a sheet of glass, copper, or pewter, exposing the sheet to the light from two to four hours to make a *copie de gravure* or fully eight hours to produce a *point de vue.*

When the image on the varnish (or asphaltum, as it was also called) was hardened and the picture became visible to the eye, he brought the plate into a darkroom for treatment. First he subjected the plate to an acid bath which dissolved the varnish under the lines of the engraving. This varnish had been protected from the action of light during the exposure, and, accordingly, had remained soft and soluble. Niepce then sent the plate to his friend, the artist-engraver Lemaître (1797–1870), who incised the lines, inked the plate, and pulled an edition of prints as he would have done from any etched or engraved plate. Niepce's most successful heliograph was of Cardinal d'Amboise early in 1827.

According to the historian Georges Potoniée, it can be proved that Niepce obtained a permanent impression in the camera obscura during the year 1822.

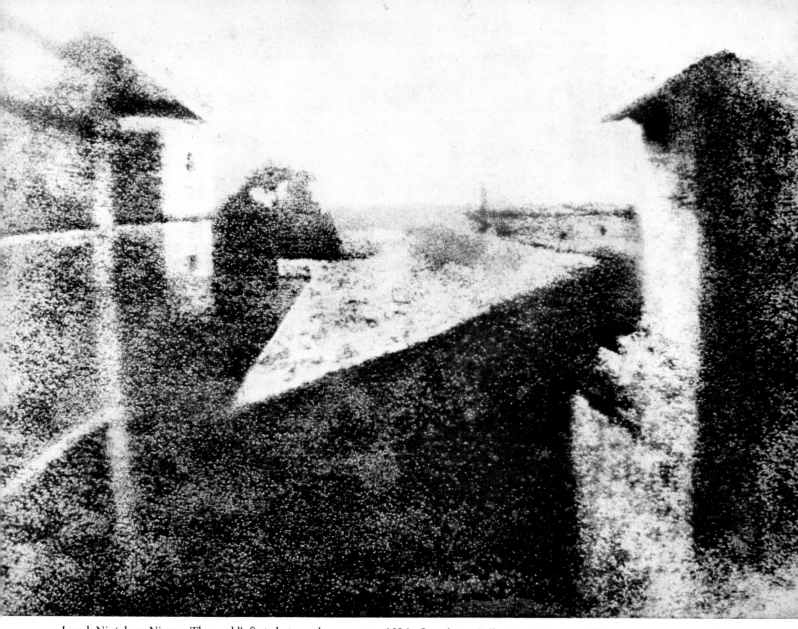

Joseph Nicéphore Niepce. The world's first photograph, on pewter. 1826. Gernsheim Collection, University of Texas, Austin

However, only one of his extant *points de vue* can definitely be dated 1826. (It is in the Gernsheim Collection at the University of Texas, Austin.) This picture seems certain to have been taken in 1826 because that was the year that Niepce turned to pewter instead of copper and zinc plates. Exposure took eight hours, and this caused the sun to light both sides of the view, a building, taken from his room. Niepce wrote his son Isidore explaining that he preferred pewter, since it was darker than copper and bright when polished, so that the contrast of black and white lines remained much sharper.

His friend Lemaître suggested the perfect metal, silver plating on copper, which Daguerre was later to make universally popular in the daguerreotype. Niepce considered Lemaître's suggestion the perfect solution, for he intended to etch the best of his camera views, making incisions with a burin through the thin silver plate to the sturdier plate of copper below, which would enable him to pull an edition of prints.

Niepce continued to improve his heliogravure method, making the image a bit sharper by exposing the metal plate to the fumes of a few grains of iodine, then removing all the bitumen varnish to disclose the bare metal. The result was an image composed by the iodine vapors which had blackened the silver, contrasted to the shiny polished silver which had been under the hardened bitumen and which became visible when alcohol dissolved the varnish.

Niepce treated a glass plate as he did metal, with this distinguishing difference: when the asphaltum was dissolved in oil of lavender the plate was then washed and dried and viewed as a transparency. It is strange that Niepce, who was working toward a solution of the problem of making multiple reproductions, never seems to have used the transparency as a negative, to make prints from it on paper sensitized with silver salts. This negative-positive principle—from which all modern photography stems—was to be the invention of Fox Talbot several years later in England.

17

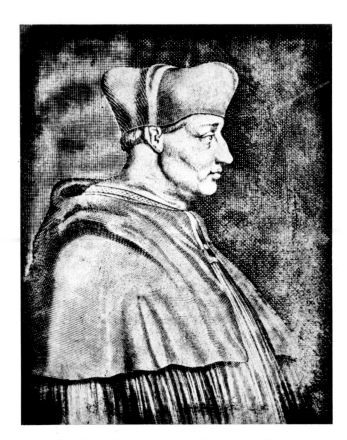

Joseph Nicéphore Niepce. *Cardinal d'Amboise.* 1827.
Print pulled from a heliograph engraving made in 1826.
Gernsheim Collection, University of Texas, Austin

successful because of his invention of a new camera.

Returning from England later in that year, 1827, after visiting his sick brother, Niepce met with the affluent, prosperous Daguerre, twenty years his junior. They became partners in 1829, after Daguerre convinced Niepce not to publish his process even though he felt he couldn't improve it any further. Daguerre's letter reads, "... there should be found a way to get a large profit out of the invention before publication, apart from the honors you will receive."

In October, 1829, Niepce wrote Daguerre, offering to cooperate with him "for the purpose of perfecting the heliographic process and to combine the advantages which might result in a complete success." A ten-year partnership contract was signed by both parties on December 14, 1829, which reads in part, "M. Daguerre invites M. Niepce to join him in order to obtain the perfection of a new method discovered by M. Niepce, for fixing the images of nature without having recourse to an artist."

Niepce contributed his invention, Daguerre contributed "a new adaptation of the camera obscura, his talents, and his labor."

It appears to have been an uneven bargain, for to the Niepce-Daguerre partnership the camera of Daguerre was still an uncertain, untried asset and, actually, all that was known of photography was the contribution of Niepce. But Daguerre was a vital half of the partnership; the aged and ill Niepce was discouraged about the future of his experiments and badly in need of Daguerre's youth and self-confidence. Above all Niepce had faith in Daguerre's abiding interest in photography, his conviction that the process would be perfected and become a commercial success. Niepce included in the contract the proviso that his son Isidore would succeed to the partnership in case he died before the contract expired.

Niepce sent Daguerre a detailed description of his process, a note on heliography, completely explaining the preparation of silver, copper, or glass plates, the proportions of the various mixtures, the solvents used in developing the image, the washing and fixing procedures, and the application of his latest experiments in the heliograph—using iodine vapors to blacken the image.

Niepce also demonstrated his techniques to Daguerre, who went to Châlon for this purpose. Daguerre left for Paris several days later and never saw Niepce again. Each man worked on the invention; little is known of their progress other than that Daguerre wrote in 1831, asking Niepce to experiment with iodine in combination with silver salts as a light-sensitive substance. Niepce did not respond enthusiastically. He had not been too successful in previous experiments with silver iodide—a silver halide which only when mixed in exactly the proper proportions can be made sensitive to light.

In 1829 the sixty-four-year-old Niepce was ill and badly in need of money. He and his brother Claude, who had died in England the previous year, had spent their patrimony on all kinds of inventions, prospering from none. There had never been a need to make money, for the Niepce family was rich and well-educated, and lived in a luxurious home at Châlon-sur-Saône when Joseph was born in 1765. His father was a Councillor of the King, his mother the daughter of a noted lawyer. Joseph showed interest in inventions even while in his teens but studied to become a cleric, doffing the collar in 1792 to become an officer in the army, seeing active service in Sardinia and Italy. Ill health made him resign his commission, and for the next seven years he was in Nice as a member of the government administration.

He returned to his ancestral home in 1801 to devote himself immediately, with his brother Claude, to all kinds of scientific investigations, but it was heliography that was his major interest until he died in 1833.

Scientific research was costly even then. Niepce needed money desperately, but, even so, he didn't answer a letter from Daguerre, the successful entrepreneur of the Diorama in Paris, until a year had passed. And then he answered warily, giving no facts, but rather trying to ascertain the extent of Daguerre's experiments which, according to Daguerre, had been quite

Daguerre and the Daguerreotype

LOUIS-JACQUES-MANDÉ DAGUERRE (1787–1851) did not invent photography, but he made it work, made it popular, and made it his own.

Within a year after its announcement in 1839 his name and his process were known in all parts of the world. Honors were showered on him and wealth and security were his. The name of Joseph Nicéphore Niepce was practically forgotten.

It was Daguerre, however, who actually made the Niepce invention work, using chemicals that Niepce never hit upon. His ingenious idea was to bring out the image by the vapor of mercury. He experimented first with bichloride of mercury, which just barely brought out the image; improved it by using sweet or sub-chloride of mercury; and, finally, in 1837, after eleven years of experimentation, hit upon the heating of mercury, letting the vapors develop the image. He then fixed the image perfectly and permanently by using a strong solution of common salt and hot water to dissolve away the particles of silver iodine not affected by the light.

Daguerre's principle of development by mercury vapor was original, a workable process based undoubtedly on knowledge he gained from Niepce. Niepce, however, contributed nothing to further the invention after 1829, nor did his son Isidore. Isidore became Daguerre's partner after Niepce died impoverished at the age of sixty-nine in the year 1833. The son, badly in need of money, signed a new contract several years later, stating that Daguerre was the inventor of the Daguerreotype; and he permitted the original name of the firm, Niepce-Daguerre, to be reversed.

These were the steps of Daguerre's process:

1. Thin sheet of silver soldered onto a thicker sheet of copper.
2. Silver surface polished to a perfect finish.
3. Silver plate iodized by fumes of iodine making it sensitive to the light.
4. Prepared plate put in light-tight holder in the dark; plate holder placed in camera.
5. Camera placed on tripod, set in landscape, and pointed to any object in direct sunlight.
6. Lens uncovered 15 to 30 minutes (the best time

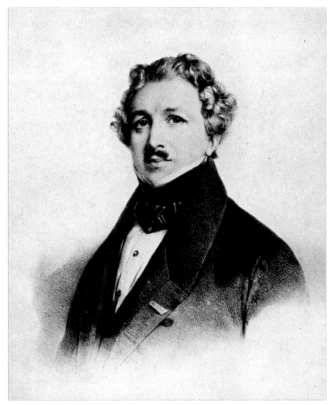

Henri Grevedon. *Louis-Jacques-Mandé Daguerre.* 1837. Lithograph. Daguerre was often a subject for artist friends. This was drawn two years before he published the daguerreotype process. George Eastman House, Rochester, New York

for a picture by Niepce was 8 hours).

7. Latent image developed and made permanent by the following steps:

 a. Plate placed in a cabinet on a 45° angle above a container under which a spirit lamp heated the mercury to 150°F.

 b. Plate watched carefully until picture was made quite visible by the mercury particles adhering to the exposed silver.

 c. Plate plunged into cold water to harden surface.

 d. Plate submerged in a solution of common salt (after 1839 replaced by hyposulphite of soda, the

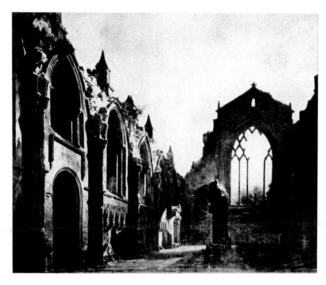

Louis-Jacques-Mandé Daguerre. *Holyrood Chapel, Edinburgh*.
1824. Oil painting. This was considered Daguerre's best easel
painting, and was awarded the Legion of Honor when it was
exhibited. Walker Art Gallery, Liverpool

fixing agent discovered by Sir John Herschel and
immediately adopted by Daguerre).

e. Plate then thoroughly washed to stop the action
of the fixing agent.

The result was an individual picture, a positive. It
could be seen only in certain lights; in direct rays of the
sun it became a shiny sheet of metal. The image was
reversed as in a mirror. It could not be multiplied or
printed in unlimited numbers, as positives can be from
a single negative—the negative-positive principle of
photography was the invention of Fox Talbot. Both
discoveries were announced the same year.

To make the most of his invention Daguerre first
tried to organize a corporation by public subscription.
When this was unsuccessful, he attempted to sell it for a
quarter of a million francs, but to cautious speculators
this appeared too much of a gamble.

Daguerre created considerable interest, for he took
pictures with his heavy camera and equipment along

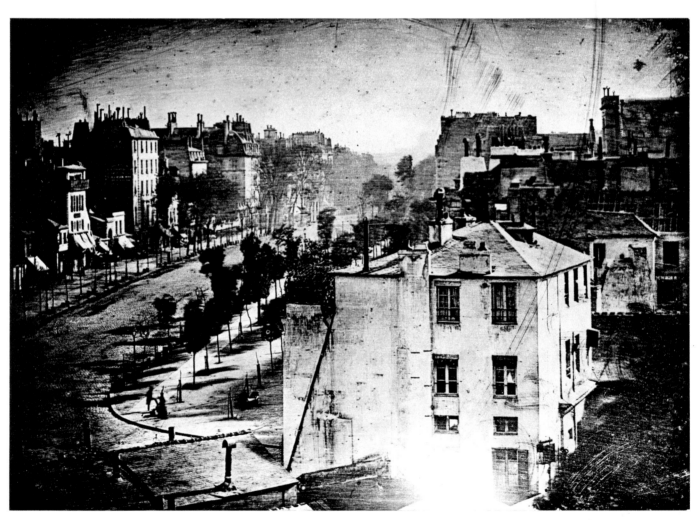

Louis-Jacques-Mandé Daguerre. *Paris Boulevard*. 1839. Daguerreotype. This first photograph of a human being was sent
by Daguerre to the King of Bavaria; the original, formerly in the Stadtmuseum, Munich, was destroyed during
World War II. When Samuel F. B. Morse saw the daguerreotype he wrote, "The boulevard, so constantly filled with a
moving throng of pedestrians and carriages, was perfectly solitary, except for an individual who was
having his boots brushed." George Eastman House, Rochester, New York

the boulevards of Paris. But he did not explain the operation and businessmen remained cold to its possibilities.

Daguerre then interested scientists in the invention, particularly the influential astronomer, Dominique-François Arago (1786–1853). Arago, believing a rumor that Russia and England were offering to buy the daguerreotype, reported Daguerre's achievement on January 7, 1839, to the Academy of Sciences, and proposed that the French government purchase the process.

The announcement of the daguerreotype produced a sensation. Scientific journals printed Arago's report. Daguerre became better known for this invention than for his well-established Diorama. He showed views of Paris taken by the daguerreotype process to newspaper editors, writers, and artists, who acclaimed him and his invention. Daguerre asked 200,000 francs for it and told Isidore Niepce he would split this with him if it were sold, deducting the amount Isidore had borrowed from him since his father's death.

Arago convinced Daguerre that a pension by the French government would be more of an honor, a national award of recognition for his invention, and he wrote Daguerre, "You will not suffer that we shall allow foreign nations the glory of presenting to the scientific and artistic world one of the most marvelous discoveries that honor our country."

A pension was agreed upon—6,000 francs annually for life to Daguerre and 4,000 for Isidore Niepce, with half pension for their widows. The proposal was presented to the Chamber of Deputies on June 15, 1839, and passed by King Louis Philippe a month later. On August 19 Arago made public Daguerre's startling method of obtaining a pictorial image from nature in all its details, unaided by the hand of an artist, a picture entirely drawn by the sun.

Arago's report was brilliant. He dazzled the audience with superb daguerreotypes taken by Daguerre. The members of the Academy of Sciences and the equally revered Academy of Fine Arts were entranced. Some of the finest intellects of France and of all Europe were present. Arago described the history of photography—making a number of errors, such as attributing the invention of the camera obscura to Della Porta and slighting Niepce's contribution—but he explained the daguerreotype process in scientific terms and in some detail. With clear insight he predicted its importance for the future, the consequences it would have in recording history. He closed his impassioned speech with the words, "France has adopted this discovery and from the first has shown her pride in being able to donate it generously to the whole world." Arago was apparently unaware that, just five days before, on August 14, Daguerre had secured a patent in England. The future looked rewarding.

Daguerre was again secure financially. Only several months before, on March 8, when his famous Diorama was burned to the ground, he had seemed destitute.

It was the Diorama, a huge, special structure with enormous 72-by-46-foot canvases, that, apparently, had brought Daguerre to experiment with photography. He was well acquainted with the camera obscura, and had made sketches from nature in his attempts to create an illusion of reality. In the Diorama he painted tremendous canvases so astonishingly realistic that visitors believed they were three-dimensional constructions in the building. He introduced the innovation of painting pictures on both sides of this canvas. The demands of the Diorama taxed his ingenuity, but he met its challenge by creating gigantic pictures with translucent and opaque paints, inventing shutters and screens to control the natural light that entered through the windows; and he developed spectacular effects in some scenes by manipulating oil lamps as spots and, in the last five years of the Diorama's existence, by using gaslight for even more novel illusionary effects. When he opened the Diorama in 1822 in Paris he was already well known as a painter of panoramas 350 feet long and 50 feet high and as a stage designer. He had received some acclaim for his easel paintings in *trompe-l'oeil* (pictures so realistic as to "fool the eye"). One of these paintings, undoubtedly his best, *Ruin of Holyrood Chapel*, earned him the red ribbon of the Legion of Honor when it was exhibited in 1824. He was to receive the rank of *officier* fifteen years later when the daguerreotype was announced.

The Diorama was his crowning achievement as the creator of imposing spectacles. It was as popular as the movies are in our day and met about the same need for entertainment, travel, and illusion. In 1823, a year after they opened the Paris Diorama, Daguerre and his partner Bouton, also a painter of huge canvases, built a similar structure in London. Most of the thirty-one dioramas they painted for Paris were given an average showing of seven months and were then sent for viewing in the London Diorama. The exhibitions included such elaborate paintings as *The Valley of Sarnen in Switzerland, Interior of Chartres Cathedral, Effect of Fog and Snow Seen through a Ruined Gothic Colonnade, The Beginning of the Deluge, The Tomb of Napoleon at St. Helena,* the *Grand Canal of Venice,* and the *Solomon's Temple,* which burned with the Diorama in Paris but for which a sketch remains.

First official recognition of his contribution as a painter and creator of the diorama came when Arago had him include details of his diorama technique in the agreement with the government in which he disclosed the steps for making a daguerreotype. This was a ruse to obtain for Daguerre the greater share of the pension granted by the government, 6,000 francs for Daguerre and 4,000 for Isidore Niepce. How advantageous, when Daguerre had no plans to reopen the Diorama!

He concentrated on explaining the daguerreotype

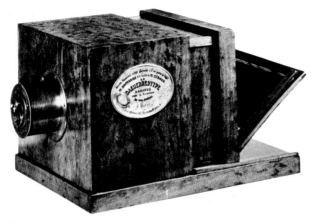

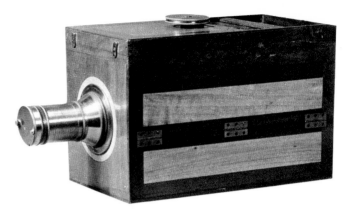

The official Daguerre camera, produced by
Daguerre's brother-in-law Alphonse Giroux,
measures 12 x 14½ x 20". The inscription
on the label reads, "No apparatus guaranteed
if it does not bear the signature of
M. Daguerre and the seal of M. Giroux.
The Daguerreotype, made under the direction
of the inventor in Paris by Alph. Giroux
et Cie. Rue du Coq St. Honoré, No. 7."
George Eastman House, Rochester, New York

A collapsible camera made by Charles Chevalier in Paris
in 1840, for whole plate, 6½ x 8½". Furnished as part of
a complete daguerreotype outfit, it could also be used
to take paper negatives.
George Eastman House, Rochester, New York

Camera and equipment, designed by Marc Gaudin and
manufactured by N.P. Lerebours of Paris in 1841, for
taking and processing daguerreotypes of ¹/₆ size.
The outer wooden box serves as both camera and as
carrying case for the following accessories:
glass-lined coating box, mercury bath with sliding support,
two single plate holders, and slotted box to hold twelve
plates. In little more than a year Daguerre's 110 pounds
of equipment had been reduced to less than ten.
George Eastman House, Rochester, New York

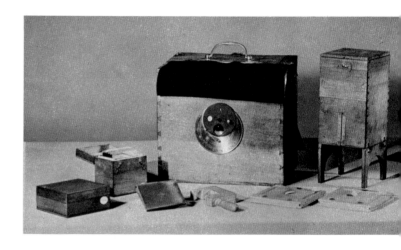

process, giving demonstrations to scientists and artists,
simplifying the complicated scientific account given by
Arago and exhibiting his own examples of the art.
Daguerre started to manufacture apparatus for the
daguerreotype with his brother-in-law, Alphonse
Giroux. Giroux, a stationer, quickly gave up his other
business to devote himself exclusively to production of
the Giroux camera. Samuel Chevalier ground the
lenses; and each camera was stamped with a serial
number, and signed by Daguerre, who thus made it
official. Half the profits of this partnership were to go to
Daguerre, who generously gave Isidore Niepce 50 per
cent of his share.

The day after Arago made his report Giroux pub-
lished Daguerre's seventy-nine-page manual. All the
cameras he had on hand as well as the manual were
sold out in a few days. The pamphlet went through
thirty editions in French. Before the year was out it was
translated into all languages and printed in all capitals
of Europe and in the city of New York.

Artists, scientists, and the general public quickly
improved and modified Daguerre's process, shortening
the exposure to several minutes, so that portraits
seemed feasible and in one month became an actuality.

A prism turned the image around from its left-to-
right-reversed attitude, so that the portrait was seen
normally, as one is seen by people, not as one sees
oneself in a mirror. A decided step forward was the
construction, by 1841, of smaller apparatus that re-
duced Daguerre's 110 pounds of equipment to less than
10 pounds. Still further improvement was protection
for the daguerreotype surface which was fragile and
easily scratched or damaged. Hippolyte Fizeau, in
1840, had the thought of toning the image with
chloride of gold. This not only increased the contrast of
the image; it produced the beautiful, deep silvery-gray
tone that oxidized into a rich, purplish brown.

Daguerre received honors and acclaim as his inven-
tion conquered the imagination of people everywhere.
He himself, however, made no further contribution to
photography after publication of his process. Until he
died in 1851, he lived in retirement at Bry-sur-Marne
about six miles from Paris. In 1843 he claimed to have
perfected instantaneous photography, to have taken a
bird in flight, but he could not prove his claim.

The inventor of the daguerreotype lies buried in a
tomb, donated by his fellow citizens of Bry, where he
was interred July 10, 1851, soon after his death.

The Daguerreotype

THE VERY FIRST YEAR of Daguerre's invention, enterprising publishers already saw great possibilities for profit from the travel books with reproductions of daguerreotype views. N. P. Lerebours of Paris, an optician who manufactured daguerreotype cameras closely resembling the official Giroux camera, hired artists and cameramen, equipped them with his outfits, and sent them to Italy, Greece, North Africa, Egypt, Damascus, Sweden, England, and as far west as Niagara Falls in the United States. Few of the daguerreotypists he commissioned are known by name today, and most of their original daguerreotypes have been lost.

Artists and tourists continued to pursue the will-o'-the-wisp—perfect pictorial landscape. The lucrative end of the daguerreotype business was in the thousands of camera outfits and millions of silvered plates sold throughout Europe. Two thousand cameras and half a million plates were sold in Paris alone during 1847, mostly for portraiture. Daguerreotype parlors in France and England took portraits, charging $2 to $5 for plates ranging in size from 1½ by 2 to 6½ by 8½ inches, which were then set in *papier-mâché* frames or imitation gilt boxes.

Antoine Claudet, a fancy glass dealer in London, bought from Daguerre for $1,000 the first license to practice in England. He learned the process from Daguerre himself, whom he visited soon after Daguerre publicly demonstrated his invention.

Early in 1841 an ex-coal merchant named Richard Beard opened the first portrait studio in London, purchasing the right to use the mirror camera invented by Alexander Wolcott in New York the previous year. This enabled him to take pictures with exposures of five seconds to five minutes, depending on the size of the plates and the amount of sunlight.

When Claudet discovered a faster combination of chemicals that enabled him to take daguerreotypes with the Giroux camera in two seconds to two minutes, he

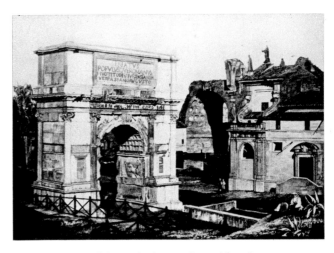

Nazareth (top) and the *Arch of Titus, Rome* (above), two aquatints by unknown photographers, published in 1840–42 by N. P. Lerebours in *Excursions Daguerriennes*. George Eastman House, Rochester, New York

also opened a professional studio for portraiture in London.

Both studios were busy all day while the light lasted. Everyone in London wanted to have his picture taken and gladly paid for the privilege.

Claudet was devoted to developing the artistry and technique of photography. He invented the darkroom red light, which did not affect the sensitive plate, and he conceived the idea of using painted backdrops in the studio to provide a pleasing change from the monotony of plain backgrounds behind the subject. Claudet photographed both inventors of photography—Daguerre and Fox Talbot—royalty, and other celebrities, and in 1853 he was appointed "Photographer in Ordinary to Queen Victoria."

The art dealer Louis Sachse brought to Berlin, in 1839, the first camera made by Giroux, Daguerre's brother-in-law. Within less than two years Voigtländer had introduced an all-metal, conical-shaped camera with the Petzval lens that enabled him to take circular pictures about three inches in diameter. With the Voigtländer-Petzval lens began Germany's high reputation for high-quality optical goods and camera equipment.

AMERICA

The first portraits taken by daguerreotype took so long that the subjects got sunburned. Portraiture was a terrible ordeal, suffered by sitting perfectly still in the direct

Photographer unknown. *Portrait of Thomas Sully* (1783–1872), American portrait painter. c. 1848. Daguerreotype. Chicago Historical Society

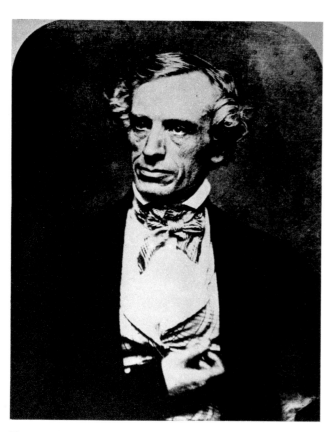

Photographer unknown. *Portrait of Samuel F.B. Morse,* painter, professor, inventor of the telegraph.
c. 1845. Daguerreotype. Morse is believed to have been the first American to learn the daguerreotype process. With his colleague, Professor Draper, he established a photographic studio on the roof of New York University. George Eastman House, Rochester, New York

Edward Anthony. *Portrait of Louis Kossuth,* Hungarian patriot. 1851. Daguerreotype taken in Washington. Chicago Historical Society

sunlight for as much as twenty minutes. It was permissible to wink; the process was so slow that it did not matter.

To enable the sitter to keep his eyes open in the sun a blue sheet of glass was interposed; this did not lengthen the exposure very much, and soon all studios were equipped with blue skylights.

Daguerreotypes were hand colored like miniatures, often by artists of some standing. The earliest attempts to color the fragile image came after experiments with painting on the protective glass proved unsuccessful. Dusting colored powders on a gum brushed onto the image also proved too harsh for the easily damaged daguerreotype. The only solution was for trained miniature painters laboriously to tint the face of the daguerreotype with as much caution and artistry as was necessary to do a miniature on ivory.

Dr. John William Draper, in 1839 in New York, said that he had to pose his models for twenty minutes in the open sunlight, the face whitened with powder and the eyes closed, to secure full-size daguerreotypes. Draper, who was a professor of chemistry at New York University, had learned of Daguerre's process by reading the first English translation to reach New York in October of 1839, but he had already experimented

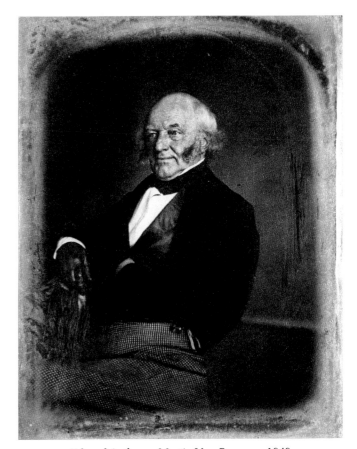

Edward Anthony. *Martin Van Buren*. c. 1848. Daguerreotype. Van Buren left the presidency in 1841 but remained a political power for years. This daguerreotype appears to have been taken when he was about sixty-six years old. Though it is not certain, the picture seems to be one of the daguerreotypes that Anthony made for his National Daguerrean Gallery, which was destroyed by fire in 1852.
Chicago Historical Society

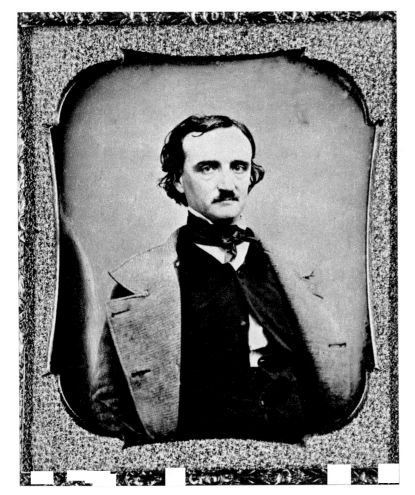

S. W. Hartshorn. *Edgar Allan Poe*. 1848. Daguerreotype. The poet, who was much enamored of the daguerreotype, sat for this portrait a year before he died. In 1840 he wrote, "In truth the daguerreotyped plate is infinitely more accurate in its presentation than any painting by human hands." Brown University, Providence, Rhode Island

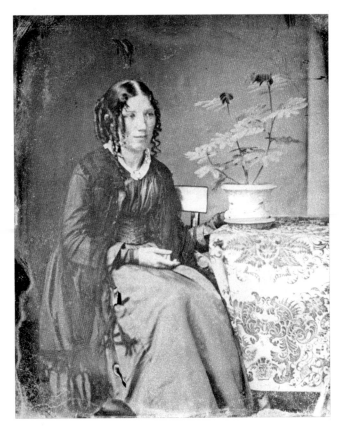

Southworth and Hawes Studio, Boston. *Harriet Beecher Stowe.*
c. 1856. Daguerreotype.
The Metropolitan Museum of Art, New York

Daguerreotypists could operate only on sunny days, which occurred in New York more often than in London—a contributing factor to making American daguerreotype portraits universally acclaimed as the best.

On dull, overcast days Morse taught the process to a number of interested students, many of whom were to become leading daguerreotypists in the United States, among them Edward Anthony, Mathew B. Brady, and Albert S. Southworth. Using a regular daguerreotype camera, they were able to take studio portraits in sittings of thirty seconds to two minutes, and could cut this time in half by posing the subject directly in the sun.

After only six months Professor Draper dissolved the partnership; he was to utilize photography for scientific purposes the rest of his life. Professor Morse moved to another roof-top studio in the *Observer* building.

All sorts of people turned to the daguerreotype to make an extra dollar. Some learned the craft well enough to open daguerreotype galleries. Others became professors of hocus pocus, making pictures in the mystifying darkroom, passing off the faint results as the best procurable; to many, daguerreotyping was a form of advertising or a sideline to attract customers to their regular business.

In addition to the charlatans there were fine workmen, practicing daguerreotypists whose studios took superb portraits of illustrious citizens and charming pictures of a bygone day in a peaceful America.

Edward Anthony, trained as a civil engineer and graduated from Columbia at the age of twenty in 1838, learned the daguerreotype process as soon as it was introduced the next year. As there was little work to be found in his professional field, he accepted a commission to take daguerreotypes of disputed territory at the Canadian-American northeast boundary. These were the first pictures taken for a government survey.

A short time after this, Anthony and a partner, J. M. Edwards, were permitted by Anthony's friend and pa-

unsuccessfully for two years with the photograph as applied to science. He made himself a cigar-box camera and with it took a picture of a Unitarian Church from a university window. A month earlier his colleague, Professor Samuel F. B. Morse, had taken a picture of the same church from his window in the university. By mid-1840, with better equipment, smaller-size plates, and faster chemicals at their disposal, the professors were ready to become partners in a portrait studio, which they built on the roof of the university.

The first daguerreotype cases were made of tooled leather, but were soon replaced by cheaper substitutes such as imitation leather and plastic cases made of sawdust and shellac with elaborate pressed-in designs (below left). The glass, the oval frame, and the daguerreotype were assembled in a flexible gilded metal frame known in England as "pinchbeck" and in America as "preserver," and then the assemblage was placed in the case. When sunlight fell directly on a daguerreotype the silvered image became a negative (below center). With a turn of the wrist, the image became a fully recognizable positive (below right). George Eastman House, Rochester, New York

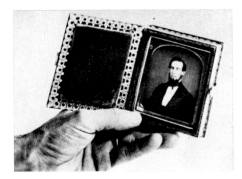

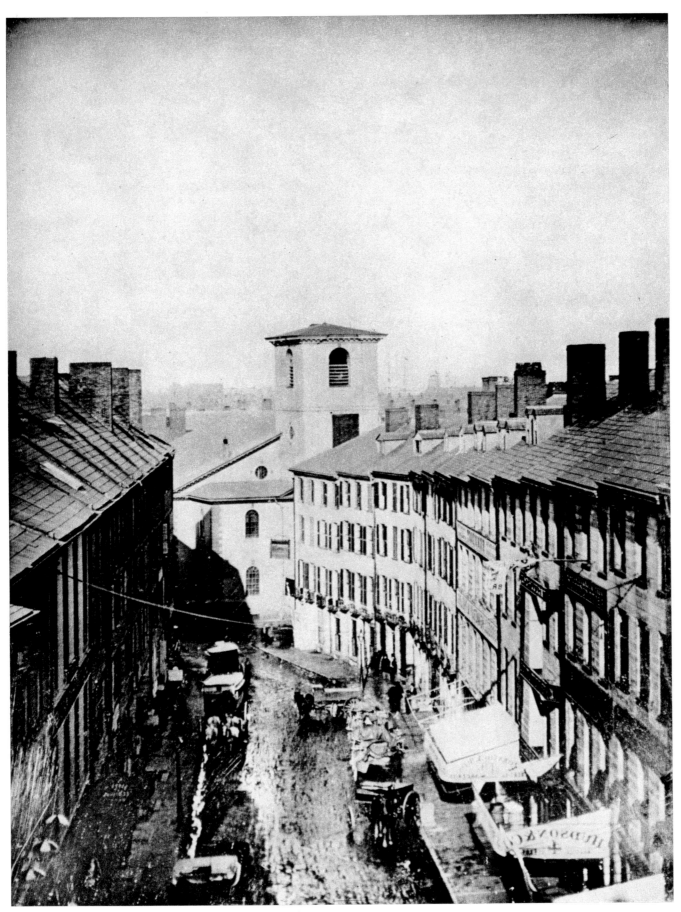

Southworth and Hawes Studio, Boston. *Looking down Brattle Street toward Brattle Square Church*. 1852. Daguerreotype.
The silver image is reversed, as can be seen in Hudson & Company's awning. The Metropolitan Museum of Art, New York

tron, Senator Thomas Hart Benton, chairman of the Senate Committee on Military Affairs, to use the committee room in Washington to take daguerreotypes of distinguished political figures. Among these was John Quincy Adams, who recorded in his diary, April 12, 1844, that he sat for three likenesses and that, as he walked out, "President Tyler and his son John came in, but I did not notice them."

Anthony took pictures of everybody of consequence, and formed a National Daguerrean Gallery which was on exhibition in New York City. This enterprise was supposedly entirely destroyed by fire in 1852 except for a single full-figure portrait of John Quincy Adams.

Oliver Wendell Holmes called the daguerreotype "the mirror with a memory." His native Boston competed with New York in refining the silver image. Yankee ingenuity made possible the excellence of American daguerreotypes. John Whipple utilized a steam engine to run the buffing wheels to give the plates the highest possible polish, to heat the mercury, to prepare the distilled water for washing the plates, to cool the clients by running fans in the waiting rooms, and also to revolve a sign on the facade of the gallery.

One of the justifiably famous galleries in Boston was the establishment of Southworth and Hawes. This gallery's portraits of celebrities are lifelike, free from the usual stiffness resulting from the rigid forked headrests and from the fixed pose often induced by filling out the subjects' hollow cheeks with wads of cotton or by fastening their jug ears to their skulls with sticking wax.

Albert S. Southworth learned the process from Morse in New York, and returned to Boston in 1843 to enter into partnership with Josiah Johnson Hawes, who remained a photographer until his death in 1901. The daguerreotypes made by Southworth and Hawes during the eighteen years of their partnership are today celebrated and sought as some of the finest examples of the art. These portraits were most often taken on whole plates 8½ by 6½ inches, and cost $5 or more. Competitors' prices were $1 for a quarter plate, with a free case.

The fine daguerreotype was doomed. It had lasted longer in America than anywhere else. At the Great Exhibition in the London Crystal Palace of 1851, Americans received three of the five medals awarded for daguerreotypes. The French by then excelled in photography on paper.

America soon turned to the cheaper process of the glass negative, from which a dozen or more positives could be made at the price of one good daguerreotype. It was the end of an era; a beautiful and unique art had died. The daguerreotype would never be revived.

2

Masters of the
Nineteenth Century

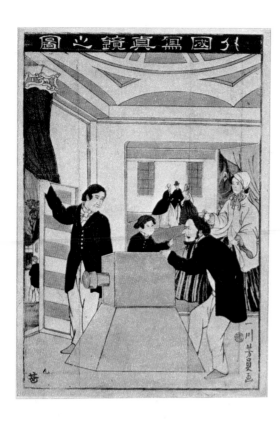

Dutch merchants with one of the first cameras allowed
into Japan. 1851. Japanese woodcut.
Collection Peter Pollack

Edgar Degas. *Self-Portrait with Mme Zoë Halévy*. 1895. Photograph.
The Metropolitan Museum of Art, New York

Negatives and Positives

PHOTOGRAPHY'S POTENTIAL FOR FULL and accurate documentation was recognized early. Photographers, the *National Gazette* of Philadelphia predicted in the 1840s, "shall visit foreign parts, the courts of Europe, the palaces of the pashaws, the Red Sea and Holy Land, and the pyramids of Geza, and bring home exact representations of all the sublime and ridiculous objects which it now costs so much to see . . . it will be impossible for a tree to bud and blossom, a flower to go to seed, or a vegetable to sprout without executing at the same time an exact photograph of the wonderful process . . . a steam boiler cannot explode, or an ambitious river overflow its banks—a gardener cannot elope with an heiress, or a reverend bishop commit an indiscretion, but straightway, an officious daguerreotype will proclaim the whole affair to the world."

Pioneer photographers lost little time in fulfilling these predictions. Already photographic studio-factories were pouring out high-quality living human likenesses by the thousand. Before the ink of the *National Gazette* was fully dry, there were photographs of architectural European monuments and of the American frontier. Soon there would be others of the Arabian Desert, the Alps, the Pyramids of Gizeh, Abu Simbel, and the Temples of Karnak; of the Mexican and Crimean war; of "Bloody Kansas" and the Sepoy Rebellion. Two photographic journals would start publishing in New York within ten months of each other. There would be photographic books, the forerunner of a mighty avalanche. A Bostonian named Whipple would couple a camera to the telescope of the Harvard College Observatory to take a sharp, detailed likeness of the moon. In 1856 the University of London would add photography to its course of study. A few years later, Mathew B. Brady and his assistants would begin to document the American Civil War.

Although straightforward documentation was photography's major purpose and function a little more than a century ago, just as it is today, there was recognition on the highest levels of the communities of art and science that there were vast and various possibilities to be discovered and exploited. Thus, Sir Charles Eastlake, President of the Royal Academy, and Lord Rosse, President of the Royal Society, joined in a single plea to Fox Talbot, inventor of the negative-positive system, to relax some of his demands in the exercise of his patent rights. Eastlake, moreover, accepted the presidency of the Photographic Society of London (now the Royal Photographic Society of Great Britain). In France, likewise, the first president of the Société Héliographique was the great painter Baron Gros, and other founding members included Eugène Delacroix and the physicist Edouard Becquerel.

The mid-nineteenth-century status of photography is revealed most clearly by the relationship that developed between photography and painting. The advent of the photographic process sent a shock wave reverberating through the world of art. At first a dangerous competitor was seen. Technological unemployment now threatened illustrators and graphic artists. The menace was the greater because the artistic ideal of detailed realism was so overpowering in those days. Partly in mourning, partly in pleasurable excitement, the painter Delaroche remarked that "from now on, painting is dead." He went on to say that photography satisfied "all the demands of art" and carried essential principles to "perfection." A number of painters, especially the less successful, abandoned their trade and mastered the new process. This development was of great benefit to photography, which was thereby provided with practitioners already skilled in the important business of fashioning well-ordered compositions. The most hostile reaction to photography came from the poet and critic Charles Baudelaire, who deplored the desertion of the secondary painters and predicted the corruption of art. Enough of an atmosphere of illegitimacy was thrown around photography so that, even today, many illustrators are reluctant to let it be known how much they depend on photos for information, study, and even inspiration. "It is admirable," J.-A.-D. Ingres said ruefully of photography, "but one must not admit it."

Fox Talbot

THE DAGUERREOTYPE HELD EVERYONE ENTHRALLED—painter, engraver, etcher, lithographer, scientist. Its delicate tonality and immense detail, discernible by magnifying glass, seduced everyone away from the rougher picture on paper invented by Henry Fox Talbot and announced the same month.

Sir John Herschel, who named Talbot's invention "photography" and who also coined the words "negative" and "positive" to explain the process, considered the grainy paper print child's play compared with the silver image.

Arago's preliminary announcement of the daguerreotype on January 7, 1839, before the Academy of Sciences in Paris, goaded Fox Talbot to publish his process first. He feared that, if Daguerre's invention was similar to his own, all his years of work would go for naught. Before the end of January Talbot had the noted scientist Michael Faraday present, at a meeting of the Royal Institution in London, several of his pictures of flowers, leaves, and lace, figures from a painted glass, and a view of Venice, all made by superimposition of object or engraving on sensitized paper. In addition, Faraday exhibited a number of Talbot's "pictures representing the architecture of my home in the country... made with the camera obscura in the summer of 1835."

On the last day of January, 1839, Talbot read before the Royal Society his report, "Some Account of the Art of Photogenic Drawing, or the Process by Which Natural Objects May Be Made to Delineate Themselves without the Aid of the Artist's Pencil." In it he referred to the experiments conducted by Wedgwood and Davy, devoting a paragraph to "the art of fixing the shadow," which is what they admitted they were unable to do, but Talbot did not explain how he accomplished it. Three weeks later, on February 20, Talbot sent the Royal Society a second letter, in which

he listed further discoveries in "photogenic drawing" and then gave full particulars of how he fixed the image—in a solution of common salt.

In *The Pencil of Nature*, published in 1844, the first book illustrated with photographs, Talbot describes what gave him the idea of making permanent the pictures that he saw through the camera obscura. He writes that it was in October, 1833, while he was at Lake Como in Italy and was trying to copy nature with the aid of Wollaston's camera lucida. "I came to the conclusion that the instrument required a previous knowledge of drawing which unfortunately I did not possess. I then thought of trying again a method which I had tried many years before. The method was to take a camera obscura and to throw the image of the objects on a piece of paper in its focus—fairy pictures, creations of a moment, and destined as rapidly to fade away. It was during these thoughts that the idea occurred to me, how charming it would be if it were possible to cause these natural images to imprint themselves durably, and remain fixed upon the paper!"

Talbot reasoned that, since light could effect changes in materials, all he had to do was to find the proper materials. Paper was the answer for him. He found that he could submerge a sheet of paper in a weak solution of salt and then, when it was dry, dip it in a solution of silver nitrate, thereby forming in the fibers of the paper the light-sensitive chemical, silver chloride. He first made copies of engravings, flowers, and lace, but, by the summer of 1835, he had experimented with both large and small cameras.

The small cameras his wife called "mousetraps." Talbot placed a number of them around his home, Lacock Abbey, near Chippenham, Wiltshire, and succeeded in securing in each, after only a thirty-minute exposure, a perfect "miniature picture of the objects before which it had been placed." He fixed this inch-

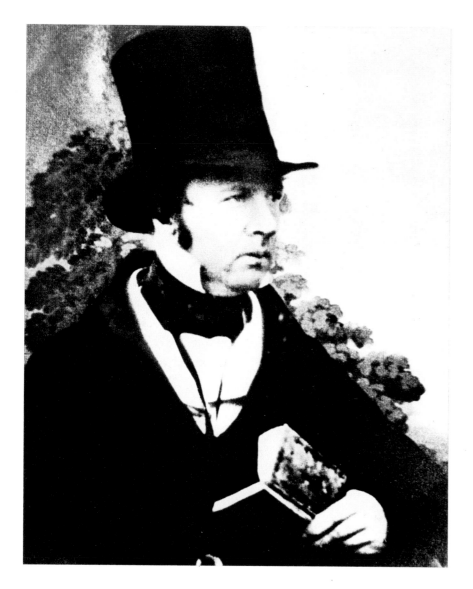

Antoine Claudet. *Portrait of Fox Talbot.*
1844. Daguerreotype.
George Eastman House, Rochester, New York

Henry Fox Talbot. *Lace.*
1843. "Photogenic drawing."
Gernsheim Collection, University of Texas, Austin

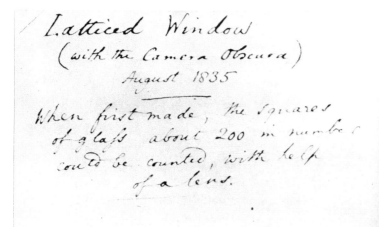

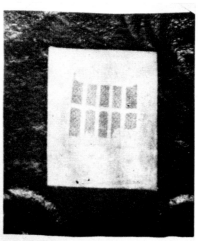

Henry Fox Talbot.
Lacock Abbey, August 1835.
First paper negative,
one inch square.
Science Museum, London

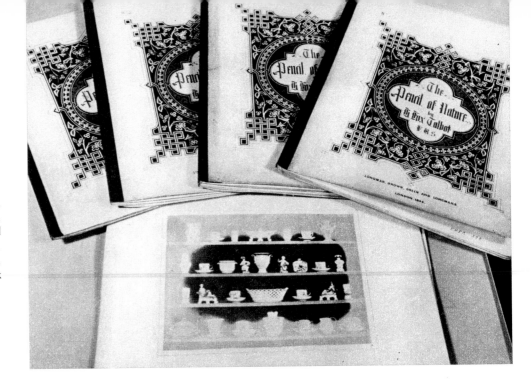

Henry Fox Talbot's *Pencil of Nature*,
issued in six parts between 1844–46,
the first book published with original
photographs, pasted in by hand.
George Eastman House,
Rochester, New York

Henry Fox Talbot. *The Broom*, from *Pencil of Nature*.
1844–46. Calotype.
Collection Harold White, Bromley, Kent, England

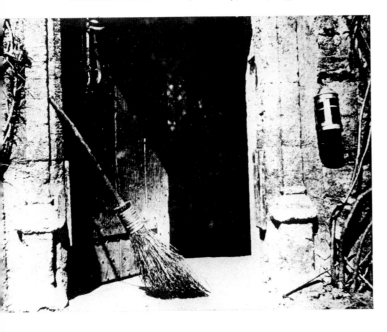

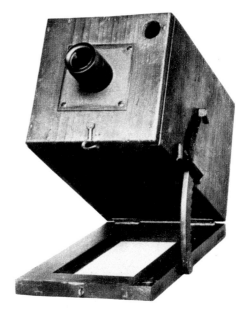

Henry Fox Talbot's earliest camera with peephole. Before
the development of the "latent image," peepholes permitted
photographers to see when the image was fully exposed
on the negatives

square image by washing the paper in a strong solution
of common salt or with potassium iodide.

After Talbot's invention was announced, Sir John
Herschel suggested to him that the unused silver
chloride could be more effectively removed, so that the
image would not change in sunlight, by using hyposul-
phite of soda, which Sir John had found twenty years
before, in 1819, to be the best solvent of silver salts.

Talbot discovered, in 1840—as had Daguerre two
years earlier—that he did not have to wait for the image
to become visible. Development of the latent image
enabled him to take a picture in minutes where it had
formerly taken him hours. No longer was it necessary
for him to peep through a hole cut in the camera to

ascertain when the image was visible. Magically, the
image appeared when the paper was developed in gallic
acid. After development, Talbot used a hot solution of
hypo to fix the image, washed the negative in pure
water, dried it, and then made it transparent by waxing
the paper. He contact-printed these negatives by sun-
light on silver chloride paper, the simple paper that he
had used from the beginning of his experiments.

These brilliantly improved negatives he called
"calotypes," from the Greek meaning "beautiful pic-
tures," but he later called them "Talbotypes."

It is to Fox Talbot that the entire world is indebted
for the invention of the negative-positive process, from
which all modern photography stems.

Hill and Adamson:
The Great Collaboration

THE GREATEST EXPONENTS of the calotype process were two men of Edinburgh, Scotland: a painter, David Octavius Hill, and a chemist-photographer, Robert Adamson. Collaborators for only five years—Adamson died at the age of twenty-seven in the year 1848—they took more than 1,500 pictures, including some of the finest portraits in the history of photography.

How necessary the young technician Adamson was to the association is evident from the fact that Hill produced few memorable photographs after Adamson's death, although he attempted to collaborate with other photographers whom he directed.

Together Hill and Adamson made some superb pictures, posing people singly, in pairs, or in groups in open sunlight, simulating interiors by placing chairs and other props and backdrops behind and around the figures. The subjects held head in hand or posed leaning body against a prop and assuming a relaxed, natural pose for exposures lasting one to three minutes.

Character is boldly expressed in each portrait. No attempt is made to hide lined features. Often deep shadows are left to emphasize the black and white masses of the face, repeated dramatically throughout all parts of the picture, in the hands, in the garments, as well as in the backgrounds. Detail was sacrificed, for the paper negative could never compete with the daguerreotype in securing seductive detail. Areas of light and dark were handled like the chiaroscuro in a drawing by Rembrandt.

It was in 1843 that Hill turned to the use of the

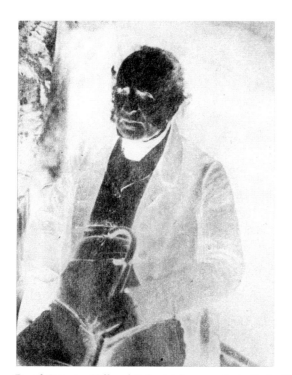 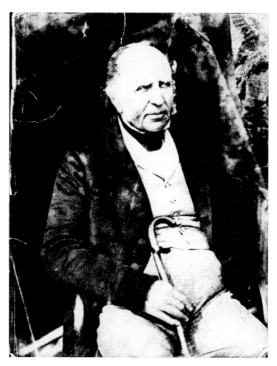

David Octavius Hill and Robert Adamson. *Portrait of a Minister*. c. 1845. Calotype negative and print; contemporary print made from the original paper negative. George Eastman House, Rochester, New York

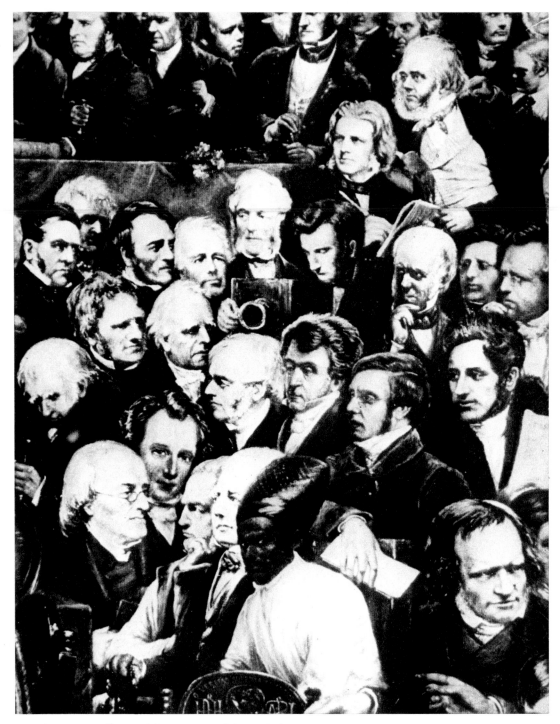

David Octavius Hill. Detail from *Signing of the Deed of Demission*.
Completed 1866. Painting. Hill is seen with pencil and sketchbook,
Adamson with camera. Gernsheim Collection, University of Texas, Austin

camera when he was commissioned by the Free
Church of Scotland to paint an enormous picture,
11′4″ by 5′, *Signing the Act of Separation and Deed
of Demission*. On this monumental canvas Hill was to
portray all 470 minister-delegates who resigned from
the Church of Scotland, on the grounds that the con-
gregation had the right to choose its own ministers, and
then met in general assembly to commemorate their
freedom from Queen and landed gentry.

Hill and Adamson secured likenesses and character
studies of practically all the delegates in the few short
years of their partnership. Each of their pictures was
marked with the unique artistry of their collaborative
seeing. They devised a perfect way of using creatively
the imperfect paper negative.

In 1866, four years before his death, Hill's culminat-
ing work to which he had devoted twenty-two years of
his life was at long last finished, and the huge canvas
was accepted by the sponsor, The Scottish Free
Church. All the ministers can be identified, as can Hill
himself, his wife, and Adamson with his camera. The
picture still hangs in the Presbytery Hall in Edinburgh.

Early Wet-plate Photography

SIR JOHN HERSCHEL EXPERIMENTED, none too success-
fully, with glass instead of paper or metal as a backing
for sensitive silver salts. Niepce de St. Victor, a cousin
of Nicéphore Niepce, perceived in 1847, upon study-
ing Sir John's report published in the *Journal* of the
Royal Society, that Sir John had failed to coat the glass
with a suitable organic substance to serve as a binder for
the sensitive silver.

A soldier by profession but an amateur scientist by
avocation, Niepce de St. Victor lost his laboratory in
the Revolution of 1848 when the barracks in which he
resided were destroyed. He nevertheless continued his
studies, experimenting first with starch and gelatin and

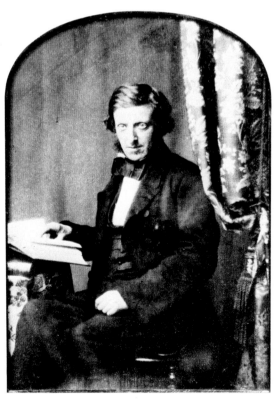

Photographer unknown. *Portrait of Frederick Scott Archer*,
inventor of the wet-collodion process that revolutionized
photography. 1855. Ambrotype. Science Museum, London

then more satisfactorily with whites of eggs. To the
white of egg he added a few drops of iodide of potassium
and bromide of potassium plus a few grains of common
salt, thoroughly whipped it into a froth, and then
strained it through fine muslin.

This solution of iodized albumen he used to coat a
sheet of glass and, when it was thoroughly dry, sen-
sitized it by immersing it in nitrate of silver. The plate
could be used wet or dry in the camera, but when dry it
required a much longer exposure than did a daguerre-
otype or calotype. Convinced that his invention would
have some importance in the world of photography,
Niepce de St. Victor communicated his albumen proc-
ess in June, 1848, to the Academy of Sciences in Paris.

Immediately after publication of the process, mod-
ifications and improvements were suggested for speed-
ing up the sensitized albumen so that it could be used
for taking portraits and figures, as well as architecture
and landscape.

To eliminate the grain and other imperfections in
paper, L. D. Blanquart-Evrard conceived the idea of
coating paper with albumen for positives. After de-
velopment, he dipped the print in a solution of chloride
of gold, to achieve a range of cold, pleasing tones in
browns and grays as well as to make the image more
permanent.

The paper negative experienced one further major
improvement before it, like the daguerreotype and all
other early processes, fell into limbo with the advent of
Scott Archer's invention of the wet-collodion process,
published in *The Chemist*, March, 1851.

Scott Archer, a British sculptor and photographer,
dissolved guncotton, ether, and alcohol to make col-
lodion (this formula had already been known to
medicine for several years) and blended this with a
solution of silver iodide and iodide of iron. This mix-
ture was coated on a clean glass plate, which was then
immersed in a solution of distilled water and silver
nitrate, and exposed wet in the camera. The plate had

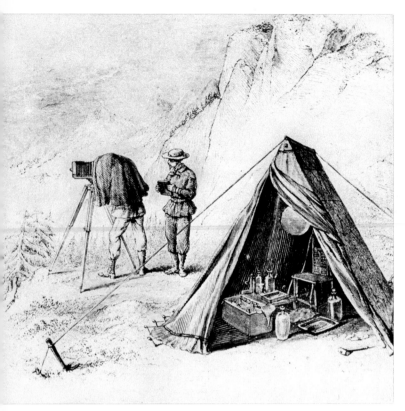

The photographer's pack, with the 70 to 120 pounds of
equipment needed for wet-collodion photography.
George Eastman House, Rochester, New York

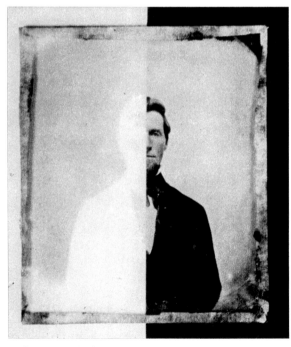

Ambrotype with black backing on one half
to show its negative-positive character.
George Eastman House, Rochester, New York

to be developed while the collodion was still moist. The
new process was faster than albumen or any of the other
photographic methods. It required only two or three
seconds of exposure to direct sunlight, and the resulting
subtleties of tonality were unequaled by any existing
processes.

How generous was Scott Archer! He could have
patented his invention and made untold fortunes for
himself and his heirs, for the wet-collodion process was
not to be superseded until more than thirty years later
when the gelatin dry plate was marketed commercially.
Archer announced his invention without restrictions
and died impoverished at the age of forty-four in 1857.

Since the ether in the collodion evaporated quickly,
it was necessary to develop the plate directly after expo-
sure. In extreme desert or mountain climates this
caused considerable difficulty, particularly since all
preparations of the plate had to be done in total or
semidarkness. Not only was it necessary for the photog-
rapher to move with cameras, tripods, lenses, chemi-
cals, glass plates of various sizes to fit his cameras,
distilled water, measuring pots and trays, he also had to
lug along a darkroom; all of this paraphernalia weighed
about 120 pounds. A tent was invariably used for de-
veloping, although wicker baskets, boats, railway cars,
wagons, and handcarts were at times transformed to
serve this purpose.

The wet-collodion process was immediately applied
to portraiture. In America, where the daguerreotype
held in fashion and demand longer than anywhere in
Europe, a patent was issued for "ambrotype" portraits
made in the same sizes as daguerreotypes and adver-
tised as having the advantage of being visible at all
times, not, like the mirror-like surface of the silver
image, only in certain lights.

Ambrotypes (from the Greek for "imperishable")
were negative portraits on glass deliberately under-
exposed to make a faint image. These were backed up
with black paper or velvet or sometimes painted black.
As the image was reversed, it was often the practice to
lay the glass negative face-down on the paper or velvet
to make it appear as a positive. With a sheet of glass as a
protecting cover, the entire assembly was then placed
in an elaborate designed "union" case, which made it
resemble even more closely the costlier daguerreotype.

Three photographers who took superb pictures with
the collodion process, one in the deserts of Egypt and
the other two in the Alps of Switzerland, were Francis
Frith of England and the Bisson brothers of France.

The Middle East was part of the Grand Tour during
the latter part of the nineteenth century, creating a
constant demand for photographs of Egyptian an-
tiquities and views of the Nile River and of the Holy
Land. Publishers in Europe and England sent expedi-
tions of photographers to appease this public demand
from which they reaped considerable profit. A pub-
lisher who was also a talented photographer, Francis

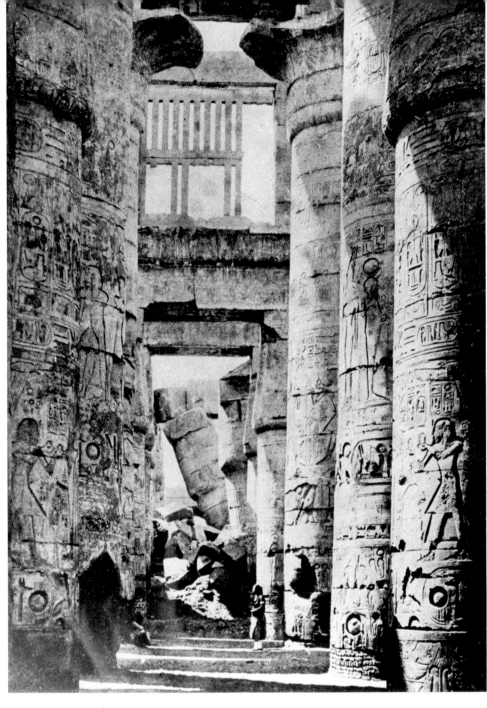

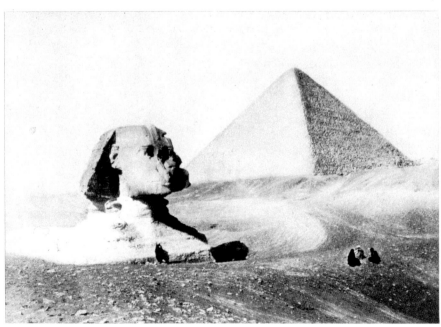

Francis Frith.
Wet-plate photographs:
(top) *Hypostyle Hall,
Luxor, Egypt*.
The Art Institute
of Chicago;
(left) *Pyramid of
Cheops and the Sphinx,
Gizeh, Egypt*.
George Eastman House,
Rochester, New York

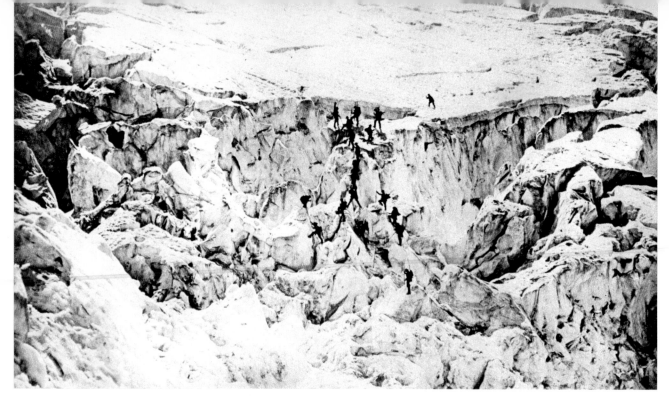

Bisson Frères. *Halfway Point, The Alps*. 1860. Wet-plate photograph.
Taken by the Bisson brothers when they ascended Mont Blanc, accompanying Emperor Napoleon III and Empress Eugénie.
George Eastman House, Rochester, New York

Frith of London, in 1856 traveled up the Nile taking pictures with various-sized cameras, one for tremendous plates measuring 16 by 20 inches. (For contact prints. There was no enlarging though Fox Talbot had included an enlarging process in his application for a patent in 1843.) Starting from the Delta, he went up the river more than 800 miles to the Fifth Cataract, beyond the present border of Egypt and the Sudan. He took magnificent pictures of the Pyramids and the Great Sphinx at Gizeh, the Temples at Karnak and Luxor, the monumental sculpture submerged in the sands at Thebes, and fragments of architecture peering through the backed up waters of the Nile at Philae.

How spectacular a series of pictures! What fortitude and resourcefulness it required of Francis Frith to get them! In the dry heat of Egypt the wet-collodion dried much faster than the usual ten minutes it took on a hot summer day in England. Every movement in the stifling darkroom tent had to be carefully husbanded. The fumes evaporating from the ether, held inside the airless tent, were suffocating. The heat of the desert outside the tent would often reach 110 degrees, and inside, at temperatures of 130, the collodion boiled. At times the sudden sandstorms would pockmark the plates or ruin them entirely. Despite all these hardships Frith secured sufficient negatives to make a selection of extraordinary pictures for publication the following year in a book on Egypt containing original photographs and descriptions of his experiences. From his three trips to Egypt and the Holy Land Frith published a total of seven books.

To some photographers using the collodion process, the hot light and hardships of the desert were not

Roger Fenton. A "Cantinière" in the Crimean War, who doubled as a nurse for Florence Nightingale. 1855. Wet-plate photograph.
George Eastman House, Rochester, New York

Roger Fenton. *Balaclava Harbor during the Crimean War.*
1855. Wet-plate photograph.
George Eastman House, Rochester, New York

William Notman. *Moose Hunting, Montreal, Canada.*
Early 1860s. Photograph.
George Eastman House, Rochester, New York

comparable to the cold light and hardships of the mountains. It became a feat of endurance to take pictures in the intense cold of ice and snow on windswept peaks at approximately 16,000 feet, in the heady atmosphere of the Alps. Some of the finest photographs of mountain scenes ever taken are the work of Louis Auguste Bisson and his brother, Auguste Rosalie.

Twenty-four photographs ranging in size from 9 inches by 15 inches to 12 inches by 17 inches were made by the brothers Bisson in 1860 on a mountain-climbing expedition when they accompanied Emperor Napoleon III and Empress Eugénie to Switzerland. The plates were coated with collodion which barely flowed in the below-zero cold of the Alps and, after development, were washed with melted snow. Despite the imperfect coating of the plates, which accounts for the uneven quality in the skies, the photographs of the mountains are superbly designed and dramatically composed in bold areas of black and white.

Another courageous photographer, the first to cover a war under fire, was Roger Fenton, who photographed the Crimean War in 1855. Equipped with a darkroom wagon boldly emblazoned "Photographic Van," he took pictures of the fortifications, ships and stores, installations, battlefields, officers, and men, and some of the most attractive behind-the-lines canteen operators seen in any war, who doubled as nurses for Florence Nightingale. The heat of the Russian peninsula in the Black Sea, coupled with the necessary long exposures, created hardships in preparing the short-lived collodion glass plates, which often kept Fenton from taking photographs during the several hottest hours of the day. Despite all discomforts and the sicknesses epidemic in the area, Fenton succeeded in securing

more than 300 negatives in less than four months.

William Notman in the 1860s became internationally famous for his wet-plate pictures of Canadian pioneers. He took a series of moose and buffalo hunters in "the bush" seated around a tent, trappers and guides wearing snowshoes in snow made of salt and white-fox fur, an Indian boy with a loaded toboggan, all held rigid in the most complicated poses in his Montreal studio, where he created elaborate settings praised as more realistic than those actually found in nature. The faster and versatile wet-collodion process freed the artistry and imagination of photographers, who left astounding records of their day throughout the entire world.

HESLER: CHICAGO PIONEER

Alexander Hesler, a pioneer photographer of Chicago, was considered in the 1850s "one of America's greatest daguerreotypists." In 1851 he was photographing the frontier on the upper Mississippi in the Minnesota Territory where he took full-size daguerreotype plates of the Falls of St. Anthony, Fort Snelling, and Minnehaha Falls. It was in connection with this last picture, which he exhibited in his Chicago studio two years later, that his early reputation as a sensitive photographer was established nationally. Henry Wadsworth Longfellow, in a letter as well as in an autographed first edition of *Hiawatha* which he sent to Hesler, acknowledged that the daguerreotype of Minnehaha Falls given him by his friend Senator Charles Sumner of Massachusetts was the inspiration for his poem *Hiawatha*. The daguerreotype was bought from Hesler by the Senator's brother either in Chicago or, as

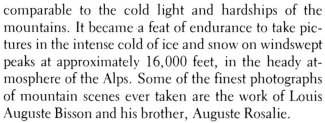

Alexander Hesler. *Portrait of Abraham Lincoln, Springfield, Illinois*. 1860. Chicago Historical Society

one story has it, while they both happened to meet in Minnesota.

In 1852 the twenty-nine-year-old Hesler was using his daguerreotype apparatus in Galena, Illinois. It had been five years since he learned the art in Buffalo, practiced it for a couple of years in Madison, and took portraits of the Wisconsin legislature in session before his trip to the Minnesota Territory. Though born in Montreal, he was still a boy when his family moved to Racine, Wisconsin, and for the rest of his life (he died in 1895) he was considered a midwestern photographer, conducting studios at various addresses in Chicago. The first of these he established in late 1853 on La Salle Street. He prospered. He opened another. He added a painter of miniatures to his staff. He learned paper photography, the wet-collodion process, and the stereograph, which enabled him to advertise that he could take any kind of photographic commission from a portrait in miniature to one more than life size.

In 1857 he took the famous ruffled-hair portrait of Abraham Lincoln later used as the frontispiece of the book by Nicolay and Hay. Hesler's two wet-plate photographs in 1860 of a well-dressed, combed, and unbearded Lincoln were both badly damaged in 1933 when sent through the mails. The fragmented glass plates were deposited in the Smithsonian Institution. In 1958 discovery was made of two copy negatives that Hesler, for his own protection, had made from the finest prints. The copy negatives were acquired by the Chicago Historical Society.

Alexander Hesler. *The Mississippi River Packet, Ben Campbell, Galena, Illinois*. 1852. Daguerreotype. The daguerreotype has been printed in reverse so that the name can be read.
The *Ben Campbell* was built in 1851 and burned in the summer of 1860. Chicago Historical Society

The Stereoscope: Pictures in Pairs

IN 1849 SIR DAVID BREWSTER invented a stereoscope with two magnifying lenses separated by 2½ inches, the usual distance between the eyes in human beings; he limited the height to three inches, making it easy to handle.

In the Crystal Palace Exhibition of 1851 in London the Duboscq and Soleil stereoscope was exhibited with a fine collection of daguerreotype stereo images. The stereoscope became tremendously popular when Queen Victoria and Prince Albert admired the display and evinced interest in this new form of photography. In Philadelphia J. F. Mascher early in 1853 received a patent for a simple folding stereoscope made of a leather box holding two images and two lenses. More than a million prism stereoscopes of the Brewster type were sold by 1856 in England alone. The London Stereoscope Company, which offered a wide selection of stereo slides to choose from at about a quarter each, advertised, "No home without a stereoscope," and offered a viewer for sale at less than a dollar.

Until 1853 either an ordinary camera set in a groove moved sideways for the second exposure or two single cameras were used to make stereo pictures. The two-lens camera with the lenses separated by 2½ inches taking two small pictures simultaneously was produced in 1853 by an English optician; many European manufacturers immediately followed suit.

By 1860 the London Stereographic Company slogan was practically a reality; few homes were without a stereoscope and a batch of slides. Hundreds of thousands of stereographic slides depicting nearly every corner of the globe were available in shops or by mail at the nominal prices of today's picture postcards, ranging from a nickel to a quarter.

Oliver Wendell Holmes was entranced with the travel pictures. The details, evoking the illusion of reality, enabled him, he said, to be "a spectator to the best views the world had to offer." He wrote three articles in two years for the *Atlantic Monthly*, the first

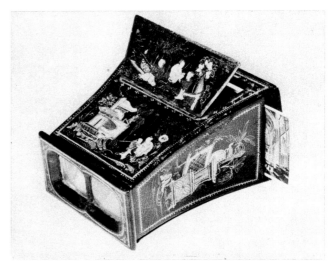

A fancy Brewster-type stereoscope, made in England c. 1850. The lid was opened to view stereo on metal plates; the bottom was opened and the top lid closed to view stereo transparencies on glass. The stereoscope was then held up to the light. George Eastman House, Rochester, New York

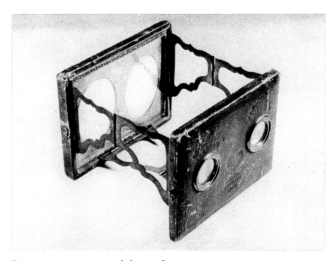

Daguerreotype case with lenses for viewing stereo pair. Patented by Stull, Philadelphia, 1855. George Eastman House, Rochester, New York

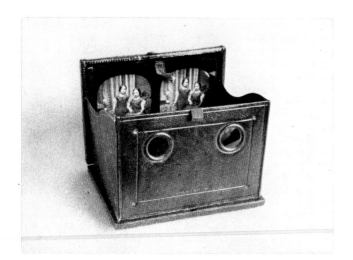

Folding pocket stereoscope, made in England in 1853 by
W. E. Kilburn. J. F. Mascher of Philadelphia patented the
identical construction early in 1853.
Gernsheim Collection, University of Texas, Austin

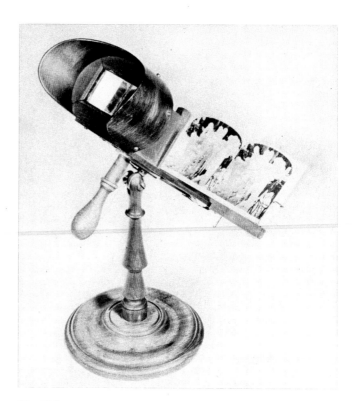

The Holmes stereoscope,
manufactured by Joseph L. Bates of Boston in 1865.
Collection Beaumont Newhall, Santa Fe, New Mexico

in 1859 entitled "The Stereoscope and the Stereo-
graph"—the latter word coined to describe the
stereopicture. Holmes urged his readers to travel with
him, by stereoscope and the imagination, to the re-
motest parts of the world "to view the wonders of the
Nile, the ruins of Baalbeck, Ann Hathaway's cottage,
the rawest Western settlement and the Shanties of
Pike's Peak" (photographers with their stereoscope
cameras had penetrated the frontier for photography
supply houses in the East). Holmes then called atten-
tion to such a universal thing as a clothesline, which
appears in pictures taken all over the world, and he
writes, "The very things which an artist would leave out
or render imperfectly, the photographer takes infinite
care with and so makes its illusions perfect."

Photographer unknown. *Oliver Wendell Holmes*.
1863. Wet-plate photograph.
George Eastman House, Rochester, New York

Nadar: "The Titian of Photography"

MANY PAINTERS, printmakers, and sculptors in France reacted violently against photography and its incredible popularity. Condemnations were showered upon it in press articles and caricatures. Not only had it become an economic threat to the artist; its claims as an art form were resented.

Too few good artists turned to photography and used it creatively. Those who did are remembered as artists with the camera. Nadar (the pseudonym of Gaspard Félix Tournachon) was such an artist. Daumier caricatured photography in his lithographs, ridiculing it as spiritless and satirizing the *bourgeoisie* for their attitude toward the new invention. Nadar, however, he respected as a man and as an artist, for, despite the mechanical quality of the camera, Nadar concentrated on face and gesture and emphasized the psychological characteristics of his subjects. He made the pose express the character of a subject as much as the face did, and he made every salient feature of body and face stand out by permitting no props or backgrounds to interfere with the person.

The extraordinary reputation of Nadar as a photographer was attested to by the fact that the great French classicist painter Ingres had him photograph everyone whose likeness the artist wanted. According to Ingres's biographer, E. de Mirecourt, Ingres painted his remarkable portraits from these photographs without having a need for the subject to be present. Artists called Nadar "the Titian of Photography."

Nadar came to the camera by way of the theatre; he was a playwright. As an artist he was a well-respected painter of portraits. As a journalist he worked with Daumier as a caricaturist for *Charivari*. At the age of thirty, in 1850, Nadar was the darling of the boulevards, celebrated for his wit, but neither theatre, salon, nor journal offered him sufficient livelihood. Though prejudiced against photography, like most artists, he joined his brother Adrien's studio in 1852, but the partnership soon ended in the law courts. In 1854 Nadar published *Le Panthéon Nadar*, a huge lithograph composed of 280 caricatures; this was the first in a

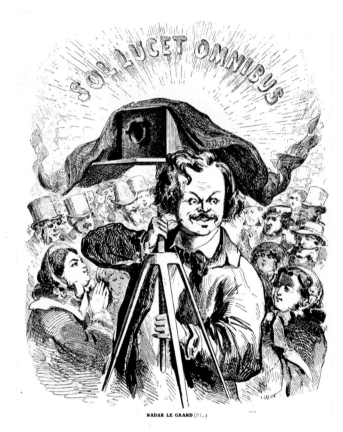

Alfred Grévin. *Nadar the Great*. c. 1870. Wood engraving. The friend of artists, a boulevardier, and popular with the many who came to his studio for portraits, Nadar was a subject for cartoons and caricatures in the press of his day. George Eastman House, Rochester, New York

proposed set of four. He had hit upon the same idea as had David Octavius Hill: to photograph his subjects before drawing their caricatures. Nadar's great portraits of the literati and the celebrated appeared not as caricatures but as perfect reproductions of his original photographs, in the expressive volumes of *Galerie contemporaine*.

Nadar opened his own photography studio on the Boulevard des Capucines. Writers, artists, and com-

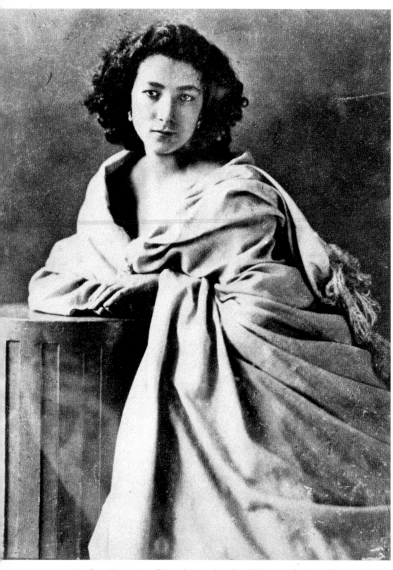

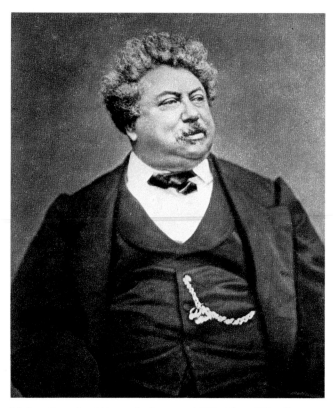

Nadar. *Portrait of Alexandre Dumas*. 1870. After a Woodbury-type reproduction of a wet-plate photograph, from *Galerie contemporaine*.
George Eastman House, Rochester, New York

Nadar. *Portrait of Sarah Bernhardt*. 1859. Nadar's real name was Gaspard Félix Tournachon. A contemporary said to him, "Your name isn't Tournachon — it's 'tour-nadar.' You stick in a stiletto and turn it." Tournachon liked the word, and took its latter half for a pseudonym.
George Eastman House, Rochester, New York

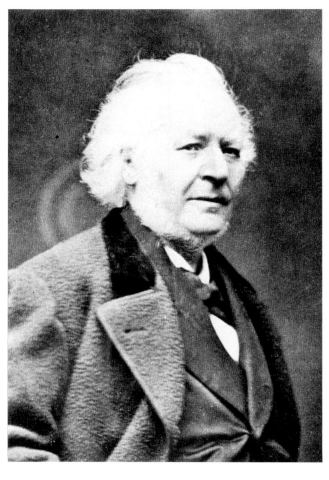

Nadar. *Portrait of Honoré Daumier*. 1877. After a Woodbury-type reproduction of a wet-plate photograph, from *Galerie contemporaine*.
George Eastman House, Rochester, New York

posers of note found the atmosphere so cordial that they met there regularly. Nadar photographed them all: Manet, Corot, Dumas, Monet, Baudelaire, George Sand, Delacroix, Sarah Bernhardt, Daumier, Doré, Berlioz, Wagner, and an uncountable number of others. He invariably signed his prints, as an artist would his etchings or lithographs.

Nadar turned over his studio for the first Impres-

sionist Exhibition in 1874. It took daring and courage to flaunt the official Salon and the press, but this action was typical of the Radical Republican, Nadar, who fifteen years earlier had refused to follow Napoleon III with his balloon photography because he had not believed in the Emperor's campaign against Austria.

Nadar was the first aerial photographer, taking pictures successfully from a balloon in 1856. His first efforts failed, for the gas seeping out of the balloon caked the collodion on his plates. Nadar had to coat and develop the wet-collodion plates, crouching in a little darkroom set up in the swinging, lurching basket of the balloon. He took a dozen views of Paris.

The siege of Paris was an ideal opportunity for Nadar and aerial photography to play an important role. On September 18, 1870, the capital was left without any means of communication with the outside world. Through Nadar's instigation the balloon Neptune was aloft within less than a week. Prussian guns could not reach the heights at which the balloon soared. During the 131-day siege, fifty-five balloons left Paris with passengers, mail, and carrier pigeons. The birds returned with microscopically photographed messages on thin collodion film—a special process conceived by M. Dagron—rolled into minute tubes and affixed to their tails. When the pigeons arrived in their Paris dovecots, the cylinders were opened and the film was placed between two sheets of glass and projected onto a screen. This process of enlarging a picture by projection worked on the same principle as the eighteenth century's magic lantern. The carrier pigeon–balloon post kept Paris in contact with the world all during the siege.

Nadar was also one of the first photographers to take pictures with artificial light. He made electric-light photographs of the catacombs and sewers of Paris in about twenty-minute exposures as early as 1860. And in arranging a photographed interview (his son took the

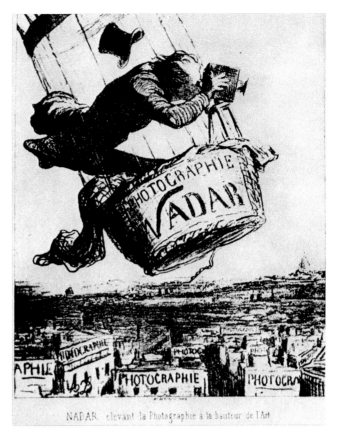

Honoré Daumier. *Nadar Elevating Photography to a High Art.* May 1862. Lithograph. Daumier shows Nadar as an aerial photographer and suggests how free Nadar was from the usual earthbound photography studios spreading all over Paris. Nadar did not take his pictures from a tripod as shown; he either attached the camera to the side of the basket or put the lens through the bottom.
George Eastman House, Rochester, New York

pictures) with the one-hundred-year-old scientist Michel-Eugène Chevreul, he originated the technique of photojournalism. Nadar lived to be ninety years old; he died in 1910.

The Ubiquitous Carte de Visite

THE CAREER OF ETIENNE CARJAT (1828–1906) ran strangely parallel with Nadar's. Carjat was also an artist, a caricaturist, and a writer as well as the editor of the journal *Le Boulevard*, which flourished for several years in the 1860s. In 1862 Daumier's caricature of Nadar taking aerial views of Paris from a balloon appeared in Carjat's publication.

Carjat ran a photostudio as a hobby, taking time from his other interests to photograph celebrities—famous men and women he met in his role as editor

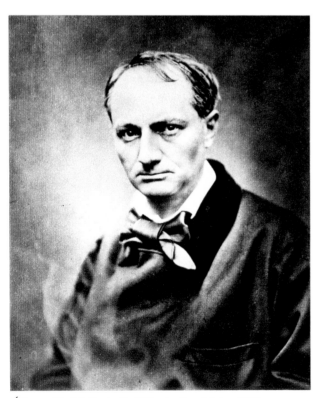

Étienne Carjat. *Portrait of Charles Baudelaire*. 1863.
After a Woodbury-type of wet-plate photograph.
From Nadar, *Galerie contemporaine*, 1870.
George Eastman House, Rochester, New York

and distinguished people who were his personal friends. Like Nadar, he attracted people in all walks of life through the warmth of his personality. Unlike Nadar, he had no assistants in his studio. He therefore produced fewer portraits, but many of these are considered finer expressions of the sitter's character than any others.

Portrait photographers, in order to compete with lithographers and etchers, tried to make ever larger and more imposing photographs. In 1854 Adolphe-Eugène Disdéri (1819–1890?) patented in Paris the *"carte de visite,"* a camera with four lenses that made eight small photographs measuring 3¼ by 2⅛ inches on a full-size plate of 6½ by 8½ inches. These eight photographs, each on an average-size 4-by-2½-inch visiting card, sold for about $4, less than half the price a portrait photographer usually charged for a single full-size print.

Disdéri was a colorful, self-confident, publicity-conscious salesman who, though uneducated, did things with a flourish that captivated commoner and king. The Emperor Napoleon III, marching to Italy at the head of his troops for another of his "prestige wars" with Austria, stopped his army, which waited on the street while he and his staff walked into Disdéri's studio to sit for *carte-de-visite* portraits. The story spread. Immediately every person in Paris had to have *carte-de-visite* photographs made by Disdéri. What a showman! Disdéri rose to the occasion. He dressed extravagantly. He draped his wide full beard over satin blouses of shrieking colors which he bound at the waist with enormous belts; below, he wore short hussar trousers. Dressed in this outlandish costume, Disdéri took pictures in his studio with dramatic, imperious gestures. The crowds loved it; they flocked to his studio. He opened a second studio in southern France and still others in London and Madrid. Emperor Napoleon III

The *carte-de-visite* camera patented by Adolphe-Eugène Disdéri in 1854.
Eight exposures were obtained on a 6½ x 8½" plate.
The print was then cut up and mounted on cards approximately
4 x 2½", the size of a visiting card.
George Eastman House, Rochester, New York

Adolphe-Eugène Disdéri. *Martha Muravieva*.
Sheets of uncut *carte-de-visite* photographs.
George Eastman House, Rochester, New York

A page from a rare *carte-de-visite* album by various French photographers of the late 1850s and early 1860s.
The photographs of Eugène Delacroix (upper left) and Gustave Courbet (lower right) are by Pierre Petit;
those of Jean-Auguste-Dominique Ingres (upper right) and Horace Vernet (lower left) are by Adolphe-Eugène Disdéri.
George Eastman House, Rochester, New York

and the Empress appointed him official court photographer.

Disdéri earned millions and he spent millions. He bought houses and horses, elegant mansions, and stables of thoroughbreds. He was a lavish host; he acquired princely habits. In 1866 the insatiable demand for *cartes de visite* ceased as suddenly as it began. Disdéri thought up novelties to revive his flagging business or touted tricks in photography which already existed, such as pictures on silk and ceramics. Nothing worked. He could not compete with the cheap competition that he had created; the price of the *carte de visite* had been driven down to $1 a dozen.

There had to be some way to save the untold thousands of cards which piled up from family and friends who either called and left cards or exchanged them on birthdays and holidays. The answer was the *carte-de-visite* album. Some albums sold at nominal prices and others were very elaborate, bound in fine, tooled, expensive leather. The album became a required feature, the perfect conversation piece for every Victorian parlor and drawing room.

Julia Margaret Cameron: Portraits Out of Focus

JULIA MARGARET CAMERON (1815–1876) was endowed with a combination of eccentricities, energy, and inspiration that prompted her to photograph great Victorian personalities and enabled her to reflect their spirit, power, and character better than any portraitist. She concentrated on their heads, revealing their depth of mind as she revealed her own depth of feeling about them. Titans of their day they were—among them Tennyson, Darwin, Browning, Longfellow, Sir John Herschel, George Frederick Watts, Anthony Trollope, and Thomas Carlyle.

It was the soul of the subject she was after. The camera provided her with the ideal instrument to record the facial characteristics of her intellectual heroes. Her studio was her gallery of the sanctified; she created ikons to worship. Her photographs of plain people were comparatively uninteresting, merely records containing little more than fuzzy likenesses of persons she obviously did not worship.

Mrs. Cameron was never known to photograph a landscape. The forms of the land and of growing things did not satisfy her as did portrait subjects as a vehicle for expression of her feelings. However, her illustrations of Tennyson's romantic poems and of her own complex allegories pleased her artistic sensibilities. She learned illustration from her mentor, George Frederick Watts; her allegorical photographs, like Watts's allegorical paintings, were tasteless and sentimental.

She was a dedicated artistic "primitive" with a camera. Her photographs are out of focus, not deliberately soft focus—this was later to become the vogue in photography—but literally not sharp because the lenses she used could not be made to photograph sharp details. Had she compromised with the size of the camera and substituted a smaller one, had she pulled back from the subject so that his every movement and

Henry Herschel Hay Cameron.
Portrait of Julia Margaret Cameron.
1870. Taken by Mrs. Cameron's son.
Gernsheim Collection,
University of Texas, Austin

51

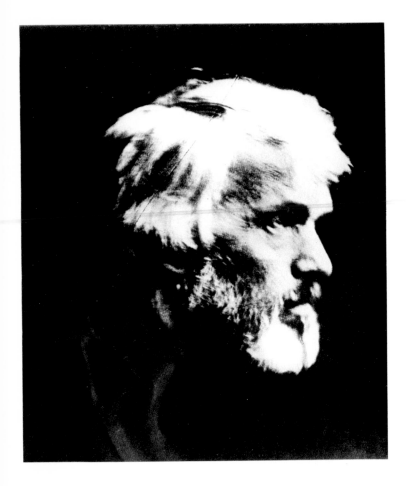

Julia Margaret Cameron: *Portrait of Thomas Carlyle* (left). c. 1867. Characteristic of Mrs. Cameron's equipment and technique, the photograph is out of focus and the plate is cracked and spotted; *Portrait of Charles Darwin* (below left). 1869; *Portrait of Alfred, Lord Tennyson* (below right). June 3, 1868. The Art Institute of Chicago. Stieglitz Collection

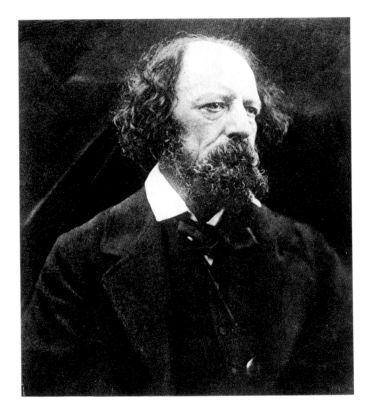

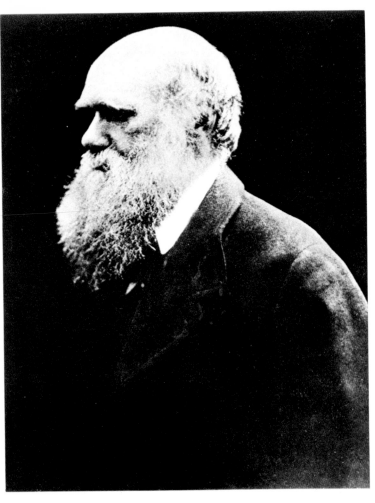

tremor would not have registered, or had she concentrated all the light possible on the subject rather than the small amount of top light she permitted to enter her small glass studio, the photographs would have been sharper and the sitter would not have been subjected to the misery of such lengthy exposures. But, had she had any consideration either for subject or herself, she would not have been Julia Margaret Cameron.

Alfred, Lord Tennyson and his poems were her inspiration for allegoric and illustrative photography. Mrs. Cameron's first volume, containing twelve photographs illustrating Tennyson's *Idylls of the King and Other Poems*, appeared in 1875; a little later a second volume with an additional twelve photographs was published.

Rejlander, Robinson, and "Art Photography"

THE ART OF THE SENTIMENTAL VICTORIAN AGE was the idealized storytelling genre or allegorical painting, as beloved in the academies of the Continent as it was in England.

Thoroughly grounded in this literary atmosphere of art was Oscar G. Rejlander (1813–1875) of Sweden, who studied painting and sculpture at the Academy in Rome. His subsequent stay in Paris served to confirm his approach to painting; his portraits glorified the sitter extravagantly and his complicated allegories became ever more involved.

He went to England when he married an English-woman and decided to pursue photography for a livelihood, but he continued to paint portraits sporadically and several of these were exhibited at the Royal Academy over the years.

Telling about his conversion to photography, Rejlander writes that he took all five lessons in one afternoon, the calotype, the waxed-paper process, and a half-hour on the collodion process. He then writes, "It would have saved me a year or more of trouble and expense had I attended carefully to the rudiments of the art for a month."

Despite this inadequate training in technique, Rejlander opened a studio. What he had learned of art and particularly the keen eye he had developed in observing unique facets of character in people benefited him greatly in photography when he emulated with the

Oscar G. Rejlander. *Two Paths of Life*. 1856. Composite photograph made from thirty negatives, 31 x 16".
George Eastman House, Rochester, New York

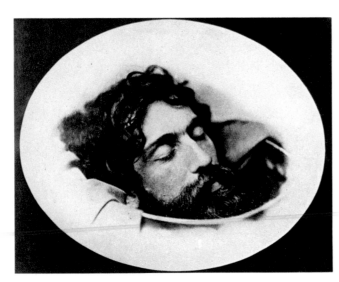

Oscar G. Rejlander. *Head of St. John the Baptist*. c. 1860.
Composite photograph made from two negatives.
George Eastman House, Rochester, New York

camera the vast theatrical and literary allegories he had made with the brush.

In 1856 he made a composite print, 31 by 16 inches, from thirty different negatives. It was an immediate sensation. This allegorical picture, *The Two Paths of Life*, represents a venerable sage introducing two young men into life. The serene, philosophical one turns to religion, charity, industry, and the other virtues, while the second young man rushes madly into the pleasures of the world, typified by various figures representing "Gambling, Wine, Licentiousness and other Vices, ending in Suicide, Insanity and Death." In the front center of the picture is a figure of "Repentance with the Emblem of Hope." Thus was this allegory described when it was first shown.

Praise was heaped on the print, although in Scotland it was refused admittance in an exhibition for its display of nudity. Shown the same year at the Art Treasures exhibition in Manchester, it was purchased by Queen Victoria.

Rejlander's combination photographs made up of artificial poses and contrived scenes from retouched negatives, with desired effects painted in and undesired effects painted out, were loved in their day and still hold the "arty" photographer enthralled.

Five years later he was still enmeshed in the pictorial aims of "high-art" photography. Ever the experimenter, however, he developed the double exposure and the photomontage, superimposing one negative on

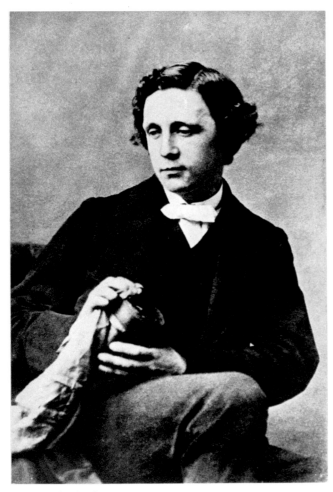

Oscar G. Rejlander.
Portrait of/The Reverend Charles L. Dodgson
(Lewis Carroll). 1863.
Gernsheim Collection, University of Texas, Austin

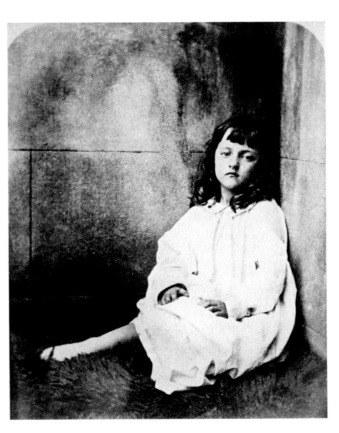

Lewis Carroll. *Portrait of/Mary Millais*. 1865.
Gernsheim Collection, University of Texas, Austin.

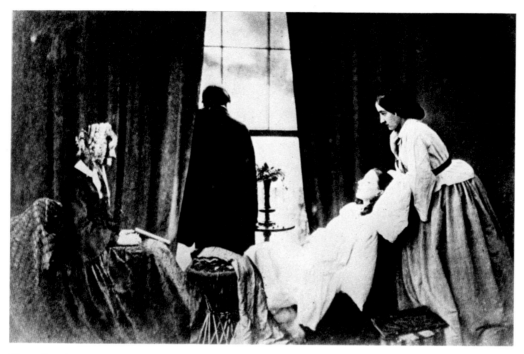

Henry Peach Robinson. *Fading Away*. 1858.
Composite photograph made from five negatives;
the joints are subtly hidden. The Prince Consort was so impressed with Robinson's
photographs that he gave Robinson a standing order for a copy of every composite print that he made.
Royal Photographic Society, London

another to make a modern-appearing multiple-exposure photograph entitled *Hard Times*. From these experiments he realized considerable recognition but little profit. His main source of income for the rest of his life were the portraits he made and the nude and clothed studies of adults and children that he supplied to artists. These pictures of children, convincingly enacting his poses and embodying the motion he tried to convey, found praise from the Reverend Charles L. Dodgson—Lewis Carroll—who came to study with Rejlander. The creator of *Alice in Wonderland* took some unforgettable pictures of artists, fellow professors, and particularly of children.

It was a long time before photography stopped looking to painting for guidance. Henry Peach Robinson (1830–1901), a talented painter who turned photographer in the year 1858, followed Rejlander into the vehement controversy over combination printing by exhibiting a picture, *Fading Away*, made from five negatives. This was a picture of a dying girl seated in a chair and sadly watched by sister and mother while father looks out of an open window.

The "art photograph," as Robinson described these elaborately fabricated pictures, was severely criticized for misrepresenting the truth, but the Royal House was impressed with combination prints and purchased *Fading Away*. The Prince Consort gave Robinson a standing order for one print of each such photograph that he would make. Robinson became not only the leading pictorial photographer of England but a prolific writer of manuals and treatises on photography. His first book, *Pictorial Effects in Photography*, was published in 1869; toward the end of his life he published *Picture Making by Photography* and *Art Photography*; all three were translated into many languages and printed in many editions.

Brady: Cameraman of the Civil War

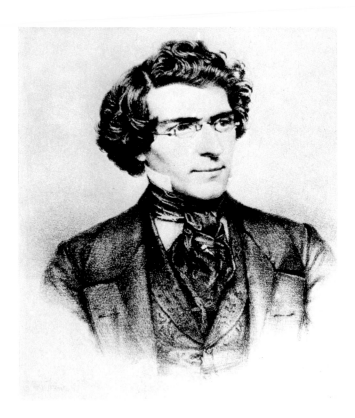

François d'Avignon. *Portrait of Mathew B. Brady*. 1850.
Lithograph. First published in *The Photographic
Art Journal*, January 1851.
George Eastman House, Rochester, New York

IT IS OFTEN FORGOTTEN that Mathew B. Brady, the most representative photographer of his day, took his portraits of the mighty and the famed with a sensitivity and artistry that he had first learned to put into pictures with a brush. His teacher was William Page, twelve years his senior, whom Brady met when he was only sixteen years old in 1839. He had just left his birthplace of Lake George, Warren County, New York. Brady painted portraits under the guidance of Page while they traveled as itinerant limners from Saratoga to New York City. Early the next year Page took Brady, still encouraging him to be a painter, to meet and perhaps study with his former instructor, Samuel F. B. Morse. Instead of signing up for courses in art, Brady enrolled in a class which Professors Morse and Draper were conducting on the daguerreotype process.

In 1841 and for the following three years, to make money not only to pay his tuition at the university but also to accumulate capital so that he could open a gallery, Brady owned a factory which manufactured cases for jewelers and daguerreotypists.

Following the practice of Samuel F. B. Morse, Brady opened a skylight-roofed studio on Broadway and Fulton Street in 1844. He had just reached his majority. That first year he was awarded a prize at the American Institute in New York for a daguerreotype; the following year he reaped more recognition by winning a gold medal; and the top award was his a year later. Brady then began to accumulate the most historically important pictorial record of the nation's statesmen and celebrities for a period of nearly fifty years, from President John Quincy Adams to President William McKinley.

Brady conceived the idea of publishing books of likenesses of the notables who sat for his camera. In 1850 Brady published *The Gallery of Illustrious Americans* with twelve lithographed reproductions.

A rare daguerreotype case made in New York and signed
M. B. Brady. Brady was in this business from 1841 until
1844 when he opened his first gallery.
George Eastman House, Rochester, New York

He continued to gather daguerreotypes not only of statesmen and soldiers but of practically all people in the public eye, including actors and actresses, doctors and professors, engineers and architects, opera stars and chess players. The people who made news in their day were recorded for posterity in elusive quicksilver made permanent through its vapors. Brady and his assistants took thousands of portraits which were used for wood engravings and lithographs to illustrate pages of the pictorial journals, newspapers, and books, until the nation's best known by-line was "From a Daguerreotype by Brady."

In 1847 Brady opened a branch gallery in Washington where it became the practice for the President and his cabinet and members of Congress, at one time or another, to entrust their heads to Brady's "immobilizer," as the torturous head clamp was called.

By 1853 Brady had almost forsaken the daguerreotype for ambrotype photographs made by the wet-plate process. He relied more and more on his assistants to man the cameras—the strain on his eyes was too tiring. He started to specialize in "imperials," enlargements of 17 by 20 inches, often life-size heads tinted or painted by artists on Brady's staff. This process made a photograph more costly than the usual oil painting procurable in the days before the Civil War. Orders for imperials by the wealthy and powerful were balanced by the mass business during the *carte-de-visite* craze as hordes of customers crowded his two establishments. As another source of income he and his assistants operated a school of photography.

In 1856 Brady paid the fare to bring Alexander Gardner from Scotland to New York. From then until 1863, when Gardner left Brady to cover the Civil War as a free-lance photographer, the two men made an ideal working team. An experienced photographer, especially in the wet-plate process and in enlarging, Gardner organized Brady's establishments to make impressive, delicately retouched and profitable monumental portraits. In 1858 Brady made Gardner manager of his Washington gallery. Brady's business flourished. Early in 1860 he moved his New York gallery for the third and last time.

One photograph that Brady himself took on February 27, 1860, changed the entire course of his life. Abraham Lincoln said of this picture two years later, "Brady and the Cooper Union speech made me President of the United States." Brady's portrait of the tall, unbearded lawyer introduced Lincoln, through the illustrated press and Currier and Ives prints, as a man of profound dignity and inner strength. This was only the first of many sittings Lincoln was to give Brady.

It was with Lincoln's election and the beginning of the war that Brady lost interest in collecting a gallery of the illustrious and determined to document through photography the entire Civil War. His historic pictures enabled people to follow the course of battle, to be

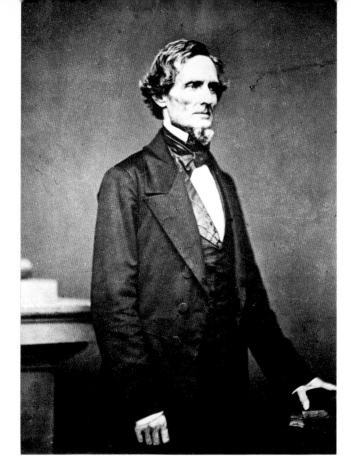

Mathew B. Brady. *Portrait of Jefferson Davis.* 1860.
Taken in Washington the year before Davis became president of the Confederate States. Chicago Historical Society

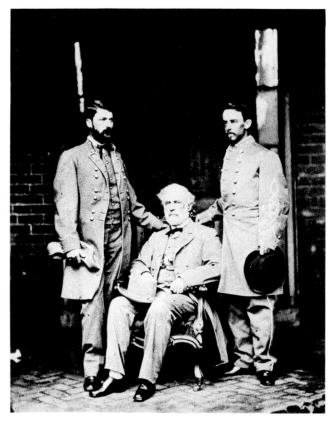

Mathew B. Brady. *General Robert E. Lee and Staff.* 1865.
This is one of five photographs that Brady took of Lee on the back porch of the Lee house on Franklin Street in Richmond; here, Lee is shown with his son Major General George Washington Custis Lee (left), and Colonel Walter Taylor (right). Chicago Historical Society

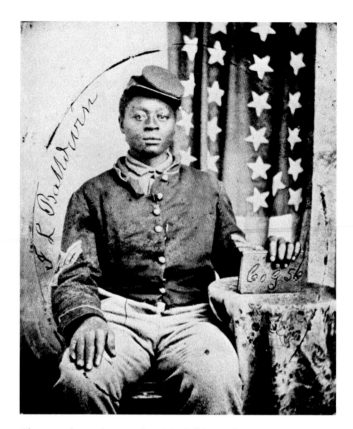

Photographer unknown. Sgt. J.L. Baldwin of Company G,
56th U.S. Colored Infantry, organized August 1863.
Tintype of the only identifiable Negro soldier of the
200,000 who served in the Union Army.
Chicago Historical Society

witness to scenes of actual conflict, and to feel the devastations of war.

Brady visited Lincoln, who wrote "Pass Brady" on a piece of paper, gave him his blessing but no money, and cautioned him that there would be no money forthcoming for such a project. Brady did not need money when the war started. By the time it was over he had spent his fortune of more than $100,000, and owed $25,000 more to Anthony's for photographic materials. But, in the beginning, every man from buck private to general had to have his picture taken and ordered *cartes de visite* by the dozen; throughout each day there would be lines before Brady's establishments. The cheap and popular tintype Brady left to others, who took literally millions of them in army camps and bivouac areas.

Brady took many of his best men with him into the field; by war's end he had financed twenty teams that had covered practically every major engagement in every theatre of war. Each was equipped with a wagon of photographic material which the soldiers dubbed a "What-Is-It?" wagon. Alexander Gardner and his son James were with the Army of the Potomac; Timothy H. O'Sullivan was at Gettysburg and Richmond; and others whose names are known, remembered by a credit line given below pictures in albums published after the war, were J. F. Coonley, C. N. Barnard, Louis H. Landy, T. C. Roche, William R. Pywell, David

Alexander Gardner. *President Lincoln and General McClellan on the Battlefield of Antietam*. October 1862.
Wet-plate photograph. George Eastman House, Rochester, New York

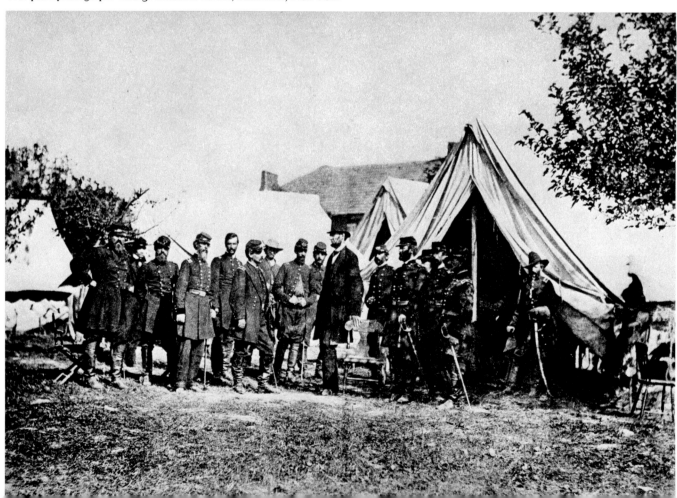

Knox, Samuel C. Chester, and D. B. Woodbury. The Confederate Army's most prominent photographer, George F. Cook of Charleston, was one of Brady's helpers.

Brady himself took the first pictures of the war, the rout at Bull Run. He returned with his wagon and a number of negatives which the press hailed as "reliable records," buying them for wood engravings and lithograph illustrations. Again beneath most pictures, this time of war, appeared the credit line "From a photograph by Brady." He had organized the first news-picture agency.

The War Department suddenly saw the value of photography and assigned George M. Barnard to the Engineers to take pictures of army installations and the terrain. Barnard's best war pictures were made as he accompanied General Sherman on his march to the sea.

It took strength of purpose and disregard of danger to coop oneself up in a wagon which invited a marksman's bullet, and prepare glass plates in the semi-darkness for cumbersome cameras like the popular stereo and the 8-by-10-inch view camera. Too slow to stop action, Brady and his men trained themselves to see and take grim still lifes which reflected the action frozen in death. The battlefield, littered like an upturned wastebasket, showering papers and pictures amidst the ungraceful, sprawling dead, made for poignant pictures of readily imagined fierce action.

Oliver Wendell Holmes saw Brady's own pictures that he took at Antietam and wrote in the *Atlantic*, "These terrible mementoes of one of the most sanguinary conflicts of the war, we owe to the enterprise of Mr. Brady of New York. . . . Who wishes to know what war is, look at this series of illustrations."

It was the sale of stereo cards which Gardner hoped would be a source of income when he opened his gallery in Washington a year after he left Brady. What caused them to separate is not definitely known, but money matters could well have been behind it. Brady owed Gardner money for services as he owed Anthony for supplies. Some of the prints Gardner took for Brady during the war Brady must have given him when they parted in lieu of salary owed. These photographs appeared in albums along with pictures identifiable as Gardner's or his son's taken after they left Brady.

No matter what happened, Brady's resolve never lessened; he persisted in recording the nation's greatest conflict. His galleries in New York, without him, made portraits of visiting celebrities; this income supported Brady's war pictures. He and his teams made thousands of grave and penetrating documents. Grant's march on Richmond was a nine-month campaign. T. C. Roche and Tim O'Sullivan were along most of the time, exposing themselves again and again in the midst of bombardment to get a picture. Brady came to Richmond immediately after the surrender. He called on

General Robert E. Lee, whom he had photographed in Washington, and convinced the revered leader of the Confederate Army to pose with his son and his aide, Colonel Taylor; they sat on the back porch of Lee's home on Franklin Street. This is one of Brady's greatest historic photographs.

In Washington the returning armies again lined up at Brady's for pictures to compare their war-lined faces with the proud face of youth Brady had captured when they sat for him the day they donned their uniforms. General Sherman and his staff came for a group picture but without General Blair. Brady or one of his assistants took the general at a later date, and pasted the deliberately posed and perfectly proportioned picture onto the board already imprinted with his name.

The excitement of the postwar period in Washington and in New York died down; business at Brady's stood still. His wife, Julia, was ill; Brady was broke. People wanted to forget the war; there was no market for war pictures. To pay Anthony's bill for supplies Brady relinquished a duplicate set of his war negatives; he sold his New York studio and some real estate he owned.

The War Department, in July, 1874, paid a storage bill Brady owed amounting to $2,840, for which they secured a large number of photographic negatives of war views as well as pictures of prominent men. General Benjamin F. Butler questioned the War Department's title to this property. He and General James A. Garfield (later President) evaluated the collection at $150,000 and succeeded in getting an appropriation of $25,000 paid to Mathew B. Brady on April 15, 1875. How many pieces were in the collection? For twenty-two years no one took the time to find out; meanwhile an untold number of glass plates were broken, irreparably scratched, or lost. The first catalogue in 1897 disclosed 6,000 plates still in good condition.

A third representative group of negatives, the Brady-Handy collection, was purchased by the Library of Congress for $25,000, paid to the two daughters of Levin C. Handy, Brady's nephew-in-law. Handy had come to Washington in 1866 at the age of twelve seeking work, and within two years Brady had made him into a fine portrait photographer. Handy ran the gallery in Washington, continuing Brady's practice of securing the distinguished and the fashionable to sit for portraits.

After the death of his wife, Brady made his home with his nephew. One day in 1895 Brady, now practically blind, was run over by a vehicle. He recovered and went to New York City, where he was planning an exhibition of his war photographs, but on January 15, 1896, two weeks before the show opened, he died.

Mathew B. Brady lies buried in Arlington Cemetery with the great Civil War heroes whom he photographed and whom the nation knows as living men primarily because of one man whose most honorable medal was a by-line, "Photograph by Brady."

Pioneers of the West

Timothy H. O'Sullivan. *Panama-Limon Bay at High Tide.*
1870. Wet-plate photograph.
George Eastman House, Rochester, New York

Timothy H. O'Sullivan. *Self-Portrait.* 1870.
Wet-plate photograph, from a stereograph,
taken during the Selfridge Darien (Panama) expedition.
George Eastman House, Rochester, New York

ONE OF THE REALLY gifted cameramen who photographed the West was Timothy H. O'Sullivan, who had been with Brady at Gettysburg and Richmond and who had seen three full years of misery through his ground glass. He had survived, but not even Brady himself could have lured him back into the sophisticated atmosphere of the studio. Though he had been born in New York, celebrities and cities held no more fascination for him.

He sought continued adventure through his camera: the sight of unexplored lands and out-of-the-way places. The government, in 1867, sponsored a geological exploration of the fortieth parallel, to be directed by Clarence King. O'Sullivan was official photographer for the three years of the expedition. He took pictures of nature's grandeur in the falls, lakes, rivers, and mountain ranges of the towering Rockies, and he went down hundreds of feet inside mines to take pictures by magnesium flares. What an impression they made as the nation saw them reproduced in the illustrated press!

In 1870 O'Sullivan came down from the mountains to take his cameras into the steaming jungles of Panama. For a year he was with the Commander Selfridge expedition, which the government had sent out to survey and map a possible ship canal across the Isthmus of Darien, as the Isthmus of Panama was then called. Insects, swamp fevers, impenetrable jungle, and wild beasts were among the hardships that he encountered that often made it as difficult to secure pictures as it had been during the war. O'Sullivan endured it all and was not deterred from his purpose. Using an 11-by-14-inch camera as well as a stereo, he made hundreds of negatives, turning them over to Commander Selfridge who four years later incorporated them into his official report.

In 1873 the Wheeler survey explored Arizona, where O'Sullivan photographed the White House

Timothy H. O'Sullivan. *Ruins of White House, Canyon de Chelly, Arizona.* These are cliff dwellings that were abandoned in the thirteenth century. Two explorers in the bed of the canyon are attached by rope to two others—all members of the Wheeler expedition—standing on the roof of the ruined house. George Eastman House, Rochester, New York

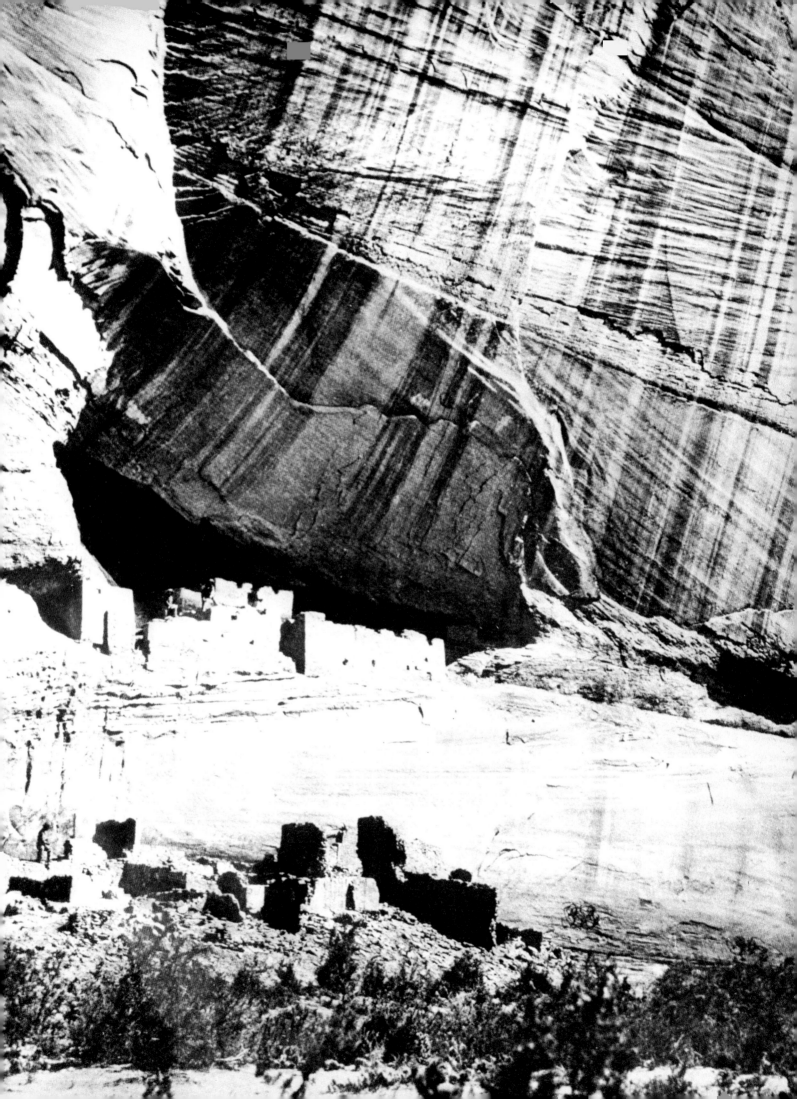

William Henry Jackson. *Mount of the Holy Cross*. 1874.
Wet-plate photograph.
George Eastman House, Rochester, New York

Photographer unknown. *W.H. Jackson in Yosemite Valley,
Observation Point*. 1873. Wet-plate photograph.
Denver Public Library. Western Collection

ruins at Canyon de Chelly, one of his most superb pictures. The name is a distortion of the Navaho, *Tse-Yee*, meaning "within the rocks." The drying up of the wells because of a drought which lasted for most of the later thirteenth century made the Indians abandon their hallowed cliff dwellings.

In the O'Sullivan picture the overhanging cliff is given prominence and the texture emphasized by the striking sidelight cutting across the striated wall. It is a brilliantly envisioned wall seen floating above the ancient dwellings, which are set in a semicircular cave on a ridge seventy feet above the canyon bed. Below, two barely discernible men hold a rope attached to two other men standing on the roof of the ruins.

Not much is known of O'Sullivan after the 1874 expedition conducted by the now-promoted Captain Wheeler. It is believed that he worked off and on for Alexander Gardner in Washington. It is definitely known that both Brady and Gardner recommended him for a job as chief photographer in the Treasury Department, for which he was hired. He worked in Washington about six months, fell ill, and resigned. The scant record lists O'Sullivan's death, two years later, on January 14, 1882; he was forty-two, perhaps forty-three. His exact birth date was never known. What is certain is that in his sick body, suffering with tuberculosis, was a courageous spirit, alert to the art of the camera, and an indomitable will to leave a living record of the terrors of war and the splendors of nature.

A contemporary of O'Sullivan who lived a year less than a century, from 1843 to 1942, was William Henry Jackson. He served the year 1862 in the Civil War. His enlistment over, he resumed work in a Vermont photographer's studio. He left in 1866 for St. Louis, where he became a bullwhacker of an ox train crossing the plains. He sketched, worked as a hired hand, tried prospecting when he was in California early the next year, and then hired on to drive wild horses back east as far as Omaha. There, in late 1867, his career as a photographer really began, in partnership with his brother, Edward, who came out from their home town of Peru, New York. They opened a studio, but Edward soon tired of photography and returned to farming.

In 1869 Jackson took a series of pictures along the Union Pacific railroad, trading photographs for bunk and board with the section hands. He roamed the country with his camera, going to Salt Lake City and the Black Hills of Wyoming, taking side trips, and returning to some out-of-the-way station where he caught a train for Omaha and his gallery. Dr. Ferdinand V. Hayden of the United States Geological Survey of the Territories hired Jackson in 1870 to join a three-month expedition from August to November, at no pay but with expenses and permission to keep the negatives with the proviso that prints be made available to Hayden when he requested them.

Jackson photographed along the Oregon-Mormon

Laton Alton Huffman. *A Typical Sheep Herder*. c. 1880.
Taken in a Miles City, Montana, photo studio.
Collection Mrs. Ruth Huffman, Miles City, Montana

Jackson liked the life. He deliberately went to Washington to sign up with Dr. Hayden as official photographer for the following year. He closed his studio in Omaha.

Yellowstone was the expedition's field of operations in 1871. Jackson took an 8-by-10-inch and a stereo camera plus 200 pounds of equipment, mostly packed on his mule, "Hypo." Jackson, who sketched and painted water colors when he did not photograph, was pleased to find the famous New York artist Thomas Moran accompanying the expedition to paint Yellowstone's scenic marvels. Other members of the party were divers scientists, geologists, topographers, and naturalists, who recorded in cold reports what Jackson photographed so beautifully. Nine of his photographs saved Yellowstone for the people of America, making an area of 3,578 square miles into the country's first national park.

Dr. Hayden bound nine of Jackson's best photographs, including Mammoth Hot Springs, Tower Falls, Grand Canyon of the Yellowstone, The Great Falls, and the Crater of the Grotto Geyser, into individually gold-embossed volumes for each member of the House and Senate. The bill passed by a good margin, and President Grant signed it March 1, 1872, removing one of the nation's wonders forever from commercial exploitation for private gain.

The third expedition of Dr. Hayden extended exploration of Yellowstone, but Jackson took off with one assistant and three different-sized cameras for the Great Teton Range near the head of Snake River. In the snow and cold at 11,000 feet he took some superb panoramic views of the Three Tetons as they towered above him.

trail; the North Platte River, where a dry gorge was named Jackson Canyon in his honor; along the badlands of Wyoming; the Uinta Mountains; down the Green River through Bridger's Pass; then on to Pike's Peak and Denver in the cold and snow of early winter.

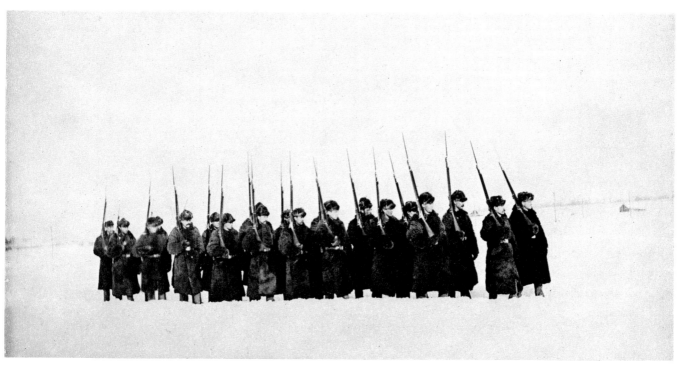

Laton Alton Huffman. *Guard Mounts in Buffalo Coats*. Wet-plate photograph taken in Fort Keogh, Montana.
Collection Mrs. Ruth Huffman, Miles City, Montana

The highest, 13,858 feet, named after Dr. Hayden, was 7,000 feet above Jackson's Lake, the second natural site named after the dedicated photographer.

In the 1873 expedition Jackson directed a botanist, an entomologist, a cook, and two assistants as a unit. Starting from Long's Peak in Estes Park, Jackson took a series of connected views, panoramas, and close-ups of Gray's Peak, Pike's Peak, and Torrey's Peak, the icy front-range summits of the Rocky Mountains. At the foot of the mountains Jackson photographed the eroded sandstone shapes of Monument Park and the Garden of the Gods. On August 24, Jackson photographed for the first time The Mount of the Holy Cross, located in the Red Table Mountains of Colorado at 14,176 feet. The snow here lies permanently frozen in a hundred-foot crevice in the shape of a cross, 1,500 feet in length and 700 feet in width.

On the same expedition Jackson photographed the weathered and deserted cliff dwellings of the Mesa Verde, now also a national park, in the San Juan Mountains of Colorado. Jackson Butte of the Mesa Verde was named after him on that trip. The following year, 1875, he again visited the region; this time, in addition to his usual cameras, he hauled along on an extra mule a camera capable of taking negatives 20-by-24 inches. What skill it required to coat evenly a glass plate two feet wide, expose, and develop, all in a maximum of fifteen minutes while the collodion was still moist!

The year 1876 Jackson devoted to the construction of a model based on his photographs of the cliff dwellings for the Philadelphia Centennial. The next year was a lost one. Exploring the Pueblos of New Mexico, again for Dr. Hayden, he used the new dry plates manufactured commercially for the first time. What a heartbreaking experience to see a year's results all come out black from the developer! The manufacturer's guaranty did replace the defective plates free of charge.

Jackson opened a studio in Denver three years later.

All over the world he sold famous views of nature on stereoscope cards, large prints suitable for framing, and smaller sizes to book publishers for illustrations. The railroads of the west bought many of his old prints and commissioned him to take new pictures for promotional purposes. His photographs made people aware of the breathtaking beauty to be seen in America, and trips to the national parks became one of the country's grand tours.

Not the wonders of nature but rather soldiers, buffalo, and the landscape of the "Big Open," as he called the prairie and badlands between the Yellowstone and Missouri rivers, were the subjects for the unique pictures of the frontier taken by Laton Alton Huffman. Huffman became post photographer at Fort Keogh, Montana Territory, in 1878.

In below-zero temperatures Huffman followed the soldiers dressed in their indispensable buffalo coats as they drilled in knee-high snowdrifts.

In 1880 Huffman opened a studio in Miles City, Montana, but for days the camera was with him photographing "buffalo by the thousands in every direction," as he recorded on May 12. Three years later the hide hunters with their heavy rifles had killed off hundreds of thousands of buffalo in just one corner of Montana alone, for hides which brought about $2.50 each. Huffman photographed the willful destruction of the prairie-lording buffalo. Later he photographed hunting parties shooting elk, antelope, bear, and other game, but by 1883 the loping bison killed for hide and tongue was only a topic for conversation around the fire.

Geographical memorials should be named in honor of L. A. Huffman and T. H. O'Sullivan to rank along with Mt. Watkins in Yosemite National Park, Mt. Millers in the Henry Mountains of Utah, Mt. Haynes in Yellowstone National Park, and the Canyon, Butte, and Lake named in honor of W. H. Jackson, all commemorating photographers of historic and artistic prominence.

Muybridge and Eakins:
Photography and Motion

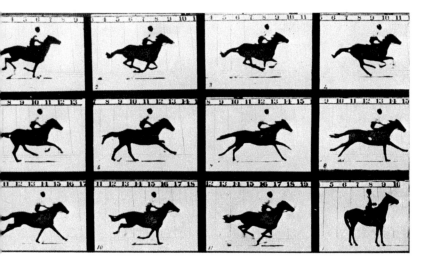 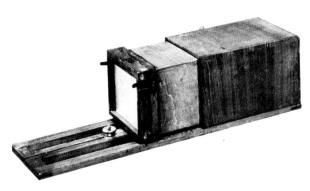

Eadweard Muybridge. *Horse in Motion.* 1878. Wet-plate photographs. In these first successful photographs of a moving horse, the horse Sallie Gardner, owned by Leland Stanford, is shown running at a 1.40 gait over Palo Alto track, San Francisco, June 19, 1878. The negatives were made at intervals of 27" to illustrate consecutive positions assumed during a single stride of the mare. The vertical lines are 27" apart; the horizontal lines represent an elevation of 4" each. The exposure of each negative was less than $1/2000$ second. Twelve cameras, of the type shown at the right, were used. George Eastman House, Rochester, New York

ONE OF THE GREAT CONTRIBUTORS to the invention of the motion picture was born in England as Edward James Muggeridge but changed his name early in life to what he believed was its true Saxon spelling, Eadweard Muybridge (1830–1904). In 1852 he migrated to America and is first mentioned for a series of large photographs he took in Yosemite in 1867. The superb cloud effects printed in from a second negative received praise from admiring critics awarding medals in international exhibitions, and twenty of these composite photographs were in the first guidebook to Yosemite's wonders.

Ex-Governor Leland Stanford in 1872, according to the traditional story, bet a friend $25,000 that a race horse had all four feet off the ground at one time during its running gait. Muybridge, who had an established reputation as a photographer, was hired to photograph

Occident, a famous trotting horse in Stanford's stable. Despite a fast shutter that Muybridge had invented and white sheets covering the track to give extra light, the wet-plate process of that time was too slow to give proof, but there was sufficient indication that the ex-Governor was correct, and Muybridge was asked to continue.

He was not to resume his experiments, however, for five years. In 1873 he photographed the guerrilla fighting amidst the lava beds in the Modoc Indian War at the California-Oregon border. The next postponement was caused not by an assignment but by a scandal and a murder that sent him to Panama and Guatemala for several years until he felt safe to return to California. In 1874 Muybridge shot and killed his wife's lover. He was acquitted by a jury, which accepted as evidence of Muybridge's temporary insanity testimony given by his former employer who said, "He was most eccentric. In

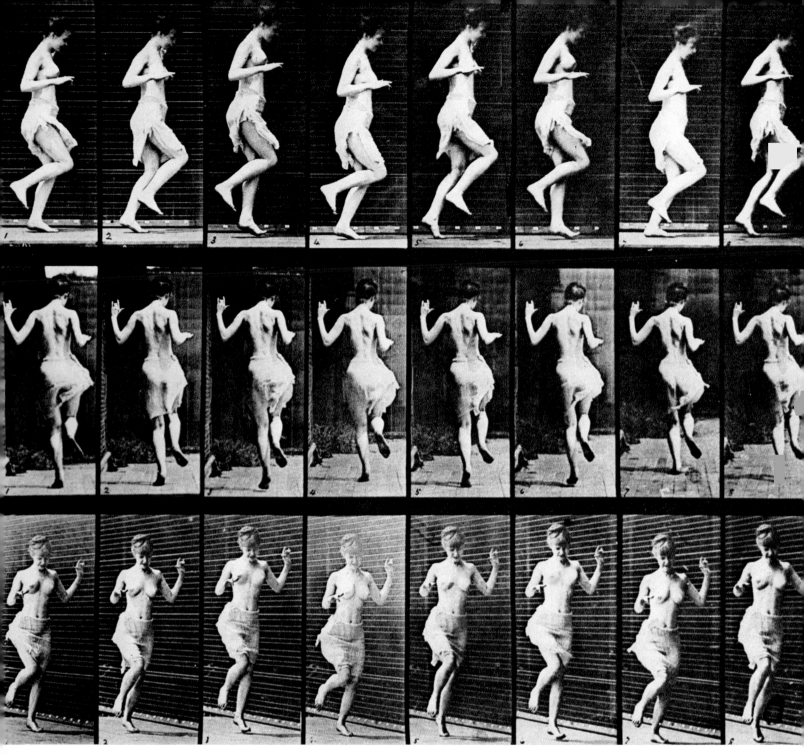

Eadweard Muybridge. *Figure Hopping.* 1887. Sequence of eight stages of movement simultaneously photographed by multiple cameras at three different positions. Cooper-Hewitt Museum Library, Smithsonian Institution, New York

his work he would not take a picture unless the view suited him." Within the California code of honor Muybridge was justified, but it was wiser not to tempt fate and he left the country.

Late in 1877 the truthfulness of a wood engraving based on a Muybridge photograph of the trotter Occident was questioned, since the photograph was admittedly retouched. In June, 1878, ex-Governor Leland Stanford invited the San Francisco press to witness

Muybridge photographing a trotting horse and racing mare.

Twelve cameras were set up, each fitted with a drop shutter triggered by a spring or rubber band. From each camera a fine wire was stretched across the track, activated by the iron rim of the wheel of the sulky, which closed an electrical circuit, thereby releasing the shutters one after another.

For photographing the handsome mare Sallie Gard-

ner twelve fine black threads were placed across the track, striking her breast high and releasing the shutters. The resulting photographs proved conclusively that the four feet of a galloping horse are all off the ground only when they are bunched together under the belly.

Photographing animal and human locomotion was Muybridge's main interest, and for this he received a grant from the University of Pennsylvania, where he stayed for three years until 1887. The eleven volumes published that year under the auspices of the university, *Animal Locomotion: Electro Photographic Investigations of Consecutive Phases of Animal Movements*, cover Muybridge's photographic experiments from 1872 to 1885 and consist of more than 100,000 photographs. The animals shown are not only the domestic dog, cat, and horse, but also the moose, elk, bear, raccoon, lion, tiger, monkey, and birds.

Muybridge published the *Human Figure in Motion* in 1901. He retired to England, and did little in photography the rest of his days; he died at his birthplace, Kingston-on-Thames, in 1904.

It is not generally known that Thomas Eakins (1844–1916), today accepted as one of America's great nineteenth-century painters, was also an ardent photographer. The stark realism and honesty with which, in his painted portraits, he brought out the inherent strength and character of the subject, Eakins tried to achieve as well in his photographs. His strong will and his rejection of the clever and fashionable likeness kept him from copying photographs when painting portraits.

A friend of Eakins once said that he would not pose for him, for "he would bring out all those traits of character that I have been trying to conceal for years."

Eakins's keen interest in photography prompted him to correspond with Muybridge. In 1879 he recommended a more accurate method of measuring the horse's gait which, however, Muybridge did not adopt. In 1884 Eakins, as head of the Pennsylvania Academy of the Fine Arts, the oldest art school in America, invited Muybridge to lecture. He also helped interest people in raising funds for Muybridge to continue his experiments at the University of Pennsylvania. Eakins was appointed a member of the supervising committee.

A brilliant anatomist, Eakins had studied human and animal anatomy for several years at Jefferson Medical College; he embraced enthusiastically the opportunity to collaborate with Muybridge. They soon differed. Eakins's scientifically trained mind readily observed that twelve or twenty-four separate cameras could not follow the speed of a subject exactly. He preferred a simpler and more accurate method, using a single camera. In front of its lens revolved a disc with a hole in it which permitted a series of superimposed distinguishable images to be taken on one plate. It was Eakins's contention that the sequence of movement

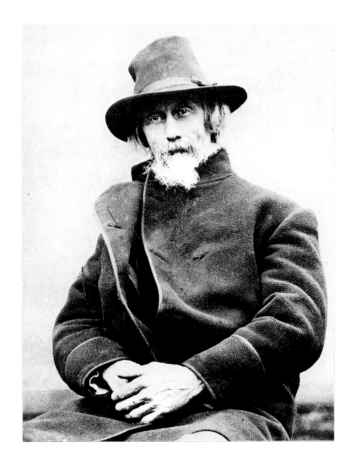

Thomas Eakins. *Portrait of William H. Macdowell*, engraver and father-in-law of the artist. c. 1890. Albumen print. The Metropolitan Museum of Art, New York

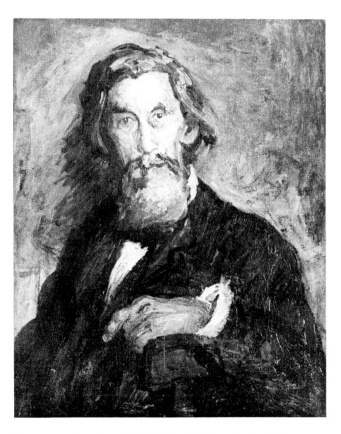

Thomas Eakins. *Portrait of William H. Macdowell*. 1891. Oil painting. Randolph-Macon Woman's College, Lynchburg, Virginia

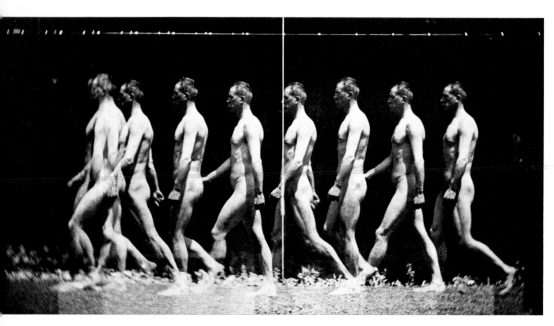

Thomas Eakins. *Man Walking*. 1884. Wet-plate photograph.
George Eastman House, Rochester, New York

Marcel Duchamp. *Nude Descending a Staircase*
1912. Oil painting.
The Philadelphia Museum of Art.
Louise and Walter Arensberg Collection

relating one shape to another throughout an entire action could be followed more easily than the separate actions photographed by Muybridge's multiple cameras.

A man walking, pole-vaulting, running, a woman model jumping or lifting an object, all became fit subjects for Eakins in 1884. He did not publish his photographs. Professor E. J. Marey of France, whose camera principle of revolving discs for fast photographs Eakins modified and used, did publish similar experiments with the multiple shapes of a nude figure superimposed on a single plate. None of the photographs published created a stir of protest. In 1912 Marcel Duchamp translated similar experiments into an oil painting, *Nude Descending a Staircase*, which created a furor of protest and, strangely enough, is still often vilified.

Eakins continued his experiments with nude athletes and models as well as with horses in motion. In 1885 he lectured at the university with a projector he either invented or borrowed from Muybridge. Having succeeded in establishing the principle that a single camera taking pictures of a subject in motion from a single viewpoint was a preferable way, he gave up his experiments. His purpose, like Muybridge's, was to analyze motion, and in this they were both successful; both contributed through their experiments to the development of the motion picture.

Eakins, the artist, continued to use the still camera for graphic art. A photograph was to be respected and retained as a fine-art print, such as an etching or lithograph. A master draftsman, he compared a fine photograph to a master drawing and felt therefore that it deserved the best of paper. Accordingly, he printed on costly platinum paper capable of retaining the most subtle and delicate tones.

As an artist Eakins was neglected until the latter years of his life; as a photographer he is only now coming into his own.

Footlights, Skylights, and Tintypes

THERE WERE MORE THAN THREE HUNDRED photographers' galleries in New York City alone by 1870. Brady was still there, though he was soon to close his establishment on Broadway in order to concentrate on his Washington practice; Gurney's widely known gallery flourished, and that of Frederick, his former partner. But the three most elegant galleries in New York operating in the seventies were those of Napoleon Sarony, William Kurtz, and José Maria Mora.

All three—like Falk, who opened his gallery a decade later—specialized in photographing celebrated actors and actresses. Their pictures of the glamorous and beautiful in turn attracted society women and first-nighters to their studios. A considerable profit was enjoyed by all galleries in the sale of cabinet-size (4-by-5½-inch) and *carte-de-visite* (3¾-by-2¼-inch) portraits of the nation's prominent theatrical personalities, dressed in the costumes of their most popular roles. Each gallery accumulated thousands of negatives and sold innumerable pictures through the theatre, hotels, the mail, and various other channels, paying a small royalty, if any, to the pictured actor or actress. The photographs were considered such good advertising by management and performer that a commission for posing was rarely exacted.

Of the three galleries, Sarony's was the best known, Mora's the most profitable, and Kurtz's the most artistic. William Kurtz, born in Germany in 1834, was an artist-adventurer who as a boy had served with the German army and had fought with the English army during the Crimean War and with the Union army in America's Civil War. In London he had been trained as a lithograph artist and had also taught art. Upon opening his New York gallery soon after the close of the Civil War, he introduced a method of lighting—modeling the subject's entire face through an arrangement of tinfoil reflectors—which became known as "Rembrandt" photography. A sensitive portrait photographer, Kurtz dispensed with elaborate or painted backgrounds, eliminated incongruous costumes, and

Napoleon Sarony in a Hussar's Uniform. c. 1870.
Taken by Sarony's assistant.
George Eastman House, Rochester, New York

used contrasting, simple backgrounds in order to secure as wide a range of tonality as possible with the wet-collodion process. The subtle Rembrandt photograph became enormously respected and popular among competent photographers, who were able to control and capture the nuances of lighting and modeling demanded by this style. Kurtz received many prizes for

69

Jeremiah Gurney. *Mark Twain*. 1870.
Carte de visite.
Collection Cornelia Otis Skinner

Jeremiah Gurney. *Edwin Booth*. 1870.
Carte de visite.
Collection Cornelia Otis Skinner

Photographer unknown.
Tintype. c. 1880. The
Metropolitan Museum of Art, New York

Napoleon Sarony. *Otis Skinner with Edith Kingdon in a Daly
Company Performance*. 1885. Collection Cornelia Otis Skinner

B.J. Falk. *Lillian Russell*. 1889. Cabinet-size
photograph. George Eastman House, Rochester, New York

Napoleon Sarony. *Oscar Wilde*. 1882. George Eastman House, Rochester, New York

portrait photography, including the highest award of the International Exhibition, Vienna, in 1873.

José Maria Mora, born in Cuba in 1849, studied art and photography in Madrid, but received two years' additional training in the intricacies of the camera from Sarony before he opened his own gallery in 1870. Immediately he prospered, and became famous for his pictures of renowned actresses whom he posed with rich accessories in front of painted scenic backgrounds. Mora's reputation grew with his designs for his painted backgrounds. Soon he had hundreds of them standing one behind another ready to be used for any kind of effect from drawing room to log cabin, from desert to mountaintop, with appropriate props to complete the picture.

L. W. Seavey introduced painted backgrounds for photographers; these quickly became standardized as accessories for the trade, along with automatic head supports, retouching machines, false pianos, balustrades, stairs, and chairs.

Photography's most famous chair was Napoleon Sarony's, in which consummate actors and actresses sat and played to his camera as to an immense audience. When the exact pose, the precise expression, was struck, the imperious five-foot-one-inch Napoleon, the same size as the Little Corporal and just as indomitable,

hollered "Hold it," and for the fifteen seconds to one minute required, the sitters all kept still. Where other photographers forced the subject's head and body into vise-like clamps, asking him at the same time to "smile and look pleasant" (a cartoon of the period was captioned, "You may resume your natural glum look in just a moment"), Sarony caught the actor in a pose best portraying a role without forced effects or awkward stiffness.

He worked hard to get a picture that satisfied him. He dressed up in a hussar's uniform. (His father had been an officer in the Black Hussars of the Austrian army and had migrated, after the battle of Waterloo, to Quebec. There the future photographer had been born and named after Napoleon, whose death had taken place the same year, 1821.)

A few days after Oscar Wilde made his famous quip to the customs officer at New York's port of entry, "I have nothing to declare except my genius," he was standing in his get-up of knee breeches, although without the gilded lily he was wont to carry, in front of Sarony's camera.

Showman and picturesque figure, Sarony printed his flowing signature in red ink on every size photograph that left his gallery, and across the facade of the five-story structure he painted his name in huge script.

The "Detective" Camera
and the Kodak

A PIONEER MAKER of gelatin dry plates in America was George Eastman, who worked during the day in a Rochester, New York, bank and at night coated glass plates by hand with the liquefied, sensitized gelatin. Eastman soon improved the uniformity of the plate by inventing a machine to do the coating. In 1879 he patented the machine in England and the following year secured a patent for the same invention in the United States. That same year E. and H. T. Anthony, the largest dealers of photographic materials in the country, were handling Eastman dry plates. Prices of cameras were cut as Anthony's advertised "dry-plate photography for the millions." A small 4-by-5 camera with a lens, a tripod, and a dozen Eastman dry plates, could be bought for as little as $12.25.

In 1881 Eastman left the bank to devote full time to his expanding dry-plate factory. During the next two years Eastman improved the plates, increasing the sensitivity of the emulsion and its stability in any kind of climate. Professional photographers swore by his products.

Eastman continued his experiments, searching for a new system of photography to supersede the gelatin dry plate. He went back to using paper as a base and invented a machine to prepare and coat a roll of paper. After exposure and processing, the paper negatives were treated with castor oil to make them transparent—just as Fox Talbot's calotypes had been dipped in oil back in the early forties. These negatives did not compare with glass plates for clarity. Eastman then tried coating the paper with two layers of gelatin. After developing and

W. F. Debenham.
Portrait of Dr. Richard Leach Maddox. 1880.
Maddox invented the gelatin-bromide dry plate
in London in 1871.
George Eastman House, Rochester, New York

73

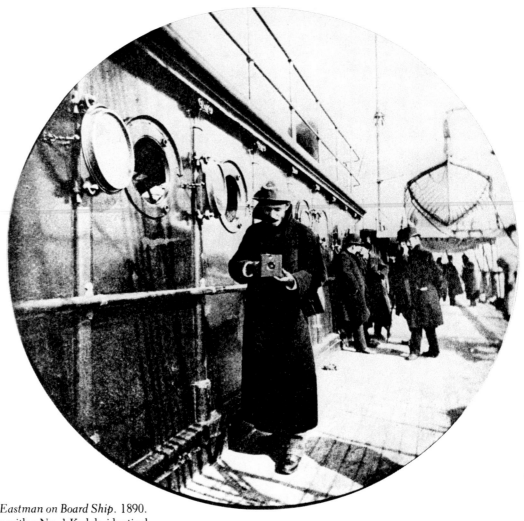

Fred Church. *George Eastman on Board Ship*. 1890.
Taken with a No. 1 Kodak, identical
to the one Eastman holds in his hands.
George Eastman House, Rochester, New York

fixing, the bottom layer was dissolved in warm water, leaving the image on the sensitized upper layer of gelatin, which was then dried in contact with a sheet of heavier gelatin.

The greatest virtue of this new "American film," as Eastman called it, was its flexibility. A roll holder could be fitted to any existing camera, even one hand held.

The fast dry plate of several years earlier had made possible the hand-held camera, thereby eliminating the tripod. Instantaneous photography was an actuality. The snapshot had come into its own. No longer was photography the field of the professional and the dedicated amateur willing to undergo the hardships demanded by the wet plate. Box cameras held in the hands of gumshoe amateurs trying to catch candid pictures gave the name "detective cameras" to the strange boxes without bellows.

Eastman in 1886 designed and patented a box camera with a standard roll holder for forty-eight 4-by-5-inch negatives, a focusing lens, and what he termed an "alligator shutter," but it did not work too well. Two

years later he developed the perfect amateur camera of its day and coined a word which has been synonymous with "camera" ever since, "Kodak." The Kodak was a small box, a little over 6 inches long, 3½ inches wide, and less than 4 inches high. Anyone could operate it who, according to the Kodak Manual, was able to: 1. Point the camera. 2. Press the button. 3. Turn the key. 4. Pull the cord.

The No. 1 Kodak was not a pinhole camera. It was fitted with a lens and masked to take a circle negative 2¼ inches in diameter. One hundred negatives were on the roll. When the roll was fully exposed the entire camera was mailed back to Eastman, who returned the camera reloaded, plus the negatives and one hundred mounted prints (or as many as were not blanks) from the first roll, all for the sum of $10. The original outlay was $25 for the first loaded camera. Every purchaser became an avid amateur.

It was George Eastman's slogan, "You press the button, we do the rest," that accounted for what was to become the first world-wide folk art.

3

Masters of the
Modern Era

Peter Henry Emerson. *Pond in Winter*. 1888. George Eastman House, Rochester, New York

Jean-Auguste-Dominique Ingres.
Louis Bertin (right). 1832.
Oil painting.
Musée du Louvre, Paris;
Jean-Baptiste-Sabatier Blot.
Daguerre (far right). 1844.
Daguerreotype.
George Eastman House,
Rochester, New York

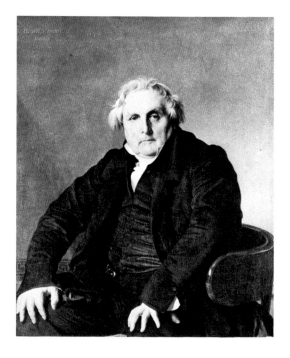

Photography Comes of Age

"FROM NOW ON, PAINTING IS DEAD!" exclaimed Paul Delaroche, painter of portraits and historical subjects, when Daguerre's new process burst upon an astonished world.

Let us take a first-class portrait painted a few years before Daguerre's invention, deprive it of its colors, and shrink its scale to that of a daguerreotype. The result is the painting illustrated on the opposite page, lower left. And then let us compare this picture with a first-class early daguerreotype portrait, shown on the opposite page at the right. These two pictures look very much alike. What do they have in common? An ideal that can be summed up in the phrase "truth to nature." Unvarnished truth: a precise, detailed, and accurate description. And naturalness: the record of a patterning born, not made; the chance result of a movement in nature rather than the artificial product of human calculation. Neither image, of course, realized this intention completely. The painter could not turn himself into a machine; and the machine could not refuse to obey the will of its master. Ingres's portrait of Monsieur Bertin has more personality and psychological insight than the portrait of Daguerre by Monsieur Blot. But that cannot be said for portraits in the same basic style by some of Ingres's very skillful but also very literal and rather unimaginative followers. Except for having color, such work had no advantage over the daguerreotype. In time, portrait painting became a vestigial art and professional portrait painters little more than fashionable hacks. There were great portraits by great painters, let it be said. But they were no longer portraits in the traditional sense, and certainly not precise, detailed, and accurate descriptions. Portraits by Van Gogh and Cézanne were, on the one hand, records of the artist's inner, personal feelings about his sitter, and, on the other, structures built of harmony, form, and color. The intentions of these artists in making portraits were as far from Ingres's as from Daguerre's.

Photography as conscious art, in the Europe of 1860 to 1890, was the "art photography" concocted by Rejlander and Robinson at mid-century. In style and spirit, as we have seen, it was enmeshed in the stubborn conservatism and heavy sentimentality of the academic printing that its practitioners imitated and revered. In America at that time there was no interest in photography as art. American photographers were far too engrossed in making likenesses of our great-grandfathers and recording the wonders of the American West. They were exposed to the ideas and images of the European pictorialists through the wistful efforts of photographic publications, but responded to them not at all.

Peter Henry Emerson, an American physician living in London, was the initiator of the bold new movement. The camera had its own rules, Emerson said, and it was the photographer's glorious task to discover them. At first he was a champion of soft-focus photography. It corresponded to natural vision, he wrote in his *Naturalistic Photography*, and was surpassed as an art only by painting. He reversed himself after becoming convinced by Whistler that he was confusing art with nature. Emerson then published a black-bordered pamphlet entitled *Death of Naturalistic Photography, A Renunciation*. A master of vituperation, he defined "photographic Impressionist" as "a term consecrate to charlatans and especially to photographic impostors, pickpockets, parasites and vanity-intoxicated amateurs." He called attention to the limitations of photography. "The individuality of the photographer is cramped...," he wrote. "Control of the picture is possible to a slight degree... the powers of selection and rejection are fatally limited... it is impossible in most subjects to alter your values as you wish...." In discussing the issue of sharpness versus diffusion, he wrote: "If the work is for scientific purposes work sharply, if for amusement please yourself, if for business do what will pay."

In 1892, in company with other earnest amateurs,

Emerson formed the Linked Ring, an international group dedicated to photography as art. One of its members was Frank Sutcliffe, whose *Water Rats* of 1896 was a marvelous revelation of what could be done with a camera. Evoking the poetry in modern urban-industrial life, this photo prefigured the paintings of Luks, Sloan, and other American painters of the Ashcan School a decade or two later. Another member of the Linked Ring was the extremely talented Frederick H. Evans, who took up photography rather late in life. Evans made large-format views of English and French cathedrals, impressive for their clean sense of space and texture and their grasp of architectural forms. He also made straightforward and unsentimental but extremely sensitive portraits of his friends and admirers Aubrey Beardsley and George Bernard Shaw. (Shaw himself was an enthusiastic amateur photographer of the soft-focus school and a brilliant writer on the subject of photography.) In 1900 Edward Steichen called Evans's work "the most beautiful rendering of architecture we have ever known," and in 1903 Alfred Stieglitz wrote, "He stands alone in architectural photography." Evans loved platinum paper for its great delicacy and permanence. His star print was *Sea of Steps* of 1903, an interior view of the chapter house of Wells Cathedral. "The beautiful curve of the steps," Evans wrote of it, "...is for all the world like the surge of a great wave.... It is one of the most imaginative lines it has been my good fortune to try and depict...." In calling his own purposes "the straightest of straight photography," Evans gave a name to the great mainstream of photographic currents of the past seventy-five years.

About 1900, the center of gravity of photography as art traveled westward to the United States, where Alfred

Frederick H. Evans: *Portrait of Aubrey Beardsley* (above). 1894.
Worcester Museum of Art, Massachusetts;
Sea of Steps (below). 1903. Chapter-house interior,
Wells Cathedral, England.
George Eastman House, Rochester, New York

Frank Sutcliffe. *Water Rats*. 1896.
George Eastman House, Rochester, New York

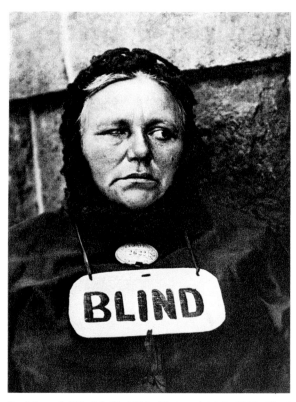

Paul Strand: *Blind* (left). 1913; *Christos* (right). 1933. The Museum of Modern Art, New York

Stieglitz became the leading figure in photography's coming of age. There were at least two greatly gifted photographers in America when Stieglitz returned there in 1890 after eight years of European training: Eakins and Riis. But Eakins's photographs were to all intents and purposes unknown, and Riis's artistry was unrecognized, least of all by Riis himself.

The new gum-bichromate process enabled the photographer to become a painter of a kind, for he could apply sensitized silver salts with a brush, build up weak areas, or wash away undesired details. Photographs came to resemble charcoal drawings, mezzotints, and watercolors. A Frenchman who adopted the gum-bichromate process, Robert Demachy, claimed in an article published in Stieglitz's quarterly magazine *Camera Work* that there was "no limit to what the photographer can do to make a photograph a work of art.... Meddling with a gum print may or may not add the vital spark, though without the meddling there will surely be no spark whatever."

The first half of the twentieth century became the great classic era of photography. Men who began as painting-bound pictorialists led the way in bringing it to an astonishing height of technical perfection, to a sweeping variety of visual image and visual idiom, to a great depth of penetration and unprecedented communicative power.

During the fertile decade defaced by the outbreak of World War I, these developers and expanders of human vision were joined by outstanding recruits to their cause of photography as art. Among them was Paul Strand, whose honesty and intensity of vision was no less than theirs. His sense of poetry in the immediate environment was also a good match for that of his elders and his sense of the poetic values latent in machine civilization was, if anything, greater. Strand was a superb craftsman—linked with the platinum-paper enthusiasts of the turn of the century through his insistence upon that extremely flexible printing medium so long as it remained on the market. He used platinum paper to achieve tonal delicacy and fully described detail. But, in spite of his concern for *matière*—the material quality of the print aside from what was being photographed—Strand looked to the subject itself for the poetic vision he wished to evoke.

Strand's vision of photography as a subject-rooted exploration of reality was adopted about 1915 by his exact contemporary Charles Sheeler, who was influenced in the new direction by the example of modern art, especially Cubism. Sheeler, a photographer of architecture for his bread and butter, in 1913 rented a Bucks County farmhouse where, on weekends, he could follow the career of painting for which he had been trained. He was fascinated by the strong forms of Bucks County barns, which he saw as patterns of cleanly defined intersecting planes, photographing and painting them with the precision of a scientist and the sensibility of a poet. He made photographs of African

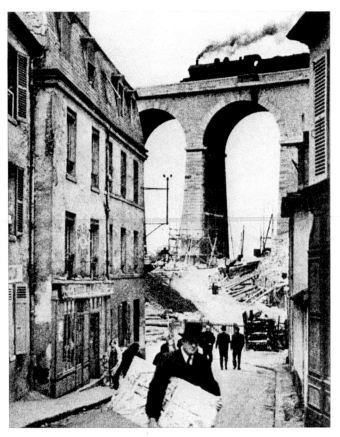

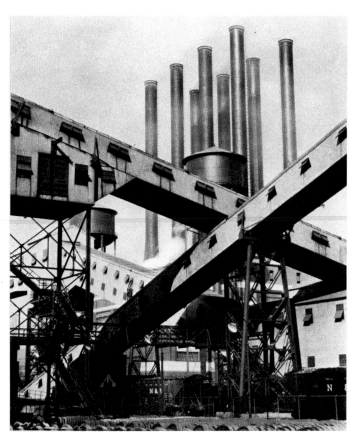

André Kertesz: *Meudon* (above). 1928;
Mondrian's Studio, Paris (below). 1926. Magnum Photos

Charles Sheeler. *Ford Plant, River Rouge*. 1927

primitive sculptures and of industrial scenes, and, in 1921, collaborated with Paul Strand in creating the film *Manhatta*, which proclaimed the pride, energy, scale, and geometric order of the modern urban metropolis. This joint effort was instrumental in securing Sheeler a Ford Motor Company assignment to photograph the huge River Rouge plant and its workings. Few images of the industrial scene can match Sheeler's River Rouge images for majesty and power.

Few new talents appeared in Europe during the years that marked the advent of Strand and Sheeler; the young men of the Old World were again at war. The novel spirit in photography continued to be represented by such veterans as Emerson and Evans. Unheralded and unsung, Eugène Atget—two years older than Emerson—was making a vast and uncompromisingly real report on Paris's streets, streetwalkers, windows, courtyards, street hawkers, and corner circuses.

New European talents, however, appeared in vast numbers in the 1920s and promptly proceeded to make up for lost time. The spirit already manifest in Strand and Sheeler began to appear in Germany in the photographs of the *Neue Sachlichkeit*—the New Realism movement—notably in the straightforward, unretouched, aggressively close-up views of objects of our common perception. Some of the best of these were taken by Albert Renger-Patsch and August Sander.

80

Stieglitz: An American Legend

THERE ARE SOME EARLY PHOTOGRAPHS by Alfred Stieglitz (1864–1946) that are poetic gems, superb pictures which, more than fifty years later, hold their own as works of graphic art. Repeated viewings do not dull their aesthetic impact—barren trees bordering a Munich road in November 1885; Paula intently writing a letter in Berlin, the summer of 1889; a Fifth Avenue horse car at the terminal in the snowstorm of 1893; sparkling wet streets at night taken in 1896 in front of New York's Plaza Hotel; delicate, budding leaves of a young tree, and an unconcerned sweeper on a soft street in *Spring Showers* of 1902; and, closing this portfolio of everlasting appealing photographs, *The Steerage* of 1907.

In the beginning, in 1890, when Stieglitz had just returned to his native land after eight years in Germany where he had forsaken the study of engineering for photography, New York first exerted its power over him. He then revealed through his pictures his imaginative response to such exciting visual stimuli. It was not reportage that he created with his camera, although his work was strikingly honest; through his cultivated eye and comprehensive technique it went beyond the limited validity of a mere record.

Stieglitz was to say in later years, "I have found my subjects within sixty yards of my door," and he spoke of the "exploration of the familiar." In 1890 these thoughts were revolutionary. Those were the days of sentimental genre pictures, composite and "high art" photographs, which Dr. P. H. Emerson, the author of *Naturalistic Photography*, had attacked in London but which were still the criteria of excellence in New York's camera clubs, where such artificial images hung on the line in every annual arty salon.

Whenever he had a free moment Stieglitz stalked the streets with his hand-held "detective camera." He took straight pictures; he did not retouch, enlarge, or indulge in any camera tricks. In this he followed Dr. P. H. Emerson, who in 1887 had given Stieglitz his first bit of encouragement by awarding him two guineas and

Alfred Stieglitz. *November Days, Munich*. 1885.
The Art Institute of Chicago. Stieglitz Collection

a silver medal. This was the first of 150 medals Stieglitz was to win in the early 1890s, at a time when he was advocating the abolition of the medal system.

Stieglitz joined the Society of Amateur Photographers and became editor of their publication, *The American Amateur Photographer*. He advocated pictorial photography and recommended a new annual photographic salon without prizes or medals. The So-

Alfred Stieglitz: *Paula, Berlin* (top). 1889;
The Terminal (above). 1893.
The Art Institute of Chicago. Stieglitz Collection

Camera Notes and founded the Photo-Secession group along with John G. Bullock, William B. Dyer, Frank Eugene, Dallett Fuguet, Gertrude Käsebier, Joseph T. Keiley, Robert S. Redfield, Eva Watson Schutze, Edward J. Steichen, Edmund Stirling, John Francis Strauss, and Clarence H. White. The official organ of the group was *Camera Work* with Stieglitz as editor and publisher and Keiley, Fuguet, and Strauss as associate editors. The purpose as outlined in the prospectus of Photo-Secession was "to hold together those Americans devoted to pictorial photography . . . to exhibit the best that has been accomplished by its members or other photographers and above all to dignify that profession until recently looked upon as a trade."

Its purposes were similar to the Linked Ring in London. In 1905 Photo-Secession opened the Little Gallery, designed by Steichen, at 291 Fifth Avenue in New York. Stieglitz was the director. For the next twelve years photographs by the members vied with paintings and drawings by Matisse, Marin, Hartley, Weber, Rousseau, Renoir, Cézanne, Manet, Picasso, Braque, Picabia, Dove, and O'Keeffe, sculpture by Rodin and Brancusi, Japanese prints and African Negro carvings. Many of these artists were shown for the first time in America, years before the shattering Armory Show of 1913 and long before any American museum purchased a sculpture by Brancusi or a painting by Picasso.

In 1910 the Albright Art Gallery in Buffalo, New York, fell to the persuasive blandishments of Stieglitz, turning the museum over to Photo-Secession for an international exhibition of pictorial photography. Five hundred photographs ranging in treatment from pictorial realism to imitation painting were installed on specially prepared walls. Fifteen were purchased for the museum's permanent collection. An important battle had been won, for official and dignified recognition. Photographers rejoiced, but under Stieglitz, who footed all its bills and found himself short of funds, "291," the Little Gallery, devoted more time to art exhibitions that helped defray expenses.

Camera Work also devoted more space to reproductions of artists' works plus articles and a box-score reprint of all that the newspaper art critics wrote about any art exhibition at "291." Reproductions by photogravure of paintings and photographs appeared regularly. Some photographers, particularly Stieglitz in America and Emerson in England, preferred this commercial form of printing for any large edition of prints. It was a short-lived contention of Stieglitz at this time that only one perfect print could be made from a negative, thereby claiming uniqueness for a photograph as for a painting.

What and who was original was aired in every issue, and Stieglitz, brilliant editor that he was, gave each writer, photographer, and artist the right to discover new and personal paths. It was a costly publication. The finest of paper and type faces, hand-pulled gravure

ciety and the New York Camera Club combined in 1897 to form The Camera Club; Stieglitz was elected vice-president and editor of its publication, *Camera Notes*. That year he saw published his first portfolio of photographs, *Picturesque Bits of New York*.

Losing patience with the stubborn conservatism of The Camera Club, Stieglitz resigned the editorship of

reproductions on "rice silk" paper tipped into each issue, and expensive individual designing of each page, made it hardly profitable to publish. The original price was $4 for an annual subscription of four issues. Toward the end it was $8 a year, but, by 1917, when publication was suspended, there were less than forty subscribers. One of the country's most distinguished magazines had folded, and soon "291" closed its doors.

Stieglitz's photographs of his friends, the artists of his gallery—John Marin, Arthur Dove, Marsden Hartley, Georgia O'Keeffe, Charles Demuth—were clear and incisive, brilliant characterizations. During the eight-year interval between the closing of "291" and the opening of Stieglitz's Intimate Gallery in 1925, the highlights of his own career were impressively manifested in three retrospective exhibitions, among them a show of prints from 1886–1921 at the Mitchell Kennerly Gallery in New York. The press extolled their virtues. In the catalogue Stieglitz's statement read in part, "My ideal is to achieve the ability to produce numberless prints from each negative, prints all significantly alive, yet indistinguishably alike."

Stieglitz continued to extend his concepts of photography, re-evaluating his work according to the contemporary requirement of using the full negative sharply. In the new Intimate Gallery he sponsored and exhibited the work of Paul Strand, a photographer of brilliant promise he had added to his roster. In 1924 Stieglitz married Georgia O'Keeffe. That same year the Boston Museum of Fine Arts acquired twenty-seven of his photographs and the Royal Photographic Society awarded him the Progress Medal.

In 1930 he opened An American Place at 509 Madison Avenue in room 1710. His camera lay idle most of the time; he had suffered a heart attack and rarely left the gallery. He saw the artists whom he had handled become accepted internationally and their work enter the nation's major museums.

In his lifetime Alfred Stieglitz was a legendary personality, so much so that twelve years before his death he was eulogized in a published collective panegyric portrait. Stieglitz has remained a powerful figure in the annals of American art, and the sustained interest of people today in viewing his prints—in the museums throughout the country to which Georgia O'Keeffe donated his life production for posterity—is evidence of Stieglitz's universal recognition as one of America's pre-eminent photographers.

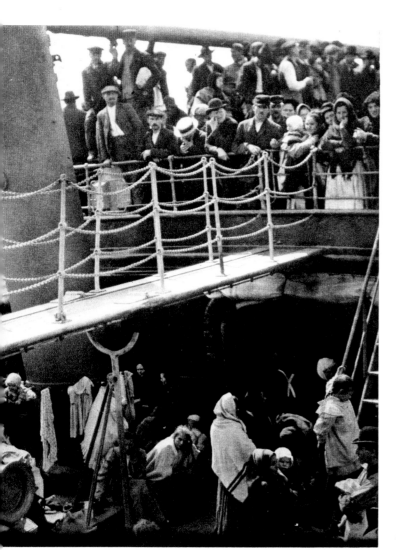

Alfred Stieglitz. *Reflections at Night* (above). 1896.
Collection Peter Pollack

Alfred Stieglitz. *Steerage*. 1907.
The Art Institute of Chicago. Stieglitz Collection

83

Steichen: Painter, Photographer, Curator

Joan Miller. *Edward Steichen*. 1963.
The Museum of Modern Art, New York

EDWARD STEICHEN was born in Luxembourg in 1879 and raised in Wisconsin, for the family soon moved to Milwaukee. At the age of fourteen he went to Chicago to see the art and photography exhibitions at the World's Columbian Exposition. He was going to be a painter. During the next several years he sent canvases to the Art Institute of Chicago's annual exhibitions, but not one was accepted. He took a job as illustrator in a lithography plant. He made snapshots of people and photographs for advertising. One sold. Again he submitted pictures to the Art Institute. This time they were photographs and they were accepted by a jury that included Alfred Stieglitz and Clarence White. Stieglitz and White were impressed with a photograph entitled *The Pool*, which Stieglitz bought two years later and called a "masterpiece" (a term art critics accused photographers of using quite casually).

Milwaukee could not hold Steichen much longer after this bit of encouragement. He went to see Stieglitz in New York soon after the turn of the century. The following year he was in London photographing George Bernard Shaw.

Then Steichen was in Paris. In 1902 he entered two paintings in the Paris Salon, and also sent a bunch of photographs labeled drawings, but the jury rejected these just before the opening—not, they explained, because they were not as good as the paintings but because they feared an avalanche of photo entries.

Steichen returned to the United States in 1902. He designed the Photo-Secession Gallery, "291." Stieglitz bought prints from him, paying him $50 to $100 each. Stieglitz demanded respect for photography and he demanded a price for photographs. Advertisers not only paid handsomely for the use of photographs; they had to insure the print against the slightest smudge of the printer's thumb.

Stieglitz exhibited and sold Steichen's paintings and photographs. The usual price was $50 or $60 per print, but for the portraits of Theodore Roosevelt and William Howard Taft a national magazine paid $500 each for the privilege to reproduce them. In the first issue of *Camera Work*, January, 1903, Steichen wrote a statement on "ye fakers," claiming that all artists take liberties with reality and "fake" or make a picture. In the second issue of *Camera Work*, three months later, eight of Steichen's photographs were reproduced, with a tribute to him and his work written by the Japanese-Irish-American art critic, Sadakichi Hartmann. Stieglitz published a Steichen supplement in the April,

1906, issue, reproducing sixteen photographs by photogravure, one in two colors, and in the following issue published a three-color reproduction of a powerful portrait of G. B. Shaw by Steichen.

An American art critic, Fitzgerald of *The New York Evening Sun*, wrote, "I am ignorant whether Eduard [he spelled it with a "u" until after World War I] Steichen is more painter or photographer."

In 1908 Steichen was again in France, this time for a sojourn of six years.

World War I changed his life. He returned to the States. During the Second Battle of the Marne he was appointed technical adviser of the army's aerial photographic services. Here was the end of the gum prints; the arty, fuzzy photograph was a thing of the past. Sharp and brilliant detail was required; photographs had to be so clearly defined that everything could be recognized from aerial views. Lives depended on it. The army taught Colonel Steichen a new way of photography.

He took a year out after his discharge to experiment with straight photography. He photographed a white

Edward Steichen. *Swanson*. 1925. For *Vanity Fair*. The Museum of Modern Art, New York

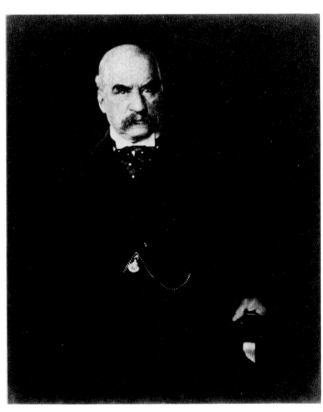

Edward Steichen. *J. P. Morgan*. c. 1903. This is Steichen's most famous portrait. It was commissioned by the artist Carlos Baca-Flor, who did a painting of Morgan that he based on the photograph; the painting now lies forgotten in a storage bin. The highlight on the arm of the chair resembles a poised dagger held in the financier's hand. The Metropolitan Museum of Art, New York

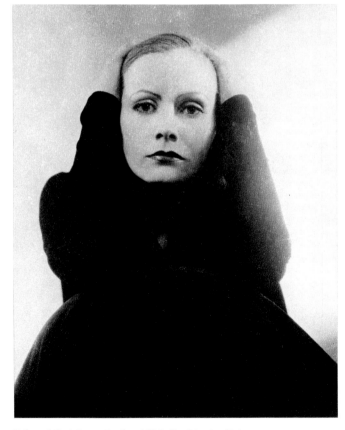

Edward Steichen. *Garbo*. 1928. For *Vanity Fair*. The Museum of Modern Art, New York

cup and saucer against a black velvet background more than a thousand times. He sought perfect control to achieve maximum realism and the faintest, most subtle gradations in white, gray, and black. He put away his brushes, burned his paintings. What he knew of art and design, the keen eye he had developed in painting portraits, now combined with a masterful technique, enabled him to portray forcefully the diverse personalities, the intellectuals and the socially prominent who came to pose.

Elegant fashions and industrial advertising became his forte in photography. He made commercial photographic art pay. In 1923 Frank Crowninshield induced him to join Condé Nast's staff as photographer for *Vogue* and *Vanity Fair.*

The United States Navy in the early days of World War II waived age limitations for Captain Edward Steichen, USNR. His "Road to Victory" photography exhibition, which was shown in Grand Central Station soon after Pearl Harbor, was a powerful force in unifying the nation's will. There was no one better qualified to organize a department with an avowed purpose to photograph the entire war at sea, no matter how long it would take. The record of the men he commanded adds up to a remarkable pictorial account of every engagement of the navy that will be a boon for all future historians.

An army colonel in World War I and a navy captain in World War II, the high-ranking officer Edward Steichen fought his valiant battles with film carried by some of the nation's prized magazine and press photographers. He doffed his uniform to serve as director of photography for The Museum of Modern Art, New York.

He arranged photography exhibitions by creative photographers who used any camera or style they chose. Through his efforts photography as an art form found acceptance among critics and visitors along with paintings and prints. No excessive claims were made for photography; no academic form was insisted upon. Only "good" photographs were eligible for exhibition. This example in free expression for creative photography, inaugurated by Beaumont and Nancy Newhall, Steichen's predecessors at The Museum of Modern Art, and carried forward by him, is now followed by progressive museums all over the country.

"The Family of Man," the most popular photography exhibition ever assembled, was selected by Steichen from among two million prints sent in by photographers from all over the world, and was on tour for five years.

In 1960, at the age of eighty, Steichen married for the third time. He once said, "Boredom and disinterest and lack of awareness are what characterize a superannuated mind, no matter what the chronological age may be. Happily growth is not something for children only." In 1964, the Edward Steichen Photography Center was established at The Museum of Modern Art.

Edward Steichen died on March 25, 1973, two days before his ninety-fourth birthday.

Lartigue: Boy Photographer
of La Belle Époque

THE CLEAR, UNWAVERING VISION of childhood is one of the qualities most longed for by mature artists. Lartigue, as a photographer, has this vision—he has shared it with children, for he *was* a child. Even in his first photographs, his technique was precociously accomplished and mature, and, happily, was used not in aping the photographer's elders but in recording the innocent, miraculous seeing of childhood. In consequence, the world was rewarded with a unique set of images, unsurpassed for authenticity and freshness.

Jacques-Henri Lartigue was born in the 1890s, that elegant decade which saw the flowering of the *Art*

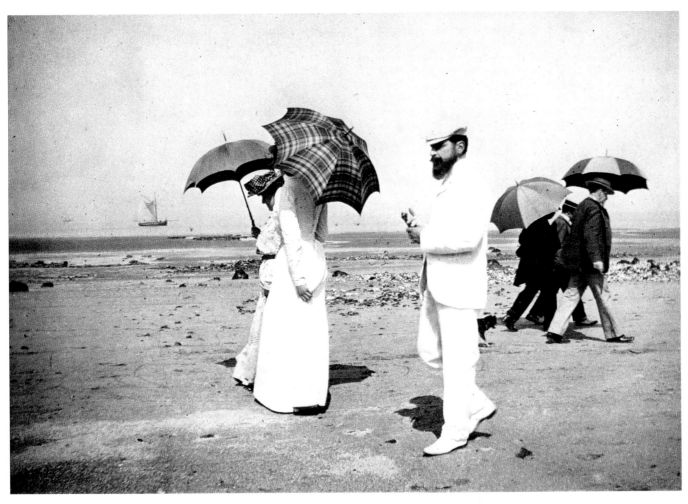

Jacques-Henri Lartigue. *The Beach at Villerville*. 1908. Rapho-Guillumette Pictures, Paris and New York

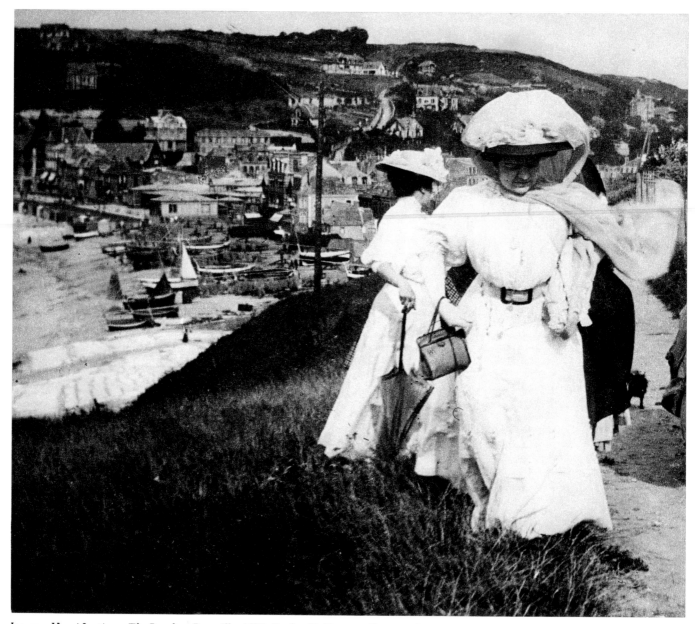

Jacques-Henri Lartigue. *The Beach at Pourville*. 1908. Rapho-Guillumette Pictures, Paris and New York

Nouveau style in the arts and decoration. Its impulses had still not subsided in 1903, when the seven-year-old Lartigue was given his first camera, and were not to disappear until the disastrous reality of World War I would close the prewar world forever. Meanwhile, some of the finest photographs recording the wit and sense-bound happiness of the period were to come from the camera of that little boy.

He was much too young to take the aging "grand horizontals" at Maxim's, but the exquisite gowns of the women in his family hint at the colorful décolleté that couturiers conceived for the ladies of prewar Europe.

The ladies were but one of Lartigue's interests. The activities of his exuberant family were the center of his life—his brothers and cousins cavorting on homemade aquatic vehicles or playing in the pond at his father's large estate in Corbevoie. Everything he and his family

did at home or on vacations, accompanied by swarms of relatives and servants, he took with the ever-better cameras and equipment that he acquired between his eighth and twenty-first year, when he gave up photography temporarily for easel painting. The keenness of his insight and brilliance of his observation of people, things, and places seemed to come to an end when he started to work out his aesthetic problems on canvas.

Among the many books of Lartigue's photographs that have been published, one hundred and sixty photographs taken between 1904 and 1914, together with his comments, were included in the 1966 book *Boyhood Photographs of J.-H. Lartigue: The Family Album of the Gilded Age*. Three years earlier, forty-two of the photographs had been shown at The Museum of Modern Art, New York, after having been left forgotten in a closet for half a century.

Atget and the Streets of Paris

EUGÈNE ATGET TURNED TO the camera in 1898, when he was forty-two years old. For a decade he had tried to be an actor, playing bit parts in the provinces of France and the suburbs of Paris. He seems hardly to have been the matinée-idol type, this taciturn man who had shipped out as a cabin boy at thirteen and had followed the sea for more than fifteen years before putting on greasepaint.

With the decision to leave the stage came the necessity of finding work to support himself and an ailing wife ten years his senior. He tried painting for a year, but this was not the answer; he wanted to record everything that he felt was of importance in Paris and for this

Eugène Atget. *Wellhead, Paris*. c. 1910.
George Eastman House, Rochester, New York

the brush was inadequate. He acquired a heavy, bulky view camera with a simple and not very sharp lens; it never left the tripod on which he mounted it. For the next twenty-nine years, until he died in 1927, Atget photographed as realistically as possible whatever appealed to him in his beloved Paris. He would carry his cumbersome equipment, traveling by bus in all seasons of the year, often before dawn, to capture the morning light on the silent streets. All districts knew this wizened man, his hands and especially his fingernails permanently blackened by photographers' chemicals, who

Eugène Atget. *Street Circus, Paris*. c. 1910.
George Eastman House, Rochester, New York

Eugène Atget.
*Girl in the Doorway of a
Brothel, Paris*. c. 1920.
George Eastman House,
Rochester, New York

was seen standing in a long, stained overcoat, pockets bulging with plate holders for his large 7¼-by-9¼-inch negatives.

He photographed with remarkable clarity of detail, making a graphic historical record of his personal and often poetic vision. Critics have since referred to him as "the Walt Whitman of the camera." He made a precarious livelihood by taking commissions from authors—for a book on prostitution he made photographs of brothels in Paris, and for the French Archives he made a series of documentary photographs of historical buildings and medieval statuary—and to the artists of Paris he made available photographs of a thousand subjects. On the ground floor of the building where he had a fifth-floor apartment and darkroom he placed a

sign, "Atget—Documents for Artists." Braque and Utrillo were the first to buy some of his prints at his very reasonable prices. Atget was so proud to see his photographs being used by the artists, serving as the artists' memory, as substitutes for detail drawings or pictures of the mood and atmosphere of a given scene that the artist was painting.

The painter and photographer Man Ray introduced Atget to the Surrealists and to Berenice Abbott, who was working for him in Paris. She photographed Atget (still in his long coat but quite unexpectedly with face washed and hair slicked down for the occasion) in 1927, shortly before he died. After his death she rescued most of the eight thousand or so negatives that constituted his life's work.

Riis and Hine:
Social Idealists with the Camera

JACOB A. RIIS

LIKE THE PAMPHLETS OF VOLTAIRE, the photographs of Jacob A. Riis (1849–1914) helped to start a revolution. The revolt in New York in 1887 was against the wretched slums, the degrading tenements, and the venal corruption that permitted this misery to exist. Riis, America's first journalist-photographer, was a police reporter for *The Evening Sun*. His writing was convincing, but his camera was decisive in making his work an incontrovertibly powerful weapon. Riis knew the underprivileged. In 1890 he wrote *How the Other Half Lives*, a book about his observations in the overcrowded, diseased, and criminally dark tenements which Lord Bryce in his *American Commonwealth* had called "the conspicuous failure of the city."

Riis was one of the first to use flash when it was introduced in the United States. This consisted of a mixture of powdered magnesium and potassium chlorate; it was first manufactured as cartridges to be used in what appeared to be a pistol. Because it brought out many a concealed weapon of those he would photograph, Riis soon substituted a frying pan to hold the powder which he ignited by hand. It burned in a blinding flash and exploded in the air; Riis photographed, and, amid the resulting dense smoke, grabbed camera and tripod and ran. In this way he recorded the *Mulberry Bend Hideout* under a bridge, *Lodgings in Pell Street*, and *The East Side Growler Gang*.

Riis poked his camera into every unsavory street, into the most unattractive, unglamorous facets of the great city. His pictures and stories appeared in *The Sun*; he made slides of his photographs that he used in lectures; he wrote magazine articles and books. He was to see nine books published altogether, including *Children of the Poor*, 1892; *Out of Mulberry Street*, 1898; *Battle with the Slums*, 1902; and *Children of the Tenements* and *Theodore Roosevelt, the Citizen*, 1904.

Jacob A. Riis. *The Street, the Children's Only Playground*. 1892. Photograph made by John H. Heffren from the original Riis negative. The Museum of the City of New York

LEWIS W. HINE

LEWIS WICKES HINE (1874–1940) was born in Oshkosh, Wisconsin. As a boy he worked long hours in a factory, learning firsthand what he was to photograph later. He studied at the State Normal School in his home town, then attended the University of Chicago and New York University, from which he received a master's degree.

In 1901 Hine went to teach at the Ethical Culture School in New York. Two years later he acquired a camera and flash gun. He learned to control his equipment through trial and error as he took photographs intended to dramatize the school's program.

He gave up teaching to become a full-time photographer. He became a free-lance conscience with a camera. Ellis Island, New York's port of entry where

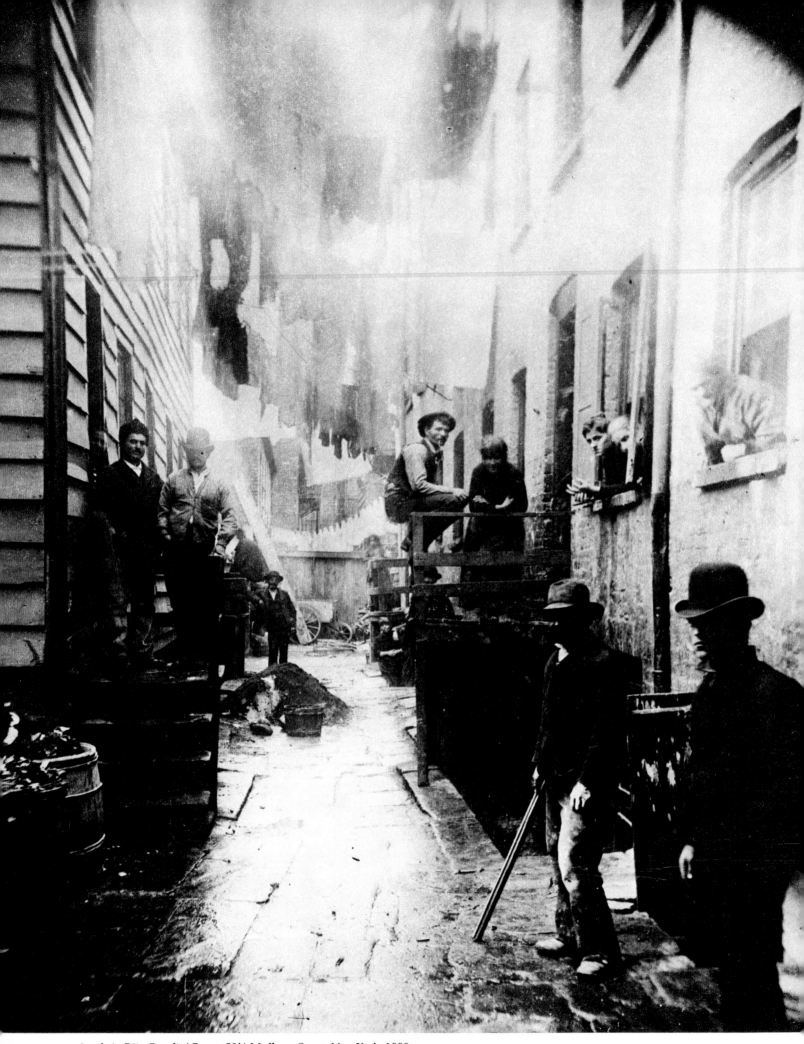

Jacob A. Riis. *Bandits' Roost, 59½ Mulberry Street, New York*. 1888.
Photograph made by John H. Heffren from the original Riis negative. The Museum of the City of New York

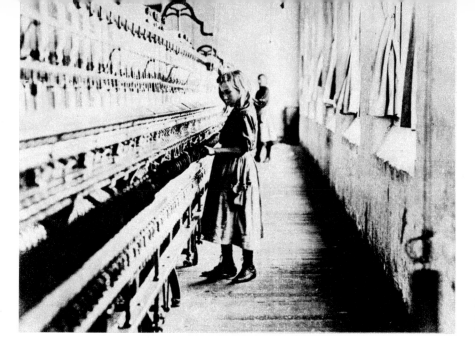

Lewis W. Hine. *Little Spinner
in a Carolina Cotton Mill*. 1909.
George Eastman House, Rochester, New York

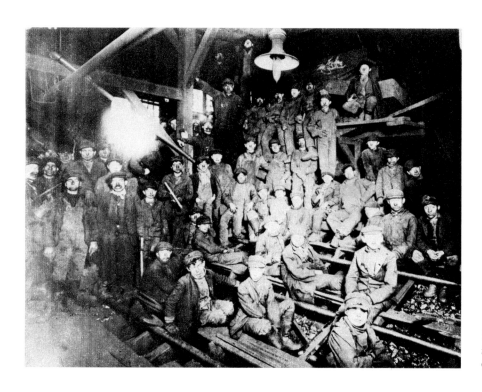

Lewis W. Hine. *Breaker Boys Inside
the Coal Breaker*. 1909.
George Eastman House, Rochester, New York

millions of immigrants first saw the "promised land," drew him to photograph sad-eyed "madonnas" surrounded by their bundles and children. He followed them through the gates into the overcrowded slums, the swarming streets, and the impossible, enslaving jobs. All this he put into sharp focus as a social indictment against the conditions offered its new citizens by the nation's largest and richest city. The magazine *Charities and the Commons* published these pictures in 1908. The same year the magazine's editors hired him to make a complete, sociological study with his camera of miners' lives; a truthful and comprehensive portrayal of their housing, health, children, education, and death, was published as *The Pittsburgh Survey*. Three years later he was appointed staff photographer for the National Child Labor Committee to investigate child-labor conditions existing in the United States. Hine returned with a series of appalling pictures that shocked the country. Children as young as eight years old worked in cotton mills tending machines, were hired as coal breakers in dangerous mines, and sold newspapers in freezing weather late at night. These starving, exploited children had little chance for an education or hope for the future. Hine took notes of what they said and estimated the children's size by marking his vest buttons. He kept a sociological record of their health, their habits, and all he encountered. The nation reacted immediately. His vivid photographs, published as human documents, were strikingly clear. A protective child-labor law was passed. Hine had made the camera into a formidable weapon for social progress.

Genthe: Celebrities and Anonymous Throngs

Arnold Genthe. *Street of Balconies, Chinatown, San Francisco.* c. 1896.
The Art Institute of Chicago

ARNOLD GENTHE (1869–1942) thought he had invented the candid photograph, but what he actually created is as formalized as the portrait technique he so valiantly fought.

For thirty years he took pictures of the world's "great": three presidents—Theodore Roosevelt, William Howard Taft, and Woodrow Wilson; two of the nation's wealthiest men—John D. Rockefeller and Andrew Mellon; many international celebrities of the stage—Bernhardt, Pavlova, Isadora Duncan, Ellen Terry, Greta Garbo, Eleanora Duse; and the highborn everywhere.

Emphasis was on soft focus with velvety blacks and brilliant whites, ideas he took from the chiaroscuro paintings of Rembrandt and Caravaggio. He created what became known as the "Genthe style."

Still, he was a radical with a camera, for he gave it the respect an artist has for his equipment, and he made it work for him creatively. He broke with the muscle-bound traditions, the uniform sharpness, the character-less stiff poses that were typical of photographers of the day, especially in San Francisco, where he opened his first gallery around the turn of the century. Nor did Genthe indulge in the practice prevalent in commercial studios and arty photographic circles of retouching or drawing on a negative.

He was selective, a master in modeling with light, always attempting to capture the poetic mood, thereby creating his conception of a romantic picture. A soft moonglow suffuses all his important portraits. Through film, lens, lighting, and the use of mat paper for printing, the age lines of his sitters were eliminated.

He took his greatest pictures in 1894 when he first arrived in San Francisco's Chinatown, and a little more than a decade later when he photographed the earthquake which destroyed San Francisco. It is for these exceptional, honest pictures, deeply charged with feeling, rather than for the Genthe style of art portraiture that he will be remembered.

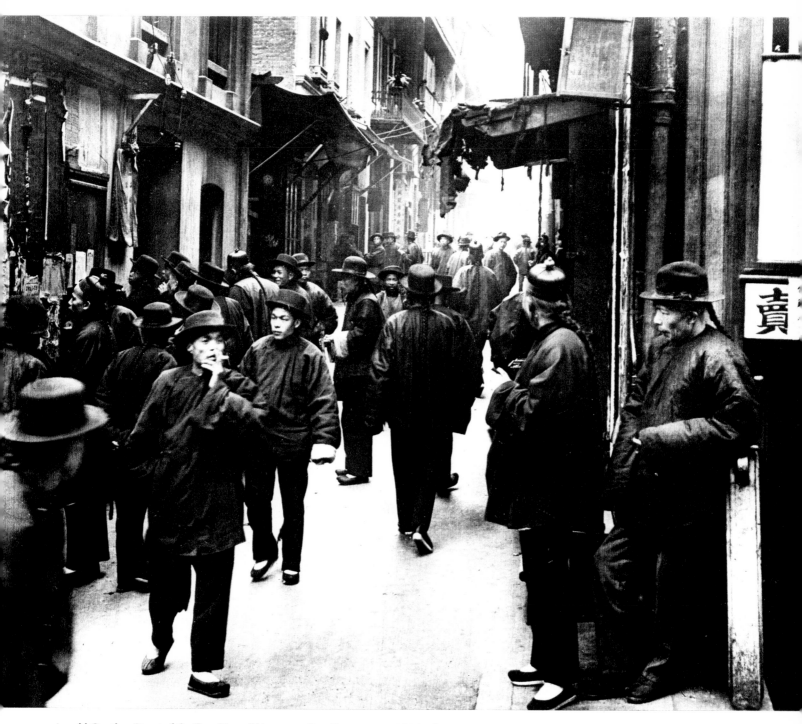

Arnold Genthe. *Street of the Gamblers, Chinatown, San Francisco.* c. 1896. The Art Institute of Chicago

Edward Weston: A New Vision

VERY FEW CREATIVE PHOTOGRAPHERS were trained as cameramen. Most were artists, others teachers, engineers, musicians, writers, or sociologists, following professions which gave them little if any aesthetic satisfaction. Often as mature men they became photographers to experiment and explore a personal way of seeing, to create their kind of a picture.

Edward Weston (1886–1958) is the exception, the rare creative photographer who as a boy definitely knew his destiny. He told me in his cabin near Carmel, California, in 1952, "I saw my first exhibition of photographs at the Art Institute of Chicago exactly fifty years ago when I was sixteen. It changed my whole life. I made father buy me a camera and from that moment on I was absorbed with it."

Three years later, in 1905, he was in California canvassing door to door, hauling a postcard camera, and taking pictures of babies, family groups, marriages, funerals; a dollar a dozen was the usual price. He worked in commercial studios, he studied and mas-

Edward Weston. *Nude on the Beach, California*. 1936. Courtesy Edward Weston, Carmel, California

Edward Weston. *Dunes, Oceano.* 1936.
Courtesy Edward Weston, Carmel, California

tered the intricacies of the darkroom. Portrait photography was to be his livelihood.

He married in 1909 and in the next decade fathered four sons. In 1911 he opened a portrait studio in Tropico, California. He specialized in portraits of children and he started to use natural light inside his studio. Soon Weston became a name to reckon with in portrait and pictorial photography. Honors were heaped upon him; he was elected to the London Salon and, closer to home, he demonstrated and lectured on his techniques. One-man shows added to his reputation but his soft-focus "arty" photographs, so acclaimed by the amateur and the camera clubs, left him feeling empty and unsatisfied. He knew that the pictures were tricky, but what qualities he wanted to capture with his camera he still did not know.

Had it not been for the San Francisco Fair of 1915, where Weston was introduced to modern art, creative music, and contemporary literature, he might have continued to photograph "exalted portraits" to meet the financial demands of his growing family. Under the stimulus of abstract art Weston generated a creative response within himself. He broke with his former success; he no longer submitted his pictures to the salons.

Weston went back to his camera. He experimented constantly with the extreme close-up and the abstraction. He created heightened effects in shadows by mixing artificial and natural light and he photographed fragments of the figure rather than the entire body.

Beginning in 1922 in Ohio, he made the first of his dramatic compositions revealing the clear forms and

Edward Weston. *Church Door, Hornitos.* 1940. Courtesy Edward Weston, Carmel, California

rhythms inherent in the great manufacturing plants of American industry. The abstract designs to be found in the substantial reality of architecture which Weston disclosed in his photographs immediately influenced photographers, who still exploit his conception.

August 2, 1923, on board ship from New York to Mexico, Weston made a first entry in his Day Book: "Certainly it is not to escape myself that I am Mexico bound... I am good friends with myself. Nor do I hunt new subject matter, that is at hand out the back door—anywhere... I feel a battle ahead to avoid being swept away by the picturesque, the romantic."

By January of the next year he recorded, "I am now only approaching an attainment in photography that in my ego of several years ago I thought I had reached long ago. It will be necessary to destroy, unlearn and rebuild."

Weston loved the country, the landscape, the people, and the art world of which he had become a vital part, but Mexico couldn't keep him; his roots were to the north. In January, 1927, he wrote, "During these three months since returning to California I have done

nothing for myself... I am not yet an integral part of these surroundings, one foot is still in Mexico."

The following summer he and his son Brett closed their portrait studio in San Francisco and moved south to Carmel in the mountains near Monterey. With his 8-by-10-inch view camera he was soon out taking pictures of tangled tree stumps, eroded rocks, and the sea at Point Lobos which his poet friend, Robinson Jeffers, had described as "strange, introverted and storm-twisted." It had a beauty that stamped itself on his emotions, resulting in a series of his most exciting photographs of nature.

He took his camera into the huge ranches of southern California shooting orchards and fields, geometric patterns of growing things, monumental vistas instead of close-ups, paying as much attention to the forms and the composition as he had to a single pepper or to a nude figure. He discovered the sand dunes at Oceano with their long undulating shapes, soft rounded forms, deep black shadows, and myriads of textured sands; here he made what many consider to be his greatest pictures.

Lensless Photography

ABSTRACT PHOTOGRAPHY took on importance when men of creative vision began to focus on relations between things rather than on the things themselves —not people, trees, flowers, animals, clouds, and rivers, but pattern and form, line and volume, texture and shape. The pioneers of this shift in seeing were the advanced painters of the 1880s and 1890s. The great liberating movements in photography during the next decades made similar experimentation in the photographic medium inevitable.

Between 1910 and 1920 Sheeler and Strand, with their geometric conception of landscape and the city scene, took major steps toward abstract photographic vision, although neither man went so far as to detach the formal relations of the seen world from the subjects that he photographed.

Alvin Langdon Coburn's "Vortographs," kaleidoscopic patterns produced as early as 1917, may well have been the first completely nonobjective photographic images. The painter-photographer Christian Schad, in 1918, imposed scraps of paper and other flat shapes on photosensitive paper, producing Cubist compositions by this means and anticipating by several years the more complicated lensless images of Moholy-Nagy and Man Ray. There were nineteenth-century precedents for Schad's techniques—if not for its Cubist aesthetic vision—notably Fox Talbot's "photogenic drawings" and the *cliché verre* glass prints made by Corot, Millet, Daubigny, and various other French painters of the Barbizon School.

Shortly after World War I, Man Ray, an American artist living in Paris, began to explore the manipulative aspects of darkroom technique and artificial-light control, in some instances achieving interesting transformations of the normal photographic image and in others creating light paintings, as it were, along the lines of Christian Schad's "Schadograph." Man Ray's "Rayographs" were richer and more complex than Schad's experimental images, for Ray's system added

Christian Schad. *Schadograph 52.* 1919.
Schad soon dropped titles and merely
numbered his compositions

beams and moving pencils of light to Schad's simpler technique of spreading objects on photographic papers.

In Germany, during the 1920s, the boundaries of photographs were boldly extended to take in vast new areas of abstract and applied photography. In the Bauhaus at Dessau, the great school for artists and designers and the center for basic experiments in every field of the visual arts, the camera was valued as an instrument for creative imagery. These images were used as elements in constructing designs for exhibi-

Man Ray. *Rayograph*. 1923. The Museum of Modern Art, New York. Gift of James Thrall Soby

Man Ray. *Rayograph*. 1926. The Museum of Modern Art, New York. Gift of James Thrall Soby

tions, photomurals, posters, advertising, layout, and typography; they became a new photographic vocabulary used to communicate ideas. Such uses, commonplace today, were first conceived by the Bauhaus group before 1930. Since then, applied photography has become firmly woven into our daily life.

The moving spirit in Bauhaus photography was László Moholy-Nagy, born in Hungary in 1895. Moholy taught at the Bauhaus during the years 1923–28. He came to the United States in 1937, and from that time until his death in 1946 he was director of the New Bauhaus, Chicago (later called The Institute of Design and now a division of the Illinois Institute of Technology).

Moholy taught that the photographic image should be a fresh, original interpretation of visual experience, and he himself created many abstract photographs, inspired by—and in turn inspiring—abstract painting. He was among the first to create the kind of image, made without using the camera, known as the photogram: an abstract photographic print made by placing

opaque objects and those of varying degrees of transparency on a sheet of sensitive paper, "painting" the subject with a flashlight, and developing to secure a single print. The cast shadows created by the flashlight enriched and unified the pattern and added the illusion of a third dimension.

György Kepes, simultaneously with Man Ray and Moholy-Nagy, experimented with the photogram in the late 1920s shortly after his graduation from the National Academy of Fine Arts, Budapest. He worked with Moholy in Berlin, went to London, and in 1937 came to America. He was a cofounder with Moholy of the New Bauhaus in Chicago. At present he is director of the Center for Advanced Visual Studies at Massachusetts Institute of Technology. A versatile and wide-ranging designer, artist, and writer, he is also one of the most influential teachers of his generation in many areas of design. Both as artist and as teacher he has contributed greatly to an understanding of light and color as the means of evoking emotional response, despite the elimination of representational images.

László Moholy-Nagy. *From the Radio Tower, Berlin*. 1928.
The Museum of Modern Art, New York

Alvin Langdon Coburn. *The Octopus, New York*. 1913.
George Eastman House, Rochester, New York

György Kepes.
Light Texture. 1950

Roy Stryker: Documentaries for Government and Industry

DURING THE DEPRESSION Roy E. Stryker, an inspired teacher, used photographs as visual aids for teaching the entire nation something about the somber, seamy existence endured by Americans residing in rural slums. In 1935, when Professor Rexford Tugwell was head of the Resettlement Administration (R.A.), he called on his former student, Roy Stryker, to head a new photography project intended for the Farm Security Administration (F.S.A.), the alphabetical successor to the R.A. Stryker left the sheltered academic life of Columbia University, where he had been teaching, for the three-ring circus of politicians, idealists, and brain-trusters then starring in the marble tents of Washington, D.C.

F.S.A. became a vigorous factor in presenting the truth, creating indignation at the plight of the migrant worker, and propagandizing for a break in the destructive grip in which economics and the elements held the marginal farmer.

The sensitivity of the photographers whom Stryker hired, combined with his own sympathy for the farmer and his keen interest in providing effective pictures for the nation's press, produced in time a series of truly remarkable documentary photographs. These are dramatically organized around a central idea, and are penetrating interpretations of how people fared on the land.

Some of today's best-known names in documentary and journalistic photography joined his staff—Ben Shahn (more famous as a painter), Edwin Rosskam, Walker Evans, Dorothea Lange, Arthur Rothstein, Carl Mydans, Marjorie Collins, Russell Lee, John Vachon, Gordon Roger Parks, Marion Post Wolcott, and Jack Delano. They took a composite picture of the country that was a revelation to the nation of how the "submerged third" existed.

Some F.S.A. photographs remain great pictures today. They are symbols of that terrible time in America, and harbingers of what may beset the nation again if people are not wary. Arthur Rothstein's photograph of an Oklahoma farmer and his children fighting their

Dorothea Lange. *California*. 1936. Library of Congress, Washington, D.C. Farm Security Administration Collection

way through a gritty duststorm never fails to elicit an emotional response, nor does Walker Evans's child's grave, a picture of a saucer burial taken in Alabama, or Jack Delano's Negro family in a rural house in Georgia. John Steinbeck credited Dorothea Lange's studies of the Okies and other migrants with inspiring his classic novel *The Grapes of Wrath*.

In the eight years of the F.S.A.'s existence, more than 200,000 photographs (all now in the Library of Congress) entered F.S.A. files, ranging in subject matter from courthouses, crops, and culture to churches, criminals, and farm workers. Roy Stryker inspired the photographers "to give their fraction of a second's exposure to the integrity of truth."

Arthur Rothstein. *A Farmer and His Sons Walking in a Dust Storm, Cimarron, Oklahoma*. 1936.
Library of Congress, Washington, D.C. Farm Security Administration Collection

Walker Evans. *A Child's Grave, Alabama*. 1936.
Library of Congress, Washington, D.C. Farm Security Administration Collection

Ansel Adams: Interpreter of Nature

IN A TIME when so much in modern art escapes the understanding of the great majority of humanity, the incredibly skillful photographs of Ansel Adams exert a tremendous appeal whenever they are exhibited in the nation's museums.

Adams's best photographs represent the aspirations held by innumerable pictorial cameramen all over the world, amateur and professional. Ansel Adams's dis-tinction is in the sensitivity and poetry that he intro-duces into his photographs and in the control that he maintains over his medium through his formidable scientific knowledge. He is the founder of a complex "zone system of planned photography." This system separates tonal values of subjects according to "zones" or levels and, after readings are taken with a light meter, provides the photographer with step-by-step guidance

Ansel Adams. *Mount Williamson, from Manzanar, California*. 1943. Collection Ansel Adams, San Francisco

Ansel Adams. *Moonrise, Hernandez, New Mexico*. 1941. Collection Ansel Adams, San Francisco

in exposure, development, and printing, to achieve a predetermined structure of tones.

Several of his finest photographs go far beyond the purely visual and the technically perfect. These are idealizations of nature that border on the profoundly spiritual. Were it not for his inherent deep feeling for the exalted landscape of the West, feeling that he instills into his works, his photographs would be merely the best obtainable in picture postcards. It is the sensitive, interpretive seeing of Ansel Adams, who constructs his photographs as pictorial architecture, that carries him far beyond ordinary photographers.

Recognition of the object is always important in Ansel Adams's work, organized though it is in decorative patterns with countless details. Abstraction and

transformation of the object, the core of strikingness and power in modern art and photography, are alien to Adams's purpose. Adams's later photographs conceived in all-over textures and patterns of leaves, ferns, trees, stones, and boards can be compared to musical sonatas and fugues. They are less complex in composition than his earlier elaborate pictures of imposing mountainous landscapes inspired by soaring symphonies.

A skilled musician, an erudite naturalist, a gifted writer and teacher, and an exuberant, warm personality, Ansel Adams willingly embraces the term "photographer" as belonging to a noble profession. This profession, he once wrote, "is deserving of attention and respect equal to that accorded painting, literature, music and architecture."

Masters of the Miniature Camera:
Salomon and Eisenstaedt

MODERN PHOTOJOURNALISM became possible with the invention of the miniature camera. The advent of the 35-millimeter Leica, invented in 1914 and placed on the market in Germany in 1925, brought many significant changes to every branch of photography. It enabled photographers to see commonplace, everyday objects in new and bolder perspectives and extended their ability to apprehend shapes and forms in space.

Behind-the-scenes glimpses of internationally famous political personalities at the League of Nations conferences in the late 1920s were taken by the brilliant multilingual lawyer, Dr. Erich Salomon, one of the first to use a miniature camera for news pictures. It was said of him that there were "just three things necessary for a League of Nations conference: a few Foreign Secretaries, a table, and Dr. Erich Salomon." Magazine and press photographers ever since have followed his unposed candid-camera style as an ideal.

Dr. Salomon was an audacious as well as ingenious photographer. He conceived a bagful of tricks to circumvent the "photographs forbidden" signs put up at all political meetings during the 1920s and 1930s. His many subterfuges included cutting a hole in his derby hat for a concealed lens or hiding his camera in a large armsling, hollowed-out books, or a flower pot, triggering the shutter by a remote cable release. Dr. Salomon's hunting grounds were not only the conference rooms of international politicians in Geneva, Paris, London, and Washington; he also covered nonpolitical activities, such as murder trials, society balls, and concerts, catching princes, presidents, and chimneysweeps off their guard. He was truly a photohistorian —photography's first—as well as an artist of rare integrity and skill.

When the Nazis destroyed the great publishing house of Ullstein with its three picture magazines, for which men like Dr. Erich Salomon (who died with his family, except for one son, Peter Hunter-Salomon, in

Dr. Erich Salomon: *It's That Salomon Again!* (above). Paris, 1931. Aristide Briand points to the photographer who, he had bet, would get into a secret session of the French Foreign Office; *King Fuad of Egypt and Entourage in the Berlin State Opera Box of President Hindenburg* (below). 1930. Collection Peter Hunter, Amsterdam

Alfred Eisenstaedt.
Feet of an Ethiopian Soldier. 1935.
Courtesy *Life* magazine, © Time, Inc.

Alfred Eisenstaedt. *Nurses Attending a Lecture,*
Roosevelt Hospital, New York. 1937.
Courtesy *Life* magazine, © Time, Inc.

Alfred Eisenstaedt. *La Scala Opera House,*
Milan. 1932.
Courtesy *Life* magazine, © Time, Inc.

the gas chambers of Auschwitz), Alfred Eisenstaedt, Philippe Halsman, and Fritz Goro (all three later worked for *Life* magazine) took celebrated news pictures, an army of brilliant photographers and editors went to all parts of the free world to found magazines that have since become world renowned.

Like Cartier-Bresson and other miniature-camera specialists, Eisenstaedt is a connoisseur of action patterns. He sees the flow of happenings around him as sequences with a beginning, a climax, and end—and he never fails to discern the image or the moment that carries the deepest significance. Many pictures serve their purpose as an illustration or technical experiment and are quickly forgotten. Few photographs by Eisenstaedt are in this class. Very many, on the contrary, become increasingly provocative with each viewing. His best works stir the senses and emotions; they haunt the memory and draw one to view them again and again in order to find fresh associations, new interpretations. Their strength lies in their simplicity of design. Eisenstaedt's portraits clearly reveal the spirit and character of his subjects, whether celebrated or unrenowned. His scenes likewise, in their intimacy, make a viewer a participant, giving him a feeling of being actually present beside the photographer, as in a picture of 1932 showing a lovely dark-haired girl seated in an adjoining box of the beautiful five-tiered La Scala opera house in Milan. It is a suspended moment, just before the conductor lifts his baton and the lights are lowered on a most appealing, festive social scene.

That brilliant, precise style of Eisenstaedt's grew out of his pioneering efforts with small cameras after he had mastered pictorial photography. There is still something of his early, soft, painterly feeling for dense shadows and soft whites to be found in his frank, realistic pictures of today.

Margaret Bourke-White:
Roving Reporter

MARGARET BOURKE-WHITE (1904–1971) discovered the objective reality of any given story, isolated it, and then related each photograph to the totality of the story she envisioned. She created a dynamic journalistic photo essay, a complete story communicating visual insights not only about how the subject looked but about what it said to her.

She sought to picture the environment and the social background of her subjects, their work and their lives. She was aware of their appearance as she was aware of their personalities; the fraction of a second when the picture was taken was alive with meaning. Her purpose was visual communication, immediate recognition for those who see superficially and deeper meanings for the more sagacious. Her way of capturing the image calls forth varying levels of emotional response; her essays are of complex dimensions, new experiences in journalistic photography. Her work is a sort of candid eavesdropping, consciously controlled by the shape of the 35mm film she used.

A graduate of Cornell University, where she had studied biology and philosophy, she found her life's interest in the camera, first as a commercial photographer, then as a photojournalist for magazine publishers, developing photojournalism to a high personal level.

Her career as a photographer was abruptly terminated in 1952, when she was afflicted with Parkinson's disease. She turned to writing her autobiography, *Portrait of Myself*, which was published in 1963. Margaret Bourke-White's agonizing battle with Parkinson's ended at age sixty-seven, on August 27, 1971.

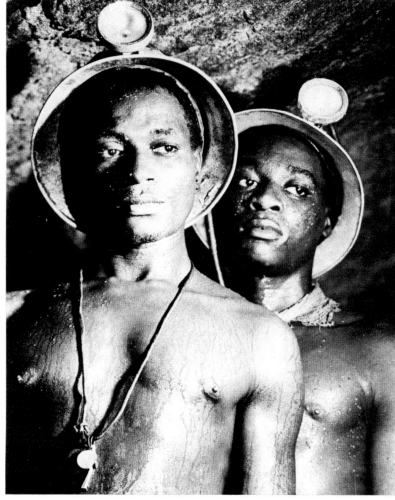

Margaret Bourke-White. *South African Gold Miners, Johannesburg*. 1950.
Courtesy *Life* magazine, © Time, Inc.

Margaret Bourke-White.
Indian Girl. 1948.
Courtesy *Life* magazine, © Time, Inc.

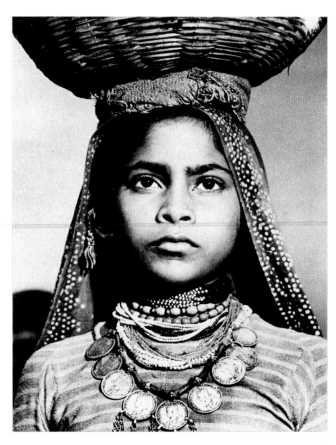

Margaret Bourke-White.
Buchenwald Victims. 1945.
Courtesy *Life* magazine, © Time, Inc.

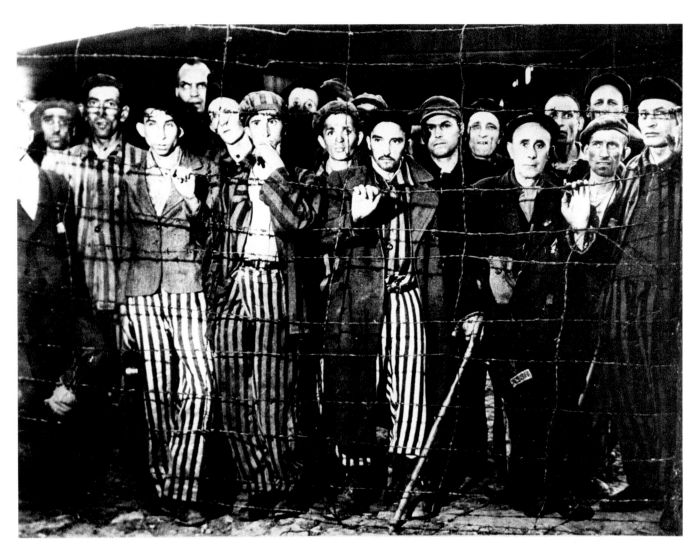

4

Color:
Another Dimension

Exploring the New Horizon

FOR THREE-QUARTERS OF A century before the advent of the new film developed a few years after World War II, color processing was specialized and laborious. Taking a color photograph required three separate negatives, and making a color print on paper required the conversion of three black-and-white negatives into three layers of dyed gelatin, which were assembled in register. The bewildering mass of chemicals and methods kept the great masters of black-and-white photography from turning their talents toward color; they made only a few color photographs. Color photographs, accordingly, belonged almost entirely to the realm of technical and applied photography. They were used in scientific work, advertising, and color reproduction. And all color theory, practical color photography, and color printing had as their most important aim the literal and faithful reproduction of natural color.

All color photography is based upon the principle that every hue can be rendered by a combination of only three "primary" colors. Practical use of this principle was made in the eighteenth century, when inexpensive color mezzotints, after well-known paintings, employed combinations of three basic colors. In 1855, James Clerk Maxwell anticipated color photography by pointing out that primary colors in light could be combined in this manner; in 1861 he projected an image of a tartan ribbon on a screen where three component color images were superimposed. In 1868 Louis Ducos du Hauron in Paris outlined a number of techniques for producing color photographs on paper. These formed the basis for color photography until 1930, when Mannes and Godowsky developed for the movies the Kodachrome method of producing a positive transparency on a single film. In 1938 Kodachrome film and the similar Agfacolor, invented almost simultaneously in Germany, became available to still photography. It was then that the use of color film became widespread, although both Kodachrome and Agfacolor had to be returned by the photographers to the film manufactur-

ers for complicated processing, which involved development, re-exposure, dyeing, and bleaching of all three sensitive coatings on the film. It was Mannes and Godowsky again who invented the reversal film, Ektachrome, which became generally available in 1950 and permitted photographers to do their own color-processing. Kodacolor and Ektacolor soon followed. These were nonreversal materials, which is to say that the exposed film, when developed, was in color, complementary to the colors of the subject photographed. The complementaries were reversed to become the colors of the subject in prints made from Kodacolor and Ektacolor films, just as black-and-white-negative values are reversed in their positive prints. In 1963 Edwin H. Land's 60-second Polacolor material was released by Polaroid. Four years earlier, Land had dethroned the classical three-color theory of color vision, showing that a full-color image is seen by the eye when only a pair of color-separation photos of a subject are superimposed, one of them illuminated by a longer wave length than the other.

The inventive genius of Edwin Land culminated in his SX-70 camera (placed on the market in 1973), which automatically ejected, with the pressing of the electronic shutter button, a 3⅛-inch-square color print that develops itself in front of the photographer's eyes, even in direct sunlight.

Most professionals reduce their "palette" and limit themselves to dark tones accented by some few brilliant beams of colored light. Conscious control of color accidents, deliberate disobedience of the film manufacturer's traffic rules for the purpose of achieving colors contrary to human experience, has become part of the technique of a number of creative photographers, such as Yale Joel, Michael Vaccaro, Fred Lyon, Erwin Blumenfeld, Nina Leen, and Marc Riboud, among others. The overbright color range of the new fast color film is the delight of the amateur seeking ever more realistic snapshots.

Gjon Mili. *Carmen Jones*. 1951. From *The Art and Technique of Color Photography*, edited by Alexander Liberman.
Condé Nast Publications

Ernst Haas: *Manhattan Spires from Brooklyn Junkyard* (left). 1953;
New York Triangle (above). 1965. Courtesy *Life* magazine and Magnum Photos, New York

Hiroshi Hamaya. *Rime on Pine Forest, Mount Zao, Japan*. 1962

Dan Budnick. *Forest of Versailles.* 1960

Dmitri Kessel. *Battle of Hastings Landscape*. 1956. Courtesy *Life* magazine, © Time, Inc.

Philippe Halsman. *Judge Learned Hand*. 1957

Marie Cosindas. *Girl with Flowers: Vivian*. 1966.
Cosindas is a gifted professional photographer whose highly personal and expressive photographs
are taken with the amateur's favorite camera, the Polaroid, and ten-second color film. Avoiding the
highly contrasting colors of Kodachrome, she achieves her unique images through the Polacolor
medium: subtle tones in a low key reminiscent of a daguerreotype tinted by a master miniaturist

Cecil Beaton. *Martita Hunt as the Madwoman of Chaillot*. 1951.
From *The Art and Technique of Color Photography*, edited by Alexander Liberman. Condé Nast Publications

Gordon Parks. *Golden Train, New York*. 1956. Courtesy *Life* magazine, © Time, Inc.

Eliot Elisofon. *Bather in Tahitian Rapids*. 1955. Courtesy *Life* magazine, © Time, Inc.

George Holton. *Penguins*. 1967

Astronaut James A. McDivitt. *The Burnt and Withered Face of African Deserts in the Blue Planet Earth:*
(above left) *Western Sahara, Mauritania – Richat Structure that could have resulted from a meteorite impact;*
(above right) *Northern Sahara – the Air Mountains of Niger;* (below) *Northern Sahara Sand Dunes in Central Algeria.*
Taken in June 1965 from *Gemini IV* 130 miles in the air. Courtesy NASA

Astronaut Col. Edwin E. (Buzz) Aldrin's visor mirrors the television camera, flag, lunar module, and Astronaut Neil Armstrong (the photographer) in this picture taken during the *Apollo XI* mission, July 16, 1969. Courtesy NASA

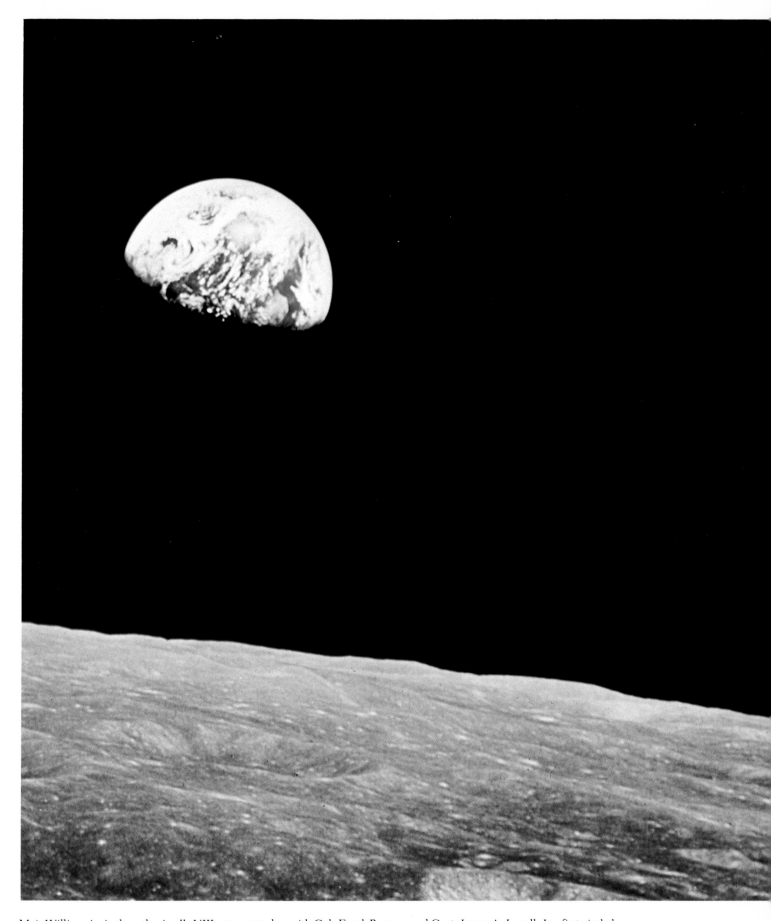

Maj. William A. Anders, the *Apollo VIII* astronaut who, with Col. Frank Borman and Capt. James A. Lovell, Jr., first circled
the moon on December 24, 1968, said, just before departure. "By having a camera connected to an eyeball connected to a brain
up there, we can really do a job that cannot possibly be done with unmanned vehicles." The astronaut's contention is supported
by this magnificent photograph of the blue-brown earth in a black sky above the desolate "wet sand" landscape of the moon.
Courtesy NASA

Fritz Goro. *Hologram*.
Three-dimensional images in space made possible by the invention of LASER (Light Amplification
Stimulated by the Emission of Radiation), a recent chapter in photography. 1965

5
Photography Today

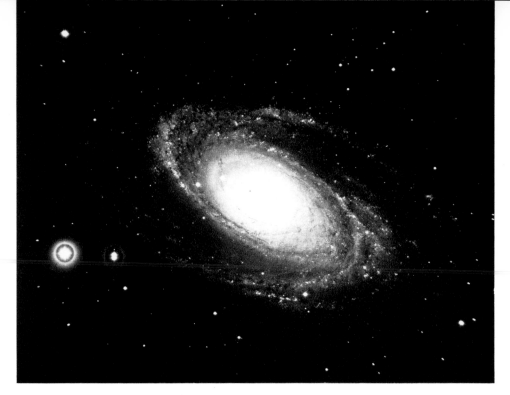

Spiral nebula, taken with a 200" Hale telescope.
Collection Mount Wilson and Palomar Observatories

Harold Edgerton. High-speed photograph of falling milk drop.
Collection Harold Edgerton, Massachusetts Institute of Technology, Cambridge

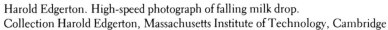

Extending the Range
of Human Vision

PHOTOGRAPHY HAS NOT ONLY GIVEN US powerful new forms of art but has found many applications in science, industry, and commerce. There it has revolutionized communications, deepened and broadened scientific research, and created new institutions of society. This process began early, for photography for practical use is as old as photography itself. Blueprints reproducing the drawings of engineers and architects were used by builders and manufacturers more than a century ago. At the same time, astronomers attached cameras to celestial telescopes to photograph the heavens.

So advanced is the photographer's arsenal in our time that a magazine photographer slings around his neck a quantity of equipment—in terms of performance—that the great Brady, in the Civil War, could never have carried in a whole train of wagons. Today's photographer may have on his person three or four cameras equipped with color or regular film. To one may be attached a battery-operated stroboscope light that provides brilliant illumination for intervals as small as a millionth of a second. The cameras themselves have lenses of great power—normal, wide-angle, and telescopic. A range-finder coupled to the lens brings the subject into sharp focus within a second or two. A light meter built into the camera frame can, automatically, provide the proper aperture for the selected shutter speed. The flick of a finger can move an exposed frame onward and bring the next unexpected frame into taking position—or, if this procedure is too slow to match the speed of the action being photographed, a spring motor can do the job automatically at the rate of thirty-six frames in a few seconds. Such equipment, it may be noted, is neither rare nor costly. Factory-made and popularly priced, it is sold every day in twelve thousand shops in the United States alone.

Camera and photosensitive emulsion can now see what the eye cannot: invisible radiation—X rays, cosmic rays, ultraviolet rays, infra-red rays—revealing objects cloaked in total darkness, bones beneath the skin, the structure of the universe; things too fast for the unaided eye—a horse winning by a nose, a bullet speeding through the shock wave of a sound barrier, a golf ball compressed by the head of a striking club; things too slow—flowers and cities growing; things too big—the earth's curvature; things too small—atoms, bacteria, metallic crystals; things too far away—spiral nebulae and the outer stars; things that would blind us if we looked at them—the sun's corona and the fireball of the nuclear bomb. Cameras can go where men would surely die—out into space, to the bottom of sea deeps as far below the surface as the Himalayas are above. Thus, over the past century, photography has extended human vision and, in combination with scientific instruments, revealed thousands upon thousands of unexpected aspects of nature on level after level, beauty and strangeness never before imagined.

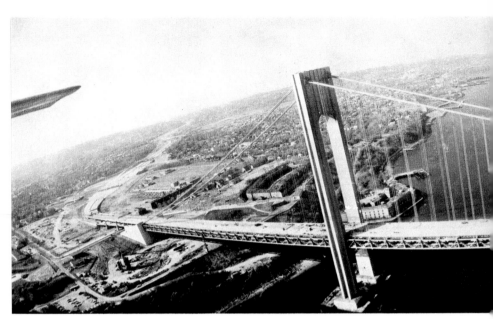

above:
A 180-degree aerial panoramic
view of Verrazano Narrows Bridge
taken from a plane flying at
low altitude. 1965.
This side-oblique shot was made
on 70mm film by a scanning sweep
which included the strut at the
right and part of the tail
assembly at the left.
Collection Perkin-Elmer
Corporation

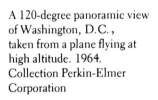

A 120-degree panoramic view
of Washington, D.C.,
taken from a plane flying at
high altitude. 1964.
Collection Perkin-Elmer
Corporation

An electron micrograph scan of
hair on a fly's tongue.
The original magnification
was 2500 X.
Collection Westinghouse
Electric Corporation

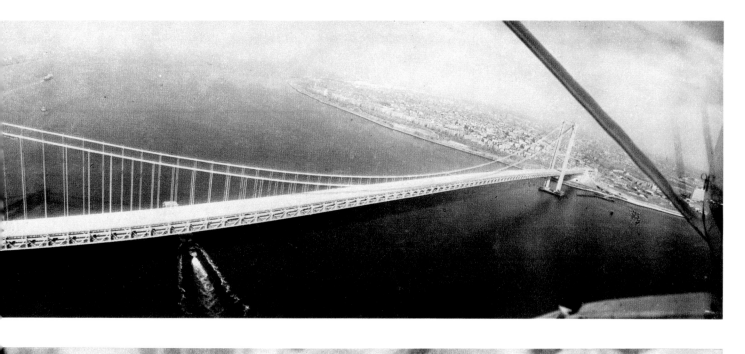

Postwar Trends

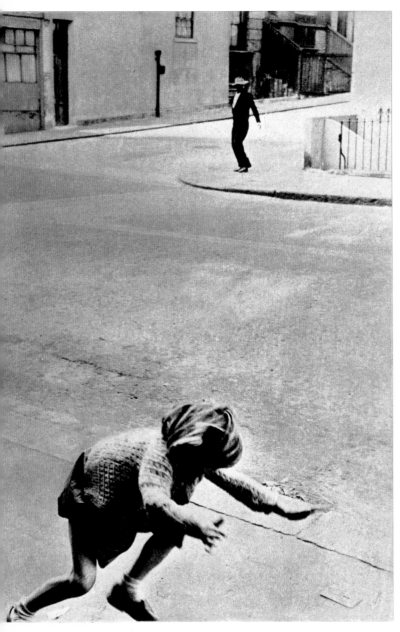

Roger Mayne. *Tension*. 1956

PHOTOJOURNALISM

THE PHOTO ESSAY, which began with Nadar and took its present shape from Margaret Bourke-White, is now a mainstay of the news and picture magazines. Typically, the photo essay is a carefully patterned sequence of pictures and captions. Sometimes the captions are merely explanatory; sometimes they carry on the thread of communication where the pictures leave off. The photographer may be a writer as well as a taker of pictures.

The photo essay is a journalistic art form of great inherent power. It brings the world to us through our own senses, as it were. We see it with our own eyes and form images in our heads of sounds and smells, tastes and textures. Words alone, no matter how compelling, by comparison seem no more than secondary reports.

The roster of distinguished photojournalists is now extensive, indeed. It is not surprising, in our unquiet times, that photographers of war and battle should rank extremely high upon that list. Combat photographers are a special breed and a special fellowship. They may be—they usually are—the gentlest of men, haters of violence, lovers of peace, dedicated men fascinated by the thing they hate and forced from within to follow it. Even more than other photographers, they are wanderers over the face of the earth, good comrades but not family men. Their home is the army camp and the battlefield. They submit to death and wounds with a bravery greater than that of any soldier because their discipline comes from inside. Scores of photographers and reporters suffered death or severe wounds in the Vietnamese War. In the Israeli-Arab War of June, 1967, the first casualty was Paul Schutzer, staff photographer of *Life* magazine; in the 1973 war three Israeli photographers were killed.

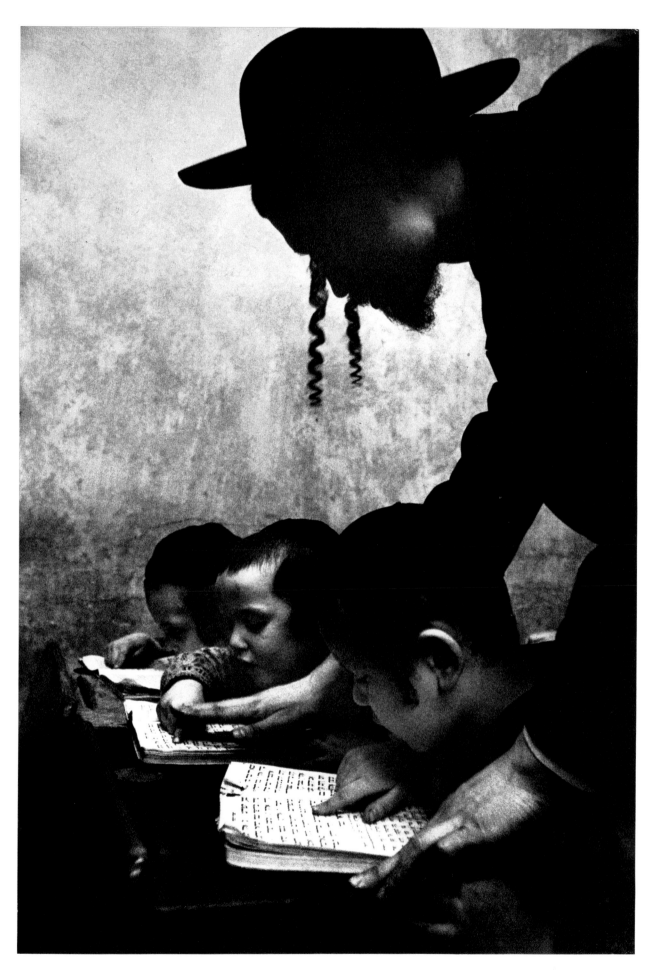

Cornell Capa. *Talmudic Study, Williamsburg, Brooklyn, New York*. 1955. Magnum Photos

Other frontiers of the modern world have their equally dedicated recorders. Robert Capa's younger brother, Cornell is one of the good ones. In his own words, he is "not a maker of images which are to be enjoyed by the viewer for their purely aesthetic value. I hope that as often as possible my pictures may have feeling, composition and sometimes beauty—but my preoccupation is with the story and not with attaining a fine-art level in the individual pictures. If I work well, my pictures mean something when connected in story form."

Different small worlds are evoked by Ken Heyman, whose picture stories of human relationships can be profoundly intimate, tender, and emotional, and by the Englishman Roger Mayne, who has photographed an astonishing record of yesterday's Teddy boys and their girls, giving us not a sociological exposé of delinquency but an honest, sympathetic presentation of these children of London's streets. Mayne is a compara-

tively detached observer who does not attempt to penetrate too deeply into humanity's interior world.

Presenting the vast, shifting panorama of world events has absorbed the major portion of photojournalistic energies. Cartier-Bresson, in his world travels, brings back picture stories more limited in sweep but with a well-nigh incredible freshness and immediacy. The Swiss photographer Werner Bischof, who was killed as his jeep fell off the mountain while he was photographing Machu Picchu, was matched by few men in technical mastery. After an early career devoted to meticulously built pictures of shells and other still lifes, he took memorable news pictures of events in Central Europe and Asia. His *Shinto Priests in Snow* attests to his acute responsiveness to the visual image.

Cartier-Bresson's protégé Marc Riboud has so extended the bounds of yesterday's photojournalism as to entitle him to be called a photohistorian. Like his mentor, he has photographed the new China. His

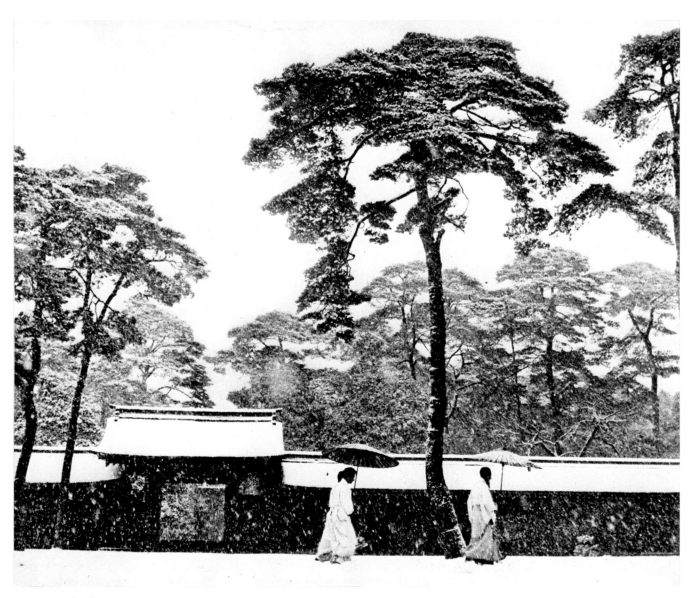

Werner Bischoff. *Shinto Priests in Snow, Japan.* 1951

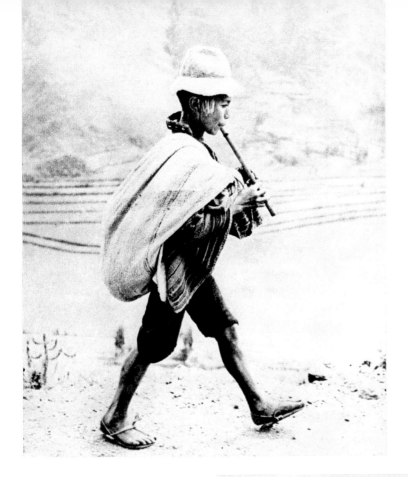

Werner Bischoff. *Peruvian Piper*. 1954

Marc Riboud.
Palace in the Snow, Peking. 1957.
Magnum Photos

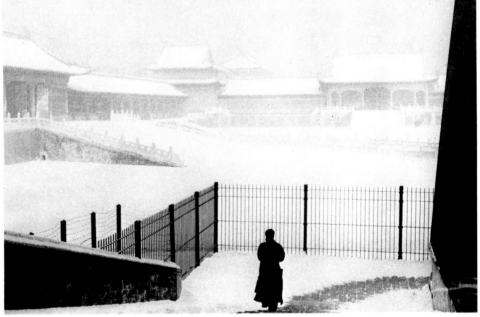

Marc Riboud.
Haying, China. 1957.
Magnum Photos

Marc Riboud. *Camel Market, India*. 1956. Magnum Photos

Elliott Erwitt. *American Soldiers on the March, Korea*. 1951. Magnum Photos

Three Banners of China was one of the great publishing events of 1966. Its fifty pages of color photographs, 150 more of black and white, and 5,000 words of text are the clearest, truest, and most telling picture that anyone has given us of the new China in all of its poverty, regimentation, strength, pride, and age-old beauty.

The largest pool of talented recorders of major international stories, unsurprisingly, was to be found among the staffmen of *Life* magazine, a brilliant photographic-communication enterprise that did more to advance the frontiers of photography than almost any number of brilliant individual photographers. *Life*, as its editors once put it, was founded for the purpose of harnessing "the optical consciousness of our time." Created for readers, not for photographers, *Life's*

imaginative editors and photographers set out to take its readers' eyes everywhere imaginable.

Paradoxically, too great a success resulted in the demise of *Life* magazine. A six-million circulation raised advertising page rates to phenomenal highs. With the Christmas issue of 1972, *Life*, mourned by readers and photographers alike, ceased publication.

Photography for newspapers and wire services is almost outside the scope of this book, for the aims of news photographers are basically different from those of other photojournalists. The differences can be seen in unusually concentrated form in the work of "Weegee," who has photographed more accidents, four-alarm fires, and murder scenes than any other photographer in history. "Weegee" is not in the least concerned with the niceties. His pictures are all action in the center and fade out to insignificance at the edges. They are unrivaled, however, for immediacy, vigor, and uncomplicated raw drama.

STRAIGHT PHOTOGRAPHY

"PHOTOJOURNALISM" and "straight photography" are both misnomers. These terms, nevertheless, are in such general use today that it would be more confusing than otherwise to employ substitutes for them. Straight photography, like photojournalism, is an art of the magazines, and not infrequently is extremely complex. The essential difference is that the meaning of photojournalistic work is revealed by picture sequences, whereas the meaning of straight photography is revealed by individual images. This is a boundary that photographers can traverse back and forth without great difficulty, and a number of men are equally distinguished in both branches of the art. Such a man is Elliott Erwitt, a photojournalist of great distinction. Another such man is Art Kane. A third is Emil Schulthess, who has given us marvelous panoramas in books on Africa, Antarctica, the Amazon, and China.

Within a class as inclusive as straight photography —the documentary, the nude, portraiture, abstraction, symbolism, and product and fashion are really separate categories in themselves—there are obviously many specialties, to say nothing of specialties within specialties. The world of William Garnett's photographs is the upper air. The late Diane Arbus's pictures of religious nudists, transvestites, and lesbians constitute a subclass within the subclass of the documentary. They show, moreover, that there is more breadth in the documentary than there was in the 1930s: truth value and shock value have been retained, but, unlike Robert Frank today and Dorothea Lange a generation ago, Arbus did not portray her subjects as figures of misery. They are targets of opportunity upon whom she turned her camera with empathy. On the other hand, Janine Niepce (a collateral descendant of Nicéphore Niepce, the father of photography) treats the disenchanted and dis-

Dimitrios Harissiadis.
Greek Frieze. 1955

above left: Janine Niepce.
Le Woum-woum, St.-Tropez. 1966.
Rapho-Guillumette Pictures,
Paris and New York

Hoishi Hojida.
Children in the Snow. 1965.
Magnum Photos

Minor White. From sequence *The Book of Infinity*. 1959

Paul Caponigro. *Dandelion 2*. 1958.
The Museum of Modern Art, New York

Paul Caponigro. *Feather-Flame*. 1963.
Collection Grace M. Mayer

possessed with less curiosity, less identification, and perhaps less sympathy, but with a keen understanding of the picture she envisions.

Japan is today one of the leading countries in the manufacture of photographic supplies and equipment, especially lenses. Photography seems to satisfy a special Japanese aesthetic need, and Japanese probers and poets with the camera are among the world's best. The art of Japan is traditionally based on close observation of the moods and details of nature, and the nude female images given us by Japanese photographers are grandly conceived, impeccably lit, and subtly evocative in form, mood, and texture. The best of them remind us of Maillol's sculpture in their balance and stability. Some of the most sensitive are by Hoishi Hojida.

Southern Europe has joined Western Europe, America, and Japan as a center of photographic art. Dimitrios Harissiadis is a leader of a small but vigorous movement in Greek photography. His personal style is apparent in his very characteristic *Greek Frieze*, a patterning of cleanly separated, darkly silhouetted elements set against a light background. Each element seems a unit in itself, but all are linked together in a beautifully balanced and thoroughly unified all-over composition, as in the classic Greek art to which the picture bears no superficial resemblance.

Interesting developments are taking place in the United States, where more and more workshops and studios of important photographers are being moved to colleges and universities, now the principal training centers for professional photographers. This trend began in the 1930s with the establishment of photography departments at Moholy-Nagy's New Bauhaus in Chicago and Black Mountain College in North Carolina. Both institutions were spin-offs of the Bauhaus in Dessau, Germany, which came to its end with the advent of Nazism in that country. College-based photographers have found an unofficial journal and forum in the magazine *Aperture*, which was founded by Minor White in 1952 and edited by him until his death in 1976. White, a brilliant photographer himself, taught photography in the Department of Design of M.I.T.'s School of Architecture. Oriented toward abstraction and symbolism, rigidly perfectionist, and not in the least concerned with mass aspects of photography, *Aperture* provides working photographers, teachers, students, and intellectuals the world over with reviews of photo-related books and exhibitions, articles on current developments in photography, and portfolios of current work, with special emphasis on emerging talents.

The work of Paul Caponigro, a truly gifted Bostonian, reflects the profound love of nature inculcated in him through study with Minor White and with Benjamin Chin of San Francisco, who was a student of Ansel Adams. With this Caponigro combines a highly developed sense of composition stemming from a deep understanding of abstract photography and a lifetime attachment to music. Like Ansel Adams before him, Caponigro first planned to make his name as a concert pianist. In photography, again like Adams, Caponigro has limited himself to black and white, for he, too, is constantly alert to the subtle tonalities available to him in the gray scale.

PORTRAITURE

PHOTOGRAPHY, as we know, came about in great measure through the efforts of portrait painters to find some reliable means of getting an accurate likeness. And, as we have seen, the camera lost little time in dethroning the brush as the recorder of our faces. Portrait photography has been a big industry for practically 130 years. This is not to say that photographers have distinguished themselves in the field of portraiture. Some have, most have not—completely aside from such standard villainous images pasted inside items such as passports and the heavily retouched inanities produced by run-of-the-mill commercial studios. For portraiture is, somehow, both the easiest and the most difficult assignment for the professional photographer. It is easy because the subject can make so important a contribution. The subject made the face, after all; and a technically competent photographer can get a pretty good portrait merely by allowing a face with character to record itself. To interpret a complex personality creatively, discovering something fresh and important to say, is something else again. The roster of giants in portrait photography does not contain too many names.

One among these few great portraitists is Philippe Halsman, whose talent ranges far beyond the borders of portrait photography. The 101 covers that he did for *Life* magazine—more than any other photographer—are evidence of his versatility. His images of Adlai Stevenson and Albert Einstein were used on two United States postage stamps. Halsman's genius as a portrait photographer can be measured not only by what he knows how to do but also by what he knows how not to do. He projects his imaginative vision, avoiding show of self—not displaying his dazzling graphic skill. His mind discovers, and his camera presents a small world of significant feeling and emotion.

Halsman has said about his portraits, "I do not direct the sitter—the only thing I try is to help him over his fears and inhibitions. I try to capture what I feel reflects something of his inner life. The main goal for me is not to impose my own ideas of the subject, but rather to get at the psychological truth of the subject and present it in a valid form, a graphic form—but I would always sacrifice design for content."

When Halsman does inject his own personality into his pictures, as he does in his non-portraits, the result

Philippe Halsman:
Homage to Op Art
(below). 1965;
Dali and the Seven Nudes
(right). 1951

Irving Penn. *Ballet Theatre Group.* 1948. Condé Nast Publications

can be wildly hilarious as well as technically astonishing. The little bit of Op art on page 142 was accomplished by projecting a transparency of an all-over pattern on the bare skin of a model and then photographing the transformation of that pattern by her shapely form. The witty photo of a skull formed by seven nudes is one of a number of startling Surrealist and semisurrealist images Halsman has created with his good friend Salvador Dali. They have earned him the appellation of "brainstorm-trooper." The Op figure and the Dali-plus-skull, of course, are high-level intellectual entertainments.

PRODUCT AND FASHION

IN THE 1920s, forward-looking advertising agencies were beginning to use sophisticated photographs, notably by Lejaren A. Hiller and Lewis Hine. Seemingly, however, photographers were not yet a major threat to illustrators, who dominated the visual aspects of advertising and editorial art at that time. To use a photograph on a popular magazine cover was utterly unthinkable; the early covers of *Time* magazine, for example, were a succession of charcoal portraits. All fashion pictures were drawings. Illustrations of products in consumer advertising were also drawings, but in 1927 a new cloud drifted across the advertising horizon in the form of a prize-winning still life of bananas appetizingly photographed by Shellock and Allison.

Photography has dominated fashion and product photography since the 1940s, when the talents of Victor Kepler, John Rawlings, Herbert Matter, Cecil Beaton, and Gjon Mili appeared. The remarkably versatile Irving Penn is a brilliant stylist both in color and black and white, and in both fashion and product photography. His chief asset as a commercial photographer is his virtuoso flair for bold composition and unearthly grace, which he fuses into single images that are not easy to forget. Another present-day photographer whose fashion photographs display his unusual capabilities is Richard Avedon, master of sophisticated softness and a unique stylist. When asked about the importance of the model in fashion photography, Avedon said, "I work with actresses—not clothes dummies or coat hangers." Through unconventional lighting, exaggerated poses, startling costumes, and exotic backgrounds, fashion photographers have created eye-catching images that have more than once changed female attire all over the world.

Irving Penn.
Girl in Black and White. 1950.
Condé Nast Publications

Doisneau:
Humorist with a Camera

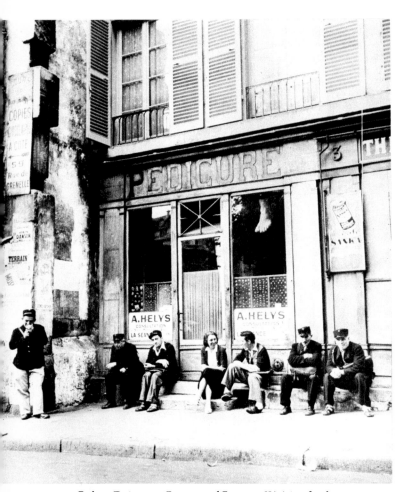

Robert Doisneau. *Porters and Postmen Waiting for the Pedicure Shop to Open.* 1953.
Rapho-Guillumette Pictures, Paris and New York

ROBERT DOISNEAU has the true Parisian's habit of strolling—but never aimlessly. He is always alert, his camera always set for the light and the site, ready for use. He seeks the incongruous, the ludicrous, the humorous, the ironic, and the satirical aspects of life. He is a rarity among cameramen, a photographer with a puckish sense of humor; what he secures in his seeing is often really funny, really witty, with nothing forced or faked. Amusing situations come into focus; his reaction is automatic—he laughs and shoots the picture at the same time.

He often anticipates whimsical tableaux. In Romi's gallery on the Left Bank he photographed expressions of people who suddenly discovered a female figure, nude but for stockings, painted from the rear as she peers through a window drapery. Doisneau caught a series of comical expressions which were published in the world's press. He received letters from all over addressed simply, "Romi, Paris," all asking to buy the painting.

His pictures are in a really universal language; the situations appeal to people everywhere. Postmen and porters wait for a pedicure shop to open; a sentinel in front of the President's palace holds bayonet poised as he intently ponders a bunch of balloons; in a three-sided wrestling match even the referee joins the grimacing mock battle.

Doisneau writes of his work, "The marvels of daily life are exciting; no movie director can arrange the unexpected that you find in the street."

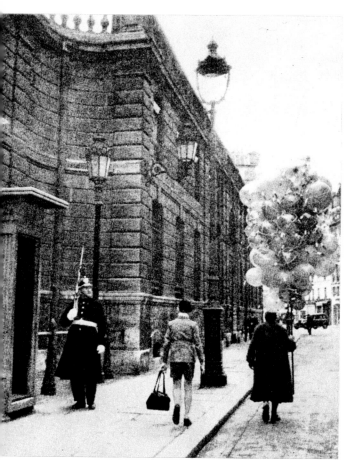

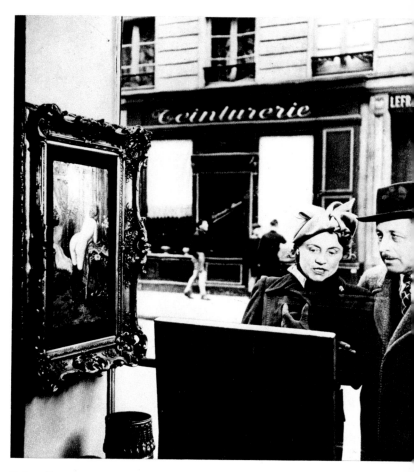

Robert Doisneau.
Sentry in Front of the President's Palace. 1951.
Rapho-Guillumette Pictures, Paris and New York

Robert Doisneau.
Side Glance. 1953.
Rapho-Guillumette Pictures, Paris and New York

Robert Doisneau. A scene from the sequence *The Skier and His Cello*. 1958.
Rapho-Guillumette Pictures, Paris and New York

David Douglas Duncan

DAVID DOUGLAS DUNCAN, an ex-marine whose reckless exploits with carbine and camera had earned him the title "The Legendary Lensman" in World War II, carried only a camera (for *Life* magazine) in the Korean War. He marched with the marines of the encircled First Division, his old outfit, in their bitter withdrawal from the border of Communist China to the Korean Sea. Icy winds of below-zero temperatures froze his gloved fingers and his camera shutters, and he thawed both out against his body. When he could feel that the shutter was working again he would quickly take a picture or two. He had to protect each roll of exposed film until he could put it aboard a plane for New York to be processed in *Life*'s darkroom.

Duncan took close-up shots of the eyes of men completely oblivious to him. He came up close to take a picture of a man crying, of men with empty, staring eyes, as mentally beat as they were physically exhausted. He took memorable pictures of men in hand-to-hand combat, the killing at point-blank despite the misery inflicted by the elements. Duncan photographed the inexhaustible courage of the marines with a sympathy and honesty that make his photographs some of the best taken in any war.

Duncan's exploit in Korea was a continuation of his incredible adventures in World War II with Fijian guerrillas who marched across the island of Bougainville to set up a base and harass the Japanese troops behind the lines. In this sixty-day campaign he fought alongside the fierce, bushy-haired Fiji Islanders.

After more than a year in the South Seas he was sent to Washington, where he wangled orders for travel anywhere in the Pacific theatre with his cameras. This was now his kind of war. He flew twenty-eight missions over Okinawa, three of them in a stifling, plexiglass belly tank which he attached under the wing of a P38. He secured a spectacular shot of a Corsair firing all of its eight 5-inch rockets over Japanese positions on Okinawa. This earned him a D.F.C. One of his best-known photographs taken at this time was of a defecting Japanese lieutenant in an American plane, talking into a microphone as he guided an American attack on his own former base.

Those roving papers allowed 2d Lt. David Duncan to range all over the Pacific. He was the only marine photographer aboard the U.S.S. *Missouri* during the signing of the historic surrender in Tokyo Bay. He returned to the States in 1946 covered with ribbons: another D.F.C., three air medals, six battle stars, and a Purple Heart for a flak wound received in a flight in which the pilot over whose shoulder he was snapping his shutter was killed by a bursting shell.

In 1956 he quit *Life* to join *Collier's* and to accom-

David Douglas Duncan.
"Black Avni" Turkish Cavalry on Maneuvers. 1948

pany John Gunther to Russia. A book resulted from this trip—*The Kremlin*, which was published in 1960, and expanded as *Great Treasures of the Kremlin* in 1969.

Duncan lived in Picasso's château in Cannes for several months in 1957, and produced a unique picture story about the great Spanish artist that proved a best seller in half a dozen languages. *Picasso's Picassos*, a magnificent book of colorplates of paintings withheld by Picasso from the world's art markets, was published in 1963.

In 1966, to close the record of a photographer who had reached the half-century mark, Duncan published *Yankee Nomad*, the autobiography of a gentle, dedicated artist who had clothed his life with violence. His career was not at an end, however, for fate decreed that in August, 1967 he would sign to cover the war in Vietnam for *Life* and ABC. Fifty-one years of age or not, he felt that whenever American marines took to the field, anywhere in the world, it was his duty to be among them, patiently securing a distinguished pictorial record that told the world what those determined men endure by their own choice.

Duncan was revolted and disillusioned by what he experienced with the marines at Khesanh, and wrote a thoroughly angry book, *I Protest*, published in 1968.

David Douglas Duncan.
Photographs taken during the
Korean War. 1950.
Courtesy *Life* magazine,
© Time, Inc.

Brassaï

HE WAS CHRISTENED GYULA HALASZ. The year was 1899; the place Brasso, Transylvania. To the world of photography he is Brassaï, a Frenchman. That is as he would have it, though he took the name of the town in which he was born for his name. He loves French literature, painting, theatre, and the city of Paris, as did his father, who had studied at the Sorbonne and had become professor of French literature at the University of Brasso. He brought the future photographer to Paris at the age of four. They lived there a year and the boy, too, fell under the spell of the city.

Twenty years later he came back, after two years' study at the École des Beaux-Arts in Budapest and an additional two years' study at the Art Academy in Berlin. Strangely, for the next eight years, he left art for journalism. To pin down certain aspects of Paris after dark he borrowed a camera from a fellow Hungarian, André Kertesz, a well-known photographer in Paris.

"Why didn't you sketch what you wanted as illustrations?" I asked Brassaï. "Why did you turn to photography?"

He answered, "How I became interested in photography reminds me of a story Isadora Duncan once told me. She was in love with an extremely wealthy man she called Lohengrin. He hired for her an accomplished pianist who played perfectly as an accompanist to her

Brassaï. *Backdrop for the Ballet "Le Rendezvous."* 1947. Made from photographs by Brassaï.
Rapho-Guillumette Pictures, Paris and New York

148

Brassaï: *"Bijoux" in Place Pigalle Bar* (left). 1932; *Le Pont des Arts, Paris, in Fog and Mist* (right). 1936.
Rapho-Guillumette Pictures, Paris and New York

dances but whom she detested. His face drove her to such distraction that she had a screen placed between them when she practiced. Her disaffection grew steadily worse. One day they found themselves in a carriage sitting opposite each other, face to face; there was no avoiding him. It was a rough, curving road. The carriage came to an abrupt stop and she was catapulted into his arms. She said to me, 'I stayed there; I understood it was to be the greatest love of my life. In fact for years he had rooms in another part of Lohengrin's castle.'"

Brassaï ended the story, "So too with me and the camera. I once detested her."

The day that the Nazis entered Paris, June 13, 1940, Brassaï left the city by subway. He took cover in the fields from the low-flying planes that were machine-gunning the roads as he walked and hitchhiked to Cannes 400 miles away. He would perhaps have sat out the occupation on the Riviera had he not happened to fall into conversation with a fellow tenant from his apartment building in Paris. He learned that the basement where he had hidden his negatives was not waterproof. The security of a decade's work became more important than his own safety. He returned to Paris and rescued his negatives.

During the occupation his kind of photography was curtailed, and he resumed sketching. He drew Amazon-proportioned figures, emphasizing the round and curvaceous forms of the nude. He showed these drawings to Picasso, who said, "Why did you give up drawing for the camera, Brassaï? You have a gold mine and instead you exploit a silver mine."

After the war, an edition of his drawings with a poem by Jacques Prévert was published. Later he executed immense straight photographic backdrops for Prévert's ballet, "Le Rendezvous," which were considerably praised in Paris and London where the ballet was seen for several years.

New York's Museum of Modern Art, during 1956, exhibited a series of Brassaï's *graffiti*, photographs of the scrawls and carvings he found on the walls of Paris. Symbols of what the young in the streets think, the *graffiti* show animals, birds, faces, gallows, hearts and arrows, and two black hollows that inevitably become empty sockets of staring death heads. Ever the consummate craftsman, Brassaï waited for the cross lighting of the late afternoon sun to secure detail and deep, dramatic shadows on the wall.

Brassaï works differently from the usual documentary photographer. His work is more static; into the instantaneous he injects his unique element of meditation, of revery. He seems not so much interested in the flux and action of a given picture as in holding the image.

In a lecture Brassaï gave before the Société française de photographie, he said, "To keep from going stale you must forget your professional outlook and rediscover the virginal eye of the amateur. Do not lose that eye; do not lose your own self. The great Japanese artists changed their names and their status ten or even twenty times in their ceaseless efforts to renew themselves... it is not right that the originality of that first vision should become a trick of the trade, a formula a thousand times repeated."

Callahan and Siskind:
The Magic of the Commonplace

HARRY CALLAHAN

HARRY CALLAHAN opens our eyes to the familiar and the commonplace. Sights of no beauty in themselves he makes beautiful—an upturned waste basket silhouetted in the dust; a desolate park bench in winter; a water fountain and a concrete step in the snow; a lowly weed consisting of three delicate tapering lines subtle as any seen in a master drawing—all taken with straight photography. With his camera he captures an intimate portrait of the inanimate, which he makes emotionally effective.

Harry Callahan. A Weed. 1951.
Collection Harry Callahan, Chicago

His pictures do not show us the totality of nature, like those of many cameramen. Callahan deliberately shows us less, making photographic discoveries by reduction, simplification, and isolation, so that the insignificant image becomes important. He has conquered the technical problems of his medium. Callahan experiments with multiple exposures or moves his camera to superimpose images, thereby achieving repeated patterns of varying tones and the interplay of lines and movements in the resultant textures.

Callahan has a profound feeling for the façades of buildings, which he presents in original graphic statements. Buildings are rarely shown with people; they are peopled with inhabitants who do not show their faces but who make themselves felt—through a window reflection, a fluttering piece of lace curtain, a still life of edibles on a window sill. The building commands us to see what the photographer saw, the proportions, the play of planes, the gradations of tones. The awesome, the fearsome, and the tawdry behind the façade are sensed only upon deeper penetration of the photograph. The emotional intensities in Callahan's photographs come through with a still kind of reticence.

AARON SISKIND

AARON SISKIND, who turned sixty-five years old in 1976, was born in New York. For fifteen years he taught at the Institute of Design (founded by Moholy-Nagy as the New Bauhaus, Chicago, now part of Illinois Institute of Technology), where he was one of the powerful influences on the students who are today's avid proponents of modern art and design.

Siskind has not always photographed in his later abstract idiom. He originally won recognition as a documentary photographer, especially for his series depicting New York's Harlem, Martha's Vineyard, and Bucks County, Pennsylvania. He has said about this long apprenticeship in craftsmanship and realism, "I found I wasn't saying anything. Special meaning was

Harry Callahan. *Dearborn Street, Chicago*. c. 1953.
Collection Harry Callahan, Chicago

not in the pictures but in the subject. I began to feel reality was something that existed only in our minds and feelings."

He turned for this "new reality" to abstract images that he found in lowly objects that are ordinarily ignored. This aspect of Siskind's work bears a striking similarity to Abstract Expressionist paintings, particularly those canvases that emphasize large unrelated forms, nongeometric abstractions, or strong textures and patterns in colors subdued almost to black and white. It is contemporary aesthetics with a camera. The photographer suggests plastic ideas to the painters, just as modern artists such as Willem de Kooning, Robert Motherwell, James Brooks, and the late Franz Kline and Jackson Pollock, through their paintings, suggest ideas to the photographer. Siskind with his camera, however, does not compete with the brush nor does he attempt to emulate or imitate painting. His work is an idiomatic photographic expression of the *avant-garde* conceptions of modern art.

One great difference between photographer and painter is that Siskind does not make his image in a darkroom; no matter how abstract it is, there is a foothold in reality. One of his motifs, to which he often returns, is the wall. To him it is never just a wall; the various forms seen in the wall come alive. Defaced and marked, the wall asserts itself far more than a blatant neon sign. It commands, like the marked walls of the public gardens in ancient Greece, where everyone was interested in the message, or, like a school-yard wall covered with messages that have meaning to children. With his camera Siskind seeks to capture meanings, not so much the message as the originality that young artists display in making drawings—combined with meaningful words or letters resembling some primitive writing—on roughly textured walls with purloined chalk. Wall images have their own reality, which Siskind wills into becoming a photograph. He sees the human element in these images and instills it in his pictures. He responds to the shape, form, and mood of a wall, and to the texture and appearance of weathered wood, jagged glass, peeled paint, rusted metal, sand and seaweed, and to the effect of time and the elements on concrete, paint, paper, plaster, and brick.

Aaron Siskind. *Degraded Sign, New York*. 1951.
Collection Aaron Siskind, Chicago

Aaron Siskind. *Oil Stains on Paper, New York*. 1950.
Collection Aaron Siskind, Chicago

Aaron Siskind. *Scrambled Fence, Harlan, Kentucky*. 1951.
Collection Aaron Siskind, Chicago

Van der Elsken:
Storyteller in Photographs

GREENWICH VILLAGE can never equal the Left Bank of Paris and, in particular, the district of Saint-Germain-des-Prés. No other place on earth means what the Left Bank has meant to the artist, the student, the expatriate, the "would-be," and the "flawed."

The district, despite all these changes and despite inflation of the franc, probably still has its seventh-floor single rooms for only a few dollars a week, with water and toilet three floors down, but there is a difference. Instead of a Mimi or Rudolph dwelling in the garrets there is a photographer, who hauls his water up three perilous flights of stairs to develop his negatives.

Ed van der Elsken was a photographer who in 1950 did not have $2 for one of these rooms. When he arrived in Paris he was less than twenty-five years old. In his native Amsterdam he had been an art student, had endured the Nazi occupation, and, at the end of the war, had turned to the camera. A year of darkroom work, and he was a ready-made free-lancer with no jobs.

In Paris he slept first under the bridges amidst the offal and filth of the derelicts, the *"clochards"* of the Seine. He learned quickly to rest during the long night sitting in a café chair. He listened to the youths of the district speaking their own peculiar brand of French, and once in a while he took a picture, unobserved. He made each shot count and he held on to his Leica even when he was starving. Night after night he sat in the cafés, observing, taking his few precious pictures. Then one morning he went to work. He had tried to write, but words were not sharp enough for his ideas. A 1.5 lens was, but he needed film. He found work in a

Ed van der Elsken. *"Dreams" in Saint-Germain-des-Prés, Paris.* 1953. Collection Ed van der Elsken, Amsterdam

153

Ed van der Elsken. *A Pitted Mirror*. 1953.
Collection Ed van der Elsken, Amsterdam

Ed van der Elsken. *Chamula Indians, Mexico.*
Photograph from *Sweet Life*, 1966.
Collection Ed van der Elsken, Amsterdam

photographer's darkroom where he did every conceivable kind of job. It was all to the good; he learned many subtleties in technique that he applied to his own work.

A picture story began in his mind one night when he met an attractive young girl from Australia who had come to Paris with ambitions to become a singer. Here was a girl who seemed to symbolize all the rebellious young talent annually drawn to the fabled Latin Quarter. He took pictures of her with the many men she attracted, art students, American sailors, Senegalese musicians, and the man who convinced her to shout a song in a café rather than sing it on a stage.

Van der Elsken followed her for two years with his camera. He took pictures of her smoking marijuana, drunk, and sober. He caught her in all her moods, and the camera worshipped her beauty. In his hand it never lied; he made it tell what the lens saw, honestly. She had become so accustomed to his being there that she was unaware of his camera. It pictured her wearing a turtle-neck sweater that emphasized her bizarre beauty; it captured an unexpected display of narcissism as she contemplated her soft-cheeked reflection in a frighteningly pitted mirror and as she kissed her intoxicated, Medusa-haired likeness in a rain-steamed window.

Holland has accepted Van der Elsken as one of her fine artist-photographers. Several years ago a Dutch television station and a shipping line enabled him and his wife to circumnavigate the globe with cameras and tape recorder. The trip yielded highly dramatic telecasts and an intimate travel book dedicated to the ship *Sweet Life*, on which they traveled through the Philippines. The book is unusual in the travel genre for its deliberate coarse-grained photography, with highlights and halos applied in the darkroom.

Cartier-Bresson
and the Human Comedy

HENRI CARTIER-BRESSON is the perfect detective with a camera: the man who never intrudes. He has the extraordinary ability to make himself part of a setting; he belittles himself whenever a subject becomes conscious of him and his camera by saying, "I'm just one of those camera bugs; I won't bother."

Cartier-Bresson searches for the meaning, the essential characteristic of the picture he instinctively sees in front of him. To make sure he sees it as a complete composition and not as some superficial charming expression or gesture, he peers through a reversing prism set on top of the ever-present Leica that he uses exclusively. The image is upside down; the bold forms stand out; when these flow into an acceptable composition he presses the shutter. It is by now a reflex action. The entire frame is filled with the picture (he rarely crops). He sees through the lens as a sniper sees through the telescopic sight on his rifle. Cartier-Bresson has repeatedly said that his right eye looks out onto the exterior world while his left eye looks inside to his personal world. The two obviously fuse in the one eye of the lens. He once wrote about this, "To me photography is the simultaneous recognition in a fraction of a second of the significance of an event, as well as the precise organization of forms that give that event its proper expression."

He explains that it is a journalist's duty to recognize what is important though he does not know in advance what that will be. Cartier-Bresson's camera is ready to take that picture the instant it takes shape. As the movement unfolds he perceives the precise instant when all the transitory elements form his kind of photograph. He clearly articulates this intention by saying, "Photography implies the recognition of a rhythm in the world of real things. What the eye does is find and focus on the particular subject within the mass

Henri Cartier-Bresson. *Allée du Prado, Marseille*. 1932

155

These photographs from Henri Cartier-Bresson,
The Decisive Moment,
Simon and Schuster, Inc., New York,
courtesy the photographer and
Magnum Photos, New York

Henri Cartier-Bresson.
A Day at the Races, Hong Kong.
1949

Henri Cartier-Bresson.
Two Prostitutes' Cribs, Mexico City.
1934

Henri Cartier-Bresson. *Sunday on the Banks of the Marne*. 1938.

of reality, what the camera does is simply to register on film the decision made by the eye."

Cartier-Bresson entered the French army in 1939, just after completing a film with Jean Renoir. As a corporal in the army's film and photo unit he was taken prisoner by the Nazis at the collapse of France. For the next thirty-six months he was a prisoner of war, escaping successfully only after the third try. He reached Paris and, for the balance of the war, served in the Underground assisting ex-prisoners of war. He organized French press photographers to cover the occupation and the retreat of the Nazis after liberation. Immediately after World War II ended in Europe, he resumed work as a cameraman for the United States Office of War Information, filming the return of war prisoners to France.

In 1946 he attended the first comprehensive exhibition of his work held at The Museum of Modern Art in New York. He stayed in the United States for the ensuing twelve months, traveling throughout the nation to acquaint himself with the immense pictorial canvas of the country. On his return to Paris he and his two good friends Capa and Chim founded the independent photo agency Magnum Photos. Magnum is owned as a cooperative by its outstanding photographers, who supply illustrated journals and magazines all over the world with photos or picture essays.

He sums up his belief in photography by saying, "For me, content cannot be separated from form. By form I mean a rigorous organization of the interplay of surfaces, lines, and values. It is in this organization alone that our conceptions and emotions become concrete and communicable. In photography, visual organization can stem from a developed instinct." Photography to the modest, unassuming Cartier-Bresson is a way of life, a creative mode of expression in which he can record the story of man with uncanny awareness, sympathy, and poetic imagination.

Yousuf Karsh: Faces of Destiny

YOUSUF KARSH, in his powerful portraits, transforms the human face into legend. Future historians covering the period between World War II and Sputnik II will turn for illumination to the perceptive, psychological portraits Karsh made of statesmen, scientists, and artists whose faces have changed the face and tastes of the world.

Karsh composes each photograph carefully, paying as much attention to background as to modeling the structure of the face and figure with light. The portrait is organized within the picture space. A dominant feature becomes the focal point, drawing the spectator's eyes through the composition and back to the objective center. The lighting appears natural, but number and sizes of light sources are carefully considered, so that the subject seems to sit in the diffused atmosphere of a courtyard lit by beams of unblinding sunlight. Each part of the picture is harmoniously linked by a balanced relationship of forms and masses, of dark areas and areas of light.

Karsh does not use decorative sweeps of drapery or painted props for backgrounds. He creates the proper background with light, and correlates it with the clothes worn by his sitter. In his photographs of Nehru, Sibelius, and Marian Anderson, the subject detaches itself to become a strongly framed light mass isolated by contrast with the darkness of the costume and the solid black background. In his photographs of Shaw and Churchill, Karsh achieves space and depth through highlighted areas made effective by the position of head and hands, clothes and accessories.

Karsh's masterful technique can create but superficially what does not exist in the subject's character. His portrait style applied to financial giants has resulted in overdramatized, brilliant photographs of apparent

Yousuf Karsh. *Winston S. Churchill*. 1941.
© Yousuf Karsh, Ottawa

outer strength without the concomitant inner force.

When he flew to Finland to photograph the distinguished composer Sibelius, Karsh took with him his 8-x-10-inch camera and hundreds of pounds of equipment, only to find the electric current available was insufficient. Until permission from the authorities was se-

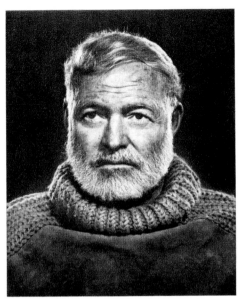 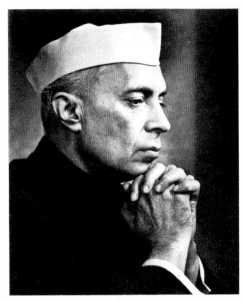 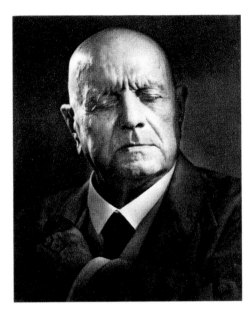

Yousuf Karsh: *Ernest Hemingway* (left). 1958; *Jawaharlal Nehru* (center). 1949; *Jan Sibelius* (right). 1949; *Marian Anderson* (below). 1948. © Yousuf Karsh, Ottawa

cured to tap the main line, Sibelius regaled Karsh with stories told with infectious gaiety. Karsh's lens probed to find the image, a divine mask with eyes closed that reflected the spirit and genius of the venerable composer.

Prime Minister W. L. Mackenzie King, a close friend and patron of Karsh, in December, 1941, arranged to have Winston Churchill pause to be photographed immediately after his speech before the combined houses of the Canadian Parliament. Karsh was given two minutes to take one shot. Churchill entered and stood impatiently, smoking a freshly lit cigar. Karsh, who had no intention of including the cigar in the portrait, walked up to him and said, "Sir, here is an ashtray." Getting no result, he said, "Pardon me," simultaneously taking the cigar from Churchill and snapping the shutter. Churchill walked over, shook hands, and remarked, "Well, you can certainly make a roaring lion stand still to be photographed." Eleanor Roosevelt, when she heard of the incident, commented, "It must have been Churchill's first major defeat "

This was the picture that made Karsh famous. Published again and again, it became a symbol of England's will to fight. The strength and power of Churchill's face stiffened the resolution of the English people, who were then bearing the full weight of Nazi bombings. The people loved the photograph; it was easy to imagine Churchill's stirring speeches issuing from this indomitable face.

Karsh writes of his profession, "If there is a driving purpose to my work, it is to record the best in people and, in so doing, remain true to myself....It has been my good fortune to meet many of the world's great men and women. People who will leave their mark on our

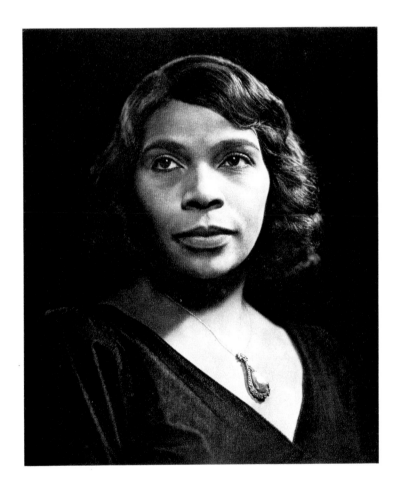

time. I have used my camera to portray them as they appeared to me and as I felt they have impressed themselves on their generation."

Karsh's great photographs of them will impress future generations, who will know through his artistry the look of the celebrated persons of this period in history.

159

Andreas Feininger

WHEN ANDREAS FEININGER was born in Paris in 1906 there was no question about whether he was destined for a career in the arts. His paternal grandparents were musicians; his mother was a painter; his father, Lyonel Feininger, was not only a great painter but a highly original composer. Lyonel Feininger was moved to awe and wonder by the eternal mystery of light—he endowed his youngest son, Theodore, with the middle name Lux, which is Latin for "light"—with which he transmuted the rational, geometric world of Cubism into luminous mystic visions. Unlike his father, Andreas is completely in the grip of outer nature, whose secrets he unravels. An analyst among photographers, he scans both natural and man-made vistas on every possible level of magnitude and complexity from telescopic to microscopic. Enlarging the scope of our nor-

Andreas Feininger. *Brooklyn Bridge, New York*. 1948. Courtesy *Life* magazine

Andreas Feininger. *New York, 42nd Street*. 1947. Courtesy *Life* magazine

mal, unaided vision, he assists us to observe the anatomy of our surroundings in unexpected forms and new beauty. Andreas Feininger intensifies our perception of nature's processes. Half scientist, all artist, he is the most scholarly of photographers and applies his encyclopedic knowledge of photographic techniques with intelligence and highly disciplined control.

Feininger uses a telephoto lens, or he bores close in to the subject, thereby eliminating extraneous detail. "With a short lens," he says, "I can reveal the hidden things near at hand, with a long lens the hidden things far away. The telephoto lens provides a new visual sensation for people: it widens their horizons. And, conversely, the things under our nose invariably look good when blown up really big."

Andreas's compositions belong to a three-dimensional conception of space that reminds us more of architecture and environmental design than of the flat world of painting. Thus, we are not surprised to learn that he was trained as an architect and worked as one for several years before turning to photography.

Feininger believes that for photographers—whom he expects to be color photographers from now on—nothing will be more valuable than interchange of ideas and stimulation between the arts of painting and photography. "The camera," he says, "can push the new medium to its limits—and beyond. It is there—in the 'beyond'—that the imaginative photographer will compete with the imaginative painter. Painting must return to the natural world from time to time for renewal of the artistic vision. The key sector of renewal of vision today is the new vistas revealed by science. Here photography, which is not only art but science also, stands on the firmest ground."

Robert Capa: Men in Combat

Robert Capa. *Death of a Loyalist Soldier*. 1936

ROBERT CAPA (1913–1954) was the foremost combat photographer of his time. A man who loved peace, hated violence and terror, and longed for a time in which there would be no wars for him to record, he dedicated his adult life to close and intimate study of men in mortal combat. His commitment to this task was passionate and complete. In 1936 he went to Spain with Chim and Gerda Taro, also a photojournalist and the woman he loved, to cover the Spanish Civil War. Carrying a camera instead of a gun, he characteristically moved along with the front-line troops, and almost immediately took his classic photograph of the death of a Loyalist soldier at the instant of the bullet's impact. Within a year, Gerda Taro was crushed to death by a tank, and, three wars and seventeen years later, Capa himself met violent death. Although a

cautious and battle-wise veteran who never took an uncalculated risk, he took a mortal risk when a wished-for picture demanded it. In 1954, driving well ahead of French troops so that he could photograph the columns as they moved along, he drove over a Vietminh land mine and was blown to bits.

He was born Andrei Friedmann in Budapest in 1913. When still in his teens, he left his native Hungary, then in the grip of Admiral Horthy's oppressive dictatorship, and went to Paris, by way of Berlin, where his compatriot György Kepes lent him an old Voigtländer camera, thus enabling Capa to discover that he and photography had been made for each other. In Paris, Capa began a lifelong friendship with Chim and Cartier-Bresson. The three youths worked together, often on the same stories, and shared darkroom space. Together, they developed the concept of what Cartier-Bresson, the most polished craftsman of the three, was later to call "the decisive moment." Capa's pictures, as John Steinbeck wrote, "were made in his brain—the camera only completed them."

After the war, Capa became what he happily called an "unemployed war photographer." In 1947, with Chim and Cartier-Bresson, he founded Magnum

Photos, the international cooperative agency for photojournalists, and divided his energies between building Magnum and encouraging and instructing a new generation of photographers. And, twice again, he became an employed war photographer, photographing the fiery birth of Israel in 1948 and France's war in Vietnam in 1954. His Vietnamese assignment, unfortunately, was his last.

Robert Capa. *D-Day, Normandy Beachhead*. 1944

Robert Capa.
*A Collaborator and Her Baby Escorted Out of Town,
Chartres, France*. 1944

W. Eugene Smith

W. Eugene Smith: *Welsh Miners* (above). Made as part of
Smith's reportage of the English election of 1950;
Soldier Drinking, World War II (below). 1943(?).
Photographed on Saipan. Collection W. Eugene Smith

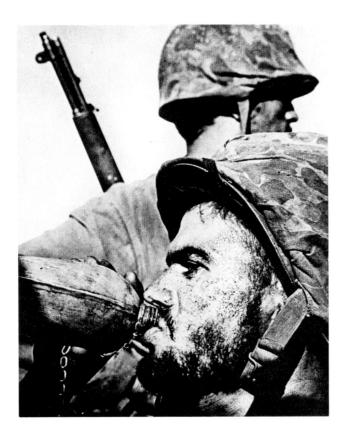

WHO IS OUR GREATEST photojournalist at this moment?
Most photographers, if asked, would reply, "Gene
Smith."

In many ways W. Eugene Smith seems an unlikely
candidate for this universal, if unofficial honor. He is a
near-perfect technician, but by no means the only one.
And hardly any other photojournalist has proved so
unadaptable to the workings of magazine-photography
publishing as it exists today. Nevertheless, Smith is an
awesome hero among photographers in his own time,
and his influence, always great, is constantly growing.

The reason for Smith's acknowledged importance is
actually not hard to find. This brooding, temperamen-
tal man is a moral force. As a practical matter, other
men cannot make the demands upon themselves that
Eugene Smith makes. If they did, they would become
impoverished; the disciplined teamwork of the com-
munication enterprise would founder; the printing
presses could no longer run. But Smith gives photog-
raphers a standard of moral and artistic responsibility in
executing assignments that serves as a guide to the entire
profession in furthering truthful communication.

"The photographer," Smith writes, "must bear the
responsibility for his work and its effect." For "photo-
graphic journalism, because of the tremendous audi-
ence reached by publications using it, has more influ-
ence on public thinking than any other branch of
photography." Smith is awed by this power and over-
whelmed by this responsibility; he sees understanding
—deep, broad, on level after level—as an inescapable
obligation. And he sees any compromise with that
understanding as a betrayal of his trust. He will research
a project as long as need be with every ounce of his
formidable intelligence and with a determinedly open
mind before taking a shot. He will then work with the
utmost care—which does not preclude, and may even
demand, the utmost speed—to bring his hard-earned
insight to his finished pictures. The living actuality of
the subject itself is the only guide whose authority he
will recognize in shaping his photographic interpreta-
tions. He will not allow instructions and suggestions
from photo editors to coerce a subject into a precon-
ceived pattern. Not only does Smith insist on taking,
developing, and printing individual pictures in his own

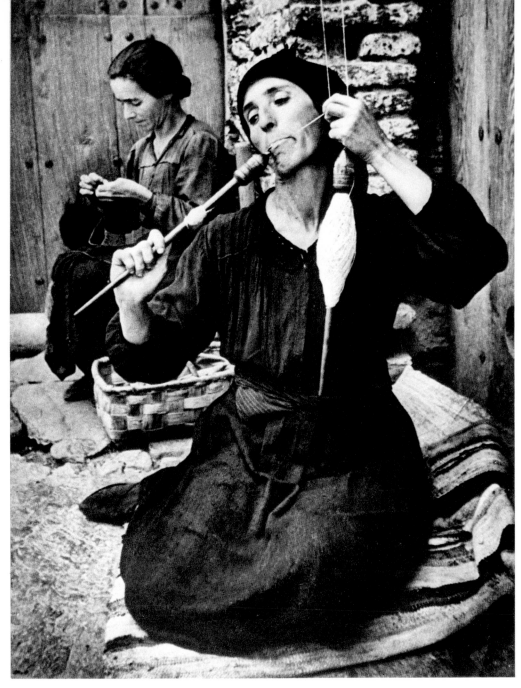

W. Eugene Smith. *Spanish Village*. 1950. Collection W. Eugene Smith

way, but also—and particularly—on selecting and arranging picture sequences and their captions to provide what he regards as a true and faithful vision.

Some of Smith's greatest picture stories—*The Doctor, Midwife, Spanish Village, Albert Schweitzer*—were done for *Life*. *Spanish Village* has been called "a new outpost in photographic journalism... rendered with some of the pictorial splendor of Spanish painting." *Labyrinthian Walk*, a most astonishing photo essay, is a "personal interpretation" of Pittsburgh that was published in 1959 in *Popular Photography*, a magazine for which Smith had been a war correspondent from 1942 to 1944, before becoming a war correspondent for *Life* and suffering crippling wounds at Okinawa. His incredibly courageous attitude in pursuing a picture story cost him the sight in one eye when he was beaten by six men while photographing the effects

of mercury poisoning on the people of Minamata, Japan, who had eaten fish from waters polluted by the town's large chemical corporation. The passionately involved fifty-seven-year-old photographer and his young Japanese-American wife persisted in staying in the Japanese fishing village for three years, securing incontrovertible evidence in a series of heart-rending photographs. These were published as a book, entitled *Minamata*, in 1975.

"I am constantly torn," Smith has written, "between the attitude of the conscientious journalist who is a recorder and interpreter of the facts and of the creative artist who often is necessarily at poetic odds with the literal facts." Only a man with two such sides to his nature, and profoundly aware of them both, could have blended and reconciled them so effectively in photojournalism's boldest thrust toward the future.

"Chim"—David Seymour

BORN IN POLAND, David Seymour (1915–1956)—"Chim"—completed his education in Germany and France, and died an American citizen. No man was more deeply loved among international photographers. A gentle soul, a gourmet of exquisite cultivation, Chim was devoted to children. He was single and forty-five years old when he was killed in 1956, a casualty of the Israeli-Egyptian War of that year, which saw England and France as the allies of Israel. Except for one sister, Chim's own family had been entirely destroyed by the Nazis in the gas chambers. The wars that he covered (and he covered many wars) he saw as enormous crimes against the world's children. He revealed the horrors of war in the faces of children, photographing the lost, the hurt, the maimed, and the parentless, their starved bodies and their indelibly seared souls. He adopted children wherever he was. He sent money for their support. He remembered their birthdays and he saw them as often as he could. Whenever possible, he placed them in the homes of his friends.

Chim's professional career as a photographer began in 1933 in Paris, where he shared a darkroom with Robert Capa and Henri Cartier-Bresson. From 1936 to 1938 he covered the Spanish Civil War and events in North Africa and Czechoslovakia. When he could, he turned his camera away from the armies and the impersonal destruction of bricks, mortar, and bodies, photographing the faces of the people and showing us the personal, human consequences of the war. In 1939 Chim covered the voyage of Spanish Loyalist refugees to Mexico. He was caught in Mexico at the outbreak of World War II, and when he crossed the border to the United States he spoke seven languages but no English. He worked as a darkroom technician in New York before volunteering in the U. S. army; he served three years in the European theatre of war as a photo interpreter for the Air Corps. Toward the end of the war he received a field promotion to lieutenant. In 1944, wearing the uniform of an American army officer, he returned to cover the liberation of Paris, where he met his friends from all over Europe who had found refuge there.

At the end of the war, Chim cofounded Magnum Photos with Capa and Cartier-Bresson, becoming its president after Capa's death in 1954. Chim's first postwar years were spent documenting the children of Europe's devastated areas for UNESCO. His pictures were exhibited first at The Art Institute of Chicago, then circulated internationally, and later published as a photobook. They touched the conscience of the world.

David Seymour ("Chim").
Loyalist Troops, Spanish Civil War. 1936

Chim. *Popular Front Sit-down Strikers, Paris.* 1936

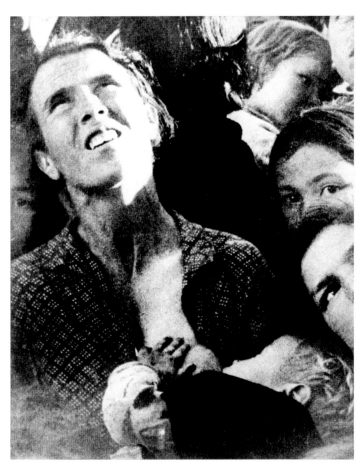

Chim. *Barcelona Air Raid.* 1936

Chim. *Bernard Berenson in the Galleria Borghese, Rome.* 1955

Bill Brandt

BILL BRANDT is one of the most well-rounded and most effective cameramen working in Britain. An architectural and landscape photographer par excellence, he is also a social commentator with the camera, a satirist of the incongruous social structure of England before World War II. After photographing a memorable document, in still pictures, of the human misery he saw in the jobless, depression-bound mining towns of Wales, he turned to photojournalism when the war broke out.

Brandt often came out of the shelters while the bombs were still falling to photograph the streets of London in the blackout. Lit by moonlight, the houses stand eerie and lonely; St. Paul's Cathedral looms steadily above the rubble, giving hope and courage to all. These pictures are indeed memorable, for Bill Brandt's mastery resurrects a true and feeling-charged image of that frightful time.

After the war Brandt made a series of photographs of the nude female figure using a wide-angle anamorphic lens. They are fascinating designs. By means of his distorting lens Brandt was able to alter familiar perspective and thereby create anatomical images of distorted shape or exaggerated mass. His conceptions of the human form approached those of Maillol's sculptures and El Greco's mystical attenuated figures. These photographs testify to Brandt's power as an inventor of forms.

Bill Brandt has photographed his personal pantheon, a gallery of celebrated portraits of Edith and Osbert Sitwell, Dylan and Caitlin Thomas, Graham Greene, Robert Graves, Cyril Connolly, Alec Guinness, Peter Sellers, Henry Moore, Picasso, and Braque, among others. This unique set of photographs exemplifies Brandt's driving concern to reveal in his portraits the precise personalities he has come to know.

Bill Brandt. *Halifax*. 1936.
Rapho-Guillumette Pictures, Paris and New York

Bill Brandt.
Parlormaids. 1932.
Rapho-Guillumette
Pictures, Paris
and New York

Bill Brandt. *Henry Moore*. 1946.
Rapho-Guillumette Pictures,
Paris and New York

Arnold Newman

ARNOLD NEWMAN SPECIALIZES in portraiture: grandly patterned, superbly composed pictures, parts of which are symbolic objects that indicate the sitter's occupation or significance in the world. With a great degree of objectivity, Newman reveals rarely seen aspects of the sitter's personality. He is particularly interested in the relation between a man's personality and his life's work. He wants to know what there is about a person that makes one of interest in our time, and he searches for symbols that suggest this importance. His attitude toward the sitter seems to be: "You are the sum of the work you've done. Therefore, in my pictures, I shall say something about the field you have made your life's work and, most important of all, how you feel toward it."

A photographer could do this easily enough, perhaps, through exaggeration, through caricaturing a salient feature of the sitter's face or body, or by prettifying, glossing over, or dramatically ennobling the subject. Arnold's exaggerations are used only for the sake of design, not for characterization. He waits patiently for the sitter to reveal an image that he has pre-envisioned and anticipates as the most characteristic, and he never misses it when it comes. In an instant he records the pictorial image that he knew would be disclosed.

Arnold is a master of lighting. He works extremely fast when on an assignment outside his studio. When he photographed the late President Lyndon B. Johnson he was allowed 1½ hours to set up his lights, but only fifteen minutes with the President to take the pictures.

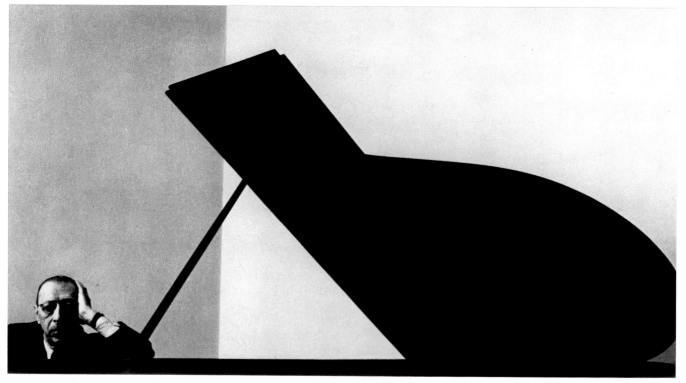

Arnold Newman. *Igor Stravinsky*. 1946

Arnold Newman. *Willem de Kooning*. 1959

Arnold Newman. *Jacob Lawrence*. 1959

Arnold Newman. *Alfred Krupp*. 1963

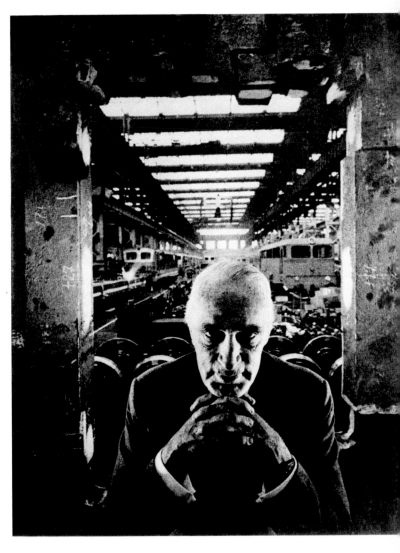

He nevertheless took thirty minutes, used two cameras —an 8 x 10 and a 4 x 5—for black-and-white and color film, respectively. He posed his subject so that the architectural features of the President's office in the White House completed the consciously controlled elements of his composition, producing a photograph that LBJ selected as the official portrait of the Chief Executive.

Newman prefers big cameras for his portraits. He works deliberately and carefully; he designs on the ground glass, controls perspective, planes, and his space of 4 x 5 proportions, and distorts and exaggerates subject or symbol as he decides. He has said, "I use the camera as a creative tool as well as a recording device.

"I think photography is a matter of controlling what's in front of you and making it do your will. This, of course, implies absolute mastery over camera, medium, techniques, and the ability to work with the subject and get him willingly and happily without any self-conscious feeling to fall into those things which are natural to him. This is a very complicated thing to do in portraiture. Mine are deliberately self-conscious portraits and therefore contain no forced feeling of candidness... the subject is unaware of the fact that I am waiting—things begin to happen—the man begins to reveal himself.

"If the background becomes overwhelming and you lose the personality, then I have not made a good portrait and it is not a good picture. I think the world is full of intelligent people who are not really trying to be flattered; what they really want is to be understood.

"The more I get to know my subject the more he gets to know me, and so often the pictures taken at the end of a sitting are much better both creatively and interpretively.... A photographer is always in a state of preparing himself for a given moment... we have only an instant in which to think and act."

171

Lucien Clergue

Lucien Clergue. *Weeds in La Camargue,
a Marshy Island near Arles, France.* 1960

LUCIEN CLERGUE was born in Arles in 1934. He learned photography from the town baker. His first photographs were of dead animals. These were followed by some of his best pictures—those that chronicle the ballet of the bullring, specifically, the slaughter of the dull-witted but beautiful beasts that are the focus of the drama.

Morbid subjects, however, did not hold Clergue's total attention. He loved the female figure and the sea with an exalted intensity that exceeded his fascination with the dead and the dying. His "Nus de la Mer" series, a glorified exposition of the female nude, was begun in 1956. The photographs have been shown in many exhibitions all over the world and were published in book form in the spring of 1967. Jean Cocteau, on being shown the collection, said, "Clergue has witnessed the birth of Aphrodite."

Picasso, when he looked at a Clergue photograph of a nude female figure, with its shimmer of highlights from the foaming sea, said, "He is the Monet of the camera." And, indeed, Clergue shares the Impressionists' feeling for light, but he is even more interested in the figure as a sculptural mass. Clergue uses light to make his memorable forms and shapes come alive; his

Venus rising from the sea is three dimensional. Her thighs, buttocks, and breasts are islands of tenderness. Her navel is a depthless pool. A billion bubbles of light are trapped in her hair. Altogether she is an exalted image, the divine woman whom countless generations have conjured up in their dreams since the sailors of Ancient Greece first put out to sea.

Through photographic magic Clergue endows soft, sensuous forms with the look of polished marble, transforming them into such shapes as sculptors carve in order to exploit the effects of light. He gives up these impressive effects, nevertheless, when he concentrates on the textures of the female figure. He purposely lets his models become chilled so that they are all goose-flesh; then he places them against coarse sands of varying shades, achieving dramatic distinctions in tactile values.

Lucien Clergue. *Nude in the Sea.* 1958

Gordon Parks

I HAVE A MENTAL PICTURE of Gordon Parks that invariably comes to my mind whenever I recall one of his picture stories in *Life* magazine. He is on skis, slaloming down some steep hill in Minnesota: a young man with brown skin, black mustache, white suit, and a red scarf, racing downhill, very much alone, alert to every obstacle on the run. He is cool and detached, maneuvering around obstacles almost without effort and keeping an eye out for careless humans who might wander into his path. Parks maneuvers his cameras with equal skill through the dangerous twists and turns on the steep slopes of human relations—of race relations especially.

Parks learned to move smoothly in every situation at a very early age. Gripped by poverty when he was sixteen and newly arrived in St. Paul from his native Kansas, he worked at a dozen jobs, from playing the piano in honky-tonks to professional basketball, lumberjacking in the North Woods, and waiting on tables in a railroad dining car traveling to and from the West Coast. Fortunately he found a camera in his hands in 1937, when he was twenty-five, and his real career began. Three years later he was in Chicago taking fashion and arty photographs. He eked out a bare existence until 1942 when he was awarded a Julius Rosenwald Fellowship. The fellowship enabled him to work for one year in Washington with the legendary Farm Security Administration photography unit so brilliantly directed by Roy Stryker. This former Columbia University professor was Parks's great photography teacher. He taught Parks to see deeply, putting him into situations that subjected him to the discrimination then prevalent in our nation's capital. Parks, never losing his innate dignity but profoundly moved by what he saw for the first time, deliberately photographed the seamiest side of Washington—sections of the city where the dome of the Capitol was visible above scenes of appalling misery.

Parks went all over the country for the F.S.A., shooting the agony of the Depression. After the outbreak of World War II he was transferred to the Office of War

Gordon Parks. *Red Jackson*. 1948.
Courtesy Gordon Parks and *Life* magazine, © Time, Inc.

Information, overseas division, as a war correspondent-cameraman. At the end of the war, he rejoined Stryker to become a member of a seven-man photographic team that made documentaries for the Standard Oil Company of New Jersey.

All these experiences in his technical and personal development were vital preparation for Gordon's career as a photographer for *Life* magazine, which he joined in 1949. His byline as photographer-reporter appeared with many major stories on subjects ranging from Harlem gangs and their violent turf rumbles to Flavio, a

tubercular boy in Brazil living amid death and poverty on a hillside of muddy shacks.

Parks has received numerous awards for his photographs from such organizations as the National Conference of Christians and Jews, the Syracuse University School of Journalism, and the American Society of Magazine Photographers. He has had innumerable one-man exhibitions in the nation's major museums, and on the occasion of the show of his work that I assembled for The Art Institute of Chicago, he wrote me: "The camera is a forthright, honest and powerful medium of self-expression, and its potentialities are far reaching and unpredictable. A good picture may not always be in focus or best in composition, but in it you are always aware of a specific moment, which has been recorded truthfully. As a photographer I relentlessly search for that specific moment."

In the spring of 1968 Parks signed a contract with Paramount to produce and direct his autobiography, *The Learning Tree*. Since then he has directed two action-packed feature films dealing with the black detective Shaft, *Shaft* and *Shaft's Big Score*; *Super Cops*; and *Leadbelly* (1976). Parks has published *Born Black*; *In Love*; and three volumes of poetry illustrated with his photographs: *Moments without Proper Names, Whispers of Intimate Things*, and A *Poet and His Camera*.

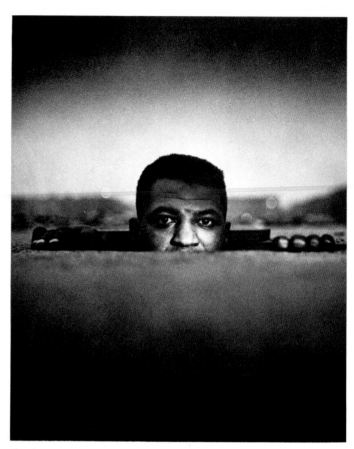

Gordon Parks. *Invisible Man*. 1956.
Courtesy Gordon Parks and *Life* magazine, © Time, Inc.

Gordon Parks. *Flavio, Rio de Janeiro*. 1961. A *Life* magazine cover.
Courtesy Gordon Parks and *Life* magazine, © Time, Inc.

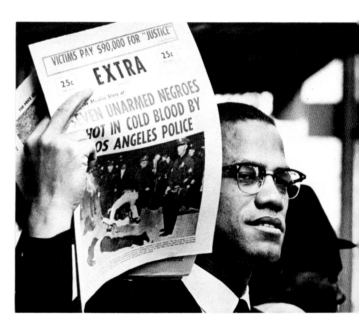

Gordon Parks. *Malcolm X*. 1963. Taken two years before he was murdered, when he was second in command to Elijah Muhammad. Courtesy Gordon Parks and *Life* magazine, © Time, Inc.

Bruce Davidson

THE PHOTOGRAPHS TAKEN over the past decade and a half by Bruce Davidson are extraordinary for the depth of their feeling and their poetic mood. They have won for their author a most enviable reputation as an original talent in the terribly over-controlled and repetitious field of photojournalism.

Bruce Davidson, an individualist in the tradition of the pioneer picture-essay photographers, did not go to work as a magazine staffman. In 1958, after studying art and philosophy at Yale, he joined Magnum Photos. Accordingly, he has had the freedom to pursue picture stories of his own conception—for example, *Brooklyn Gang, Selma March, Central Park, In the Footsteps of Christ*—and Magnum has placed these unique photo essays in the world's picture magazines. In 1962, he was awarded a Guggenheim Foundation Fellowship to make a photographic study of the American Negro.

Davidson's young people do not burn with frustration and rage. They are not aghast at the evils and miseries to be seen all around them; astonishingly, they accept these things without a great show of emotion. The painful feelings impressed on us are the photographer's. Davidson's wounded sensibility is recorded as he photographs with compassion the painful situations to which people are subjected in various parts of the country—situations that they endure because of jobs they cannot leave.

Bruce Davidson's photographs have been exhibited in some of the nation's major museums, which have acquired many of his prints for their permanent collections. He is one of the most gifted photojournalists at work today, and is reputed to be the photographer who has the most profound influence and impact on those young people leaving college who are considering photography as a vocation. Davidson teaches a photography seminar in his studio to a group of these talented young people.

Without the financial help of any foundation, Davidson spent eighteen months documenting life on East 100th Street, in New York, using camera and tape recorder to achieve a remarkable study of Puerto Rican families residing in the slums of Harlem. These photographs were exhibited at The Museum of Modern Art in the fall of 1970, and were issued concurrently in book form by Harvard University Press.

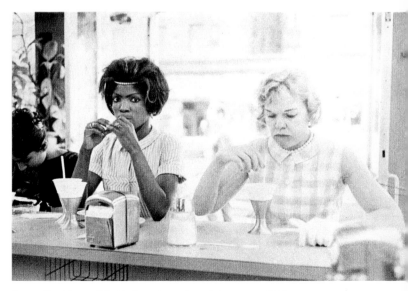

Bruce Davidson. *5 & 10-Cent Store Lunch Counter.* 1963.
Magnum Photos

175

Index

Page numbers in italic type refer to illustrations